PHOTOGRAPHY BY KEVIN CLARKE & HORST WACKERBARTH

TEXT & INTERVIEWS BY WILLIAM LEAST HEAT MOON

THE RED COUCH

A PORTRAIT OF AMERICA

ALFRED VAN DER MARCK EDITIONS • NEW YORK

Editorial Director: Robert Walter

Designer: Jos. Trautwein, Bentwood Studio

Copyeditor: Leonard Neufeld

All photography by Kevin Clarke and Horst Wackerbarth except the following documentary pictures: pp. 6-8, p. 12 (top 2), p. 13 (top left & mid right), p. 75, and p. 207 (top) by Kevin Lynch; p. 28 and p. 207 (top) by Hedy Valencise; p. 55 by Francesco Ruggeri; pp. 132 & 134 by Christine Thomas; and p. 173 by NASA.

Cover Design: John Brogna

ALFRED VAN DER MARCK EDITIONS
1133 BROADWAY, SUITE 1301
NEW YORK, NY 10010
DISTRIBUTED BY HARPER & ROW

Library of Congress Cataloging in Publication Data

Clarke, Kevin, 1953–
 The red couch.

 1. Photography—Portraits. 2. United States—Social
life and customs—1971– —Pictorial works.
I. Wackerbarth, Horst. II. Heat Moon, William Least.
III. Title.
TR680.C55 1984 779'.2'0922 84-50572
ISBN 0-912383-17-8

Typography: Typographic Arts, Inc., Hamden, CT
Color Separations & Stripping: Terry Harstad, T H Graphics, Diamond Bar, CA
Printed in Canada by Ronalds Printing

First Printing: September 1984
Second Printing: September 1985

In the fall of 1983, Bob Walter, the editor of this book, asked me to write an introductory account of the beginnings of what was then known as the ''red couch project.'' He also asked me to write brief captions to accompany the projected one hundred photographs. While we both realized that a purist may prefer to see a picture stand entirely on its visual merit, we are with those who believe that an integration of word and image often makes for more power and interest than might the photograph alone.

When a reader knows what one of the Hell's Angels did to a passerby during the making of that portrait or when the reader overhears what lunar astronaut Alan Bean talked about during his portrait, a dimension deeper than the eye alone can reveal opens. My job here, then, has been to help the photographers add that other dimension, that area where the facts behind a photograph change one's perception of its image.

Because I was not present during any of the shooting sessions—three-quarters of the pictures had already been made by the time I joined—I felt that the words in the captions should not be mine but those of the photographers themselves. From tape recordings of long conversations with Kevin Clarke and Horst Wackerbarth, as well as from their field notes and a few video interviews Wackerbarth taped of several shoots, I compiled the caption material. Despite the editing and compressing necessary because of limited page space, I have tried to retain the voices of the photographers. I have corrected a few grammatical lapses and, at Wackerbarth's request, smoothed his occasional problems with American idioms.

My contributions to the last photographs were a negligible two: use the couch more as a suggestion, and go easy on the celebrity portraits. In no way should I be considered a significant partner to the making of this splendid work. It belongs to the photographers. That is not to say, however, that I would not have liked to be in on things from those first days when the couch was at the deep end of a swimming pool.

WLHM
July 1984

WILLIAM LEAST HEAT MOON

TABLE OF CONTENTS

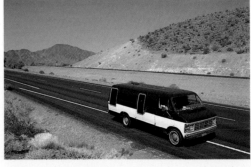

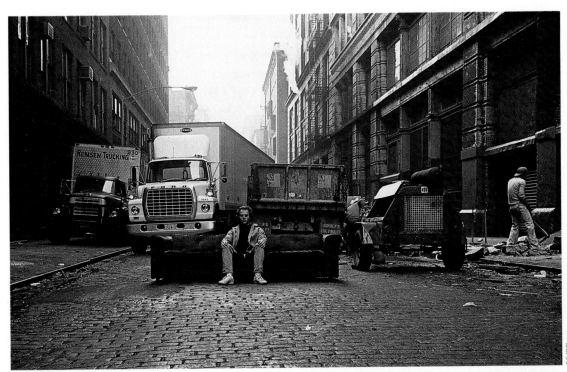

RUSSELL MALTZ
NEW YORK CITY

THE IDEA

IN THE BEGINNING there was only an eight-foot, two-hundred-pound red velvet couch, made in New Jersey, in the Manhattan loft studio of a young painter named Russell Maltz. Against the white walls, in the large and almost empty room, the red thing compelled the eye to turn to it. Like poet Wallace Stevens's jar in Tennessee, "it took dominion everywhere."

In 1976, Maltz saw an empty swimming pool near the Art Center of C. W. Post College, in Greenvale, Long Island. Two years later he and other artists began using the pool as a "given element in a series of site-oriented artworks." One sculptor draped it with bedsheets; another painted it flat black. In November 1979, Maltz asked Kevin Clarke, recently returned from three years in Switzerland and West Germany, to create something in the pool. Clarke, a sculptor and photographer who was staying with Maltz and sleeping on the red velvet couch, considered it a "piece of suburban schlock" that somehow pulled the big loft into aesthetic focus and gave it coherence. One morning, Clarke lugged the couch downstairs to Crosby Street for loading onto a truck that would take it to the pool. A shaft of sunlight fell between the buildings into the narrow street. Clarke: "It was suddenly beautiful. I had to take a picture." On a whim, he asked Maltz to pose on the couch, right there in the middle of Crosby Street, where trucks were being unloaded and cobblestones jackhammered. The couch, absurdly placed, made a bizarre picture.

At the swimming pool, Clarke assembled his piece, a "happening" in which he lay on the couch with a Sears, Roebuck catalog and dreamed of possessions: a blender, cufflinks, shoes. As he lay reflecting, he periodically tripped the shutter of a motor-driven camera with a cable release. For ten hours, his only audience was the lens. When he returned the couch to Maltz's SoHo loft, he asked elevator man Jack Miller to sit for a street portrait [page 15]. From those three pictures, the red couch project began.

A few days later, Clarke's friend, West German advertising photographer Horst Wackerbarth, with whom he had worked in Frankfurt, returned to the loft after a vacation on Cape Cod. Clarke, Wackerbarth, and Maltz sat on the couch in the white studio and talked about the effects of placing this massive piece of furniture at the intersections of everyday life. The idea developed: rent a van, carry the sofa

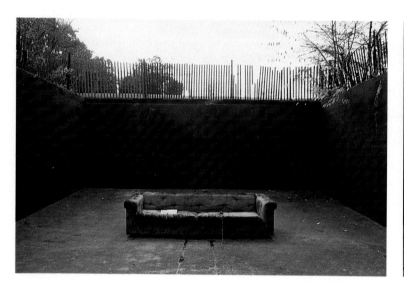 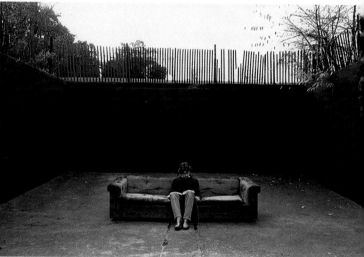

around the country, use it to disturb the commonplace into something new, and then photograph the results.

If the first three pictures were self-consciously humorous, later photographs need not be. The photographers agreed that the couch in a series of portraits would serve as a constant element of design—something to build around like the swimming pool. It would also be a common denominator, a binding ingredient to create "optical tension"; most of all, it would be a neutral object that could change the meaning of a photograph by its inclusion alone. After all, contemporary art was then full of such juxtapositions, things pulled out of intended contexts and set in new locations.

Clarke and Wackerbarth did not foresee that the deliberate misplacement of the couch would also help them interpret their own responses to a scene or measure a sitter's response to them; nor did they imagine just how such a foreign element—especially in the midst of the commonplace—could surprise a viewer of the finished

photograph. They were aware, however, that the whole idea might appear as only a media gimmick.

Wackerbarth, who always considered the couch feminine, said: "From the first days I loved the power of the couch, and I hated the restrictions she imposed on the photographs. She limited composition. Always the fight was to defeat control and overcome her domination of the picture. Always we had to see new ways to keep her under our power. We had to learn where she made a photograph and where she didn't. We couldn't just put her anywhere." For both men, the search for fresh yet unconcocted ways to employ the couch was a strain almost as great as the hunt for money to fund the project.

After a joint three-week experimental period of transporting the couch around New York City in December 1979, they returned to Germany to raise money and

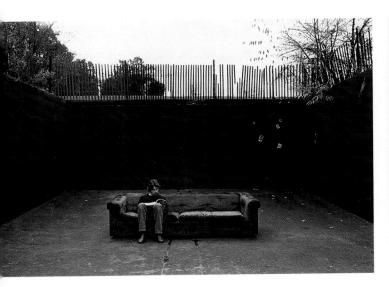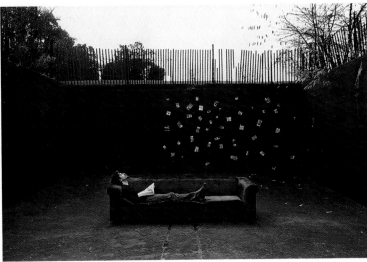

plan the project. By September 1981, they had enough funds for a two-week tour of New England. The remainder of the year, they shared the couch, each man taking it on the road alone for a few weeks. Problems produced tensions, but they kept to their plan until September, when Wackerbarth had a replica of the sofa made in Manhattan for five hundred and fifty dollars. Although the two couches were nearly identical, the new velvet made the second one a full f-stop brighter. From that time on, the men kept in touch, sharing photographs and advice, but working independently. A quiet rivalry developed that pushed each photographer toward better pictures. While the twin couches allowed a freedom of movement that encouraged distinctive visual approaches, the photographers feared that word of *two of them* would disenchant editors and readers. The divan had worked its power on even them; it had become more than just one of three hundred of that model made in the sixties. It had turned into something sacred: Thou shalt have no other davenports before me.

The Red Couch was transported in virtually every conceivable manner. Clockwise from lower left: Most often hauled by hand, on the roof of a car, or in a van (here seen stuck in the mud), it was also wrapped for portage, loaded onto a ski-lift, floated on a canoe, hoisted by helicopters and otherwise similarly abused. As a result it required constant cleaning and repair.

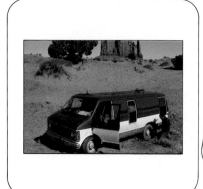

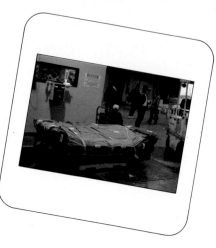

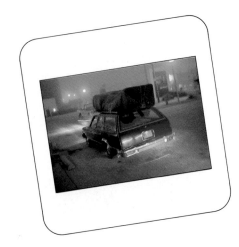

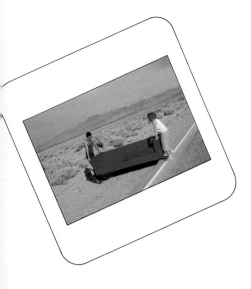

The early idea, of course, had been that the couch—as an object—would never be the subject of a photograph. In that sense, it was to be unimportant. If that was so, why not use something less demanding, more transportable, less expensive? Why not a red—or blue or white or green—folding chair? Just as a large, tripod-mounted view camera urges the sitter toward confrontation, so did this big, bright red velvet couch. It forced issues.

To a degree, both men had in mind the American tradition of documentary portraits, but the very presence of the couch prevented their photographs from being strictly documentary. In virtually every instance, Clarke and Wackerbarth conceived a picture that would represent some aspect of American life—its myths; commonplaces, cliches. Once they had visualized the photograph, they set out to find people and places to fulfill their ideas. As a result, the pictures are conceptualized documents, with Wackerbarth emphasizing the conceptual and Clarke the documentary.

The German Stephan Moses and the American Mike Disfarmer photographed people in front of blank backgrounds that stripped them of their accustomed surroundings in order to reveal who they really were. The idea here is the reverse. People on the red couch appear not only within an identifying setting, but also with possessions that further define them either as they are or as they wish to be.

Because the poor are more helpless and perhaps less interested in manipulating their symbols than are the wealthy and prominent, red couch photographs of the poor tend toward the documentary, while those of the prominent edge toward the conceptual. Yet any myth or illusion that shapes a life is just as real as poverty. Clarke: ''Straight documentary photography witnesses things as they are. Our kind of documentation bears witness not to the objective realism of the lens but rather to the truth of the imagination in circumstances that are real even though altered by a piece of furniture.''

THE JOURNEY

So, after the experimental period had proved it workable, this project that began at the bottom of a dry swimming pool got fully under way. The men initially envisioned a six- to nine-month journey of perhaps ten thousand miles through forty states. Clarke got a good buy on a used Chevrolet van flashed up with a chromed chain steering wheel and loud shag carpeting. It looked like what the sixties called a ''head wagon.'' Within five months, the van was broken into twice on the streets

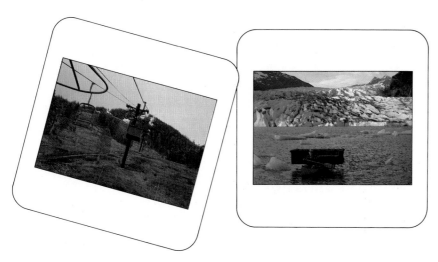

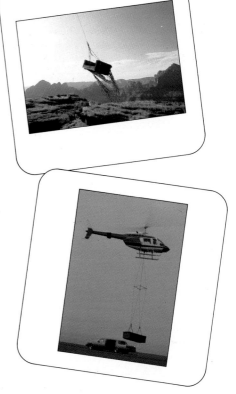

of New York City and much equipment stolen, including a three-thousand-dollar view camera. The robberies so strained relations between the men that Wackerbarth bought his own van, a used Dodge in need of many repairs. Fearing American streets as Europeans commonly do, he armed the truck with a hatchet and an ''over-and-under'' .22 rifle /.410 shotgun. One night in New York City, while he slept on the couch in the van, he was awakened. Gun in hand, he crept to the front window, only to find a transvestite touching up his makeup in the side mirror. Months later, Los Angeles police became suspicious of his New York license plate, searched the van, and found the weapons; when he bitterly protested his innocence, they worked him over. Never in three years did he need the weapons.

The project was often interrupted by Wackerbarth's having to return to Germany to keep alive his advertising photography business, which furnished project money for both men. Major assistance—money and influence—arrived in November 1982, when *Life* magazine published six pages of couch photographs; the next spring, *Stern* published twenty pages of pictures in West Germany, and the London *Times* Sunday magazine printed several photos.

Alfred van der Marck bought rights to the project in May 1983, staking the survival of his new publishing house on a project that was continuing to eat up time and money. Wackerbarth: ''I slept *on* the couch, and I slept *with* it. Always the project was there. Where was the next dollar to come from? In the mornings I woke up with a headache.''

In 1983, while Wackerbarth was photographing an over-the-road trucker just after a nasty teamster's strike, another truck driver deliberately veered close to the view camera. The air blast sent their other view camera flying to destruction. That night in Las Vegas, Wackerbarth laid out his last pocket money on admission to the annual Photo Fair. Manufacturers' representatives liked the couch pictures he showed them, and he was able to leave the fair with ten thousand dollars worth of new equipment, half of which he gave to Clarke. Even with such boons—as well as photo companies providing free film, processing, and equipment—the photographers guess that each published photograph cost five hundred dollars to make; with outside costs included, the figure rises to sixteen hundred dollars per picture.

Money was not the only problem. Wackerbarth: ''Two-thirds of this photography had nothing to do with making exposures. One-third of the time I was a furniture mover, and another third I was a psychologist—how to persuade somebody to sit on such a crazy piece in an absurd location.'' The unusualness of the request frightened some people. Others were suspicious of what the couch might represent. One man asked, ''Why is it red? Is it for communism?'' Because velvet sofas suggest home, privacy, sleep, daydreams, and sexuality, subjects often felt uneasy. Why not? Most things people do on couches they do not do on the street.

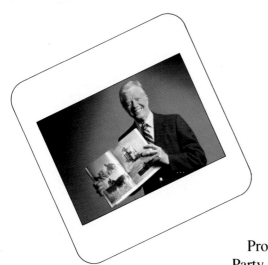

Problems occurred with model releases, especially those for the American Nazi Party, Hell's Angels, and Daughters of the American Revolution. Each group wanted publicity but feared how it would be used. In the portraits of the famous, there was a battle to keep the celebrity from controlling the making of the photograph. Wackerbarth: "Common people cooperate, maybe because they haven't been abused by the media, and maybe because they aren't so vain. With them, we could compose in freedom." But there were difficulties with the poor too—they often expected payment. Clarke and Wackerbarth found that their early rule of offering no payment other than a copy of the book was heartless. Clarke, especially, tried to pay anyone needing help. Wackerbarth: "People saw our expensive equipment and concluded we personally had money."

And then there was Clarke's former Cooper Union professor, a Marxist, who criticized the project for suggesting an "equivalence between rich and poor." He wanted the photographs to make visual judgments that would ennoble the poor and demean the rich. In spite of his opinion, Clarke and Wackerbarth continued trying to make all subjects pictorially equal, even when they did not see them as morally equal. Still, to look closely at these photographs is to discover various subtle interpretations.

Some of the most interesting experiences for the men produced either no photographs or artistically weak ones. Clarke worked months to set up a picture of three astronauts who would sit on a red couch floating in the twenty seconds of weightlessness that the NASA zero-gravity training plane creates; the space administration at first agreed, but then said no. Wackerbarth flew his sofa from Los Angeles to Atlanta, where he was to photograph Jimmy Carter for an *Esquire* magazine article. Although the former president did not like the project and initially refused, at the last minute he did good-humoredly agree to a *single* photograph of him with the couch symbolically present.

One of Wackerbarth's most touching experiences occurred during a black church service in Detroit. As the worship grew more ecstatic, the preacher jumped on the couch and worked it into his sermon, and then the congregation danced past and dropped coins and bills on it. But those photographs failed.

Of the several thousand exposures that Clarke and Wackerbarth made over nearly half a decade, they have selected one hundred pictures taken in twenty-six states and the District of Columbia. They covered nearly 100 thousand miles by car, plane, bus, boat, helicopter, horse, and ski lift. Now, the last pictures taken, they find their friendship and bank accounts nearly exhausted. But what they have left us is a strong document that a century from now will still show what we were like in the United States during those first five years of the eighties. If every American's red velvet couch portrait is not here, it well could be.

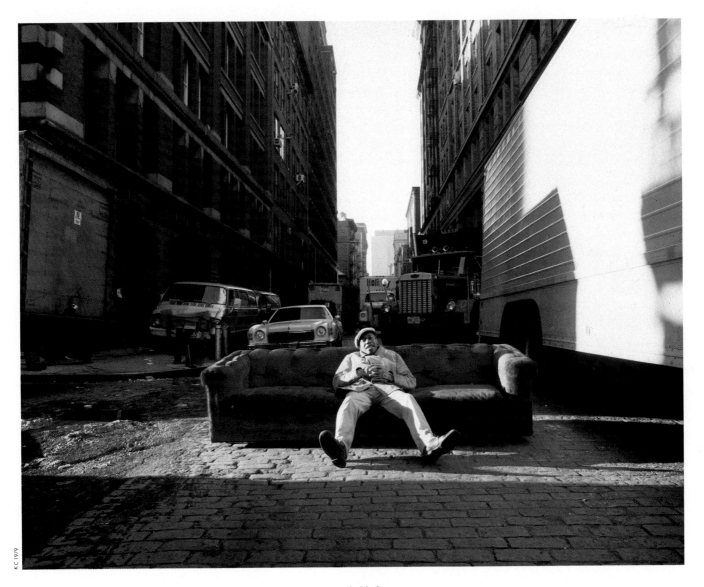

KC 1979

We had just brought an eight-foot piece of furniture down from our loft apartment, with the help of this elevator man. When I photographed him on the couch, I had no idea what was about to begin.

JACK MILLER
NEW YORK CITY

15

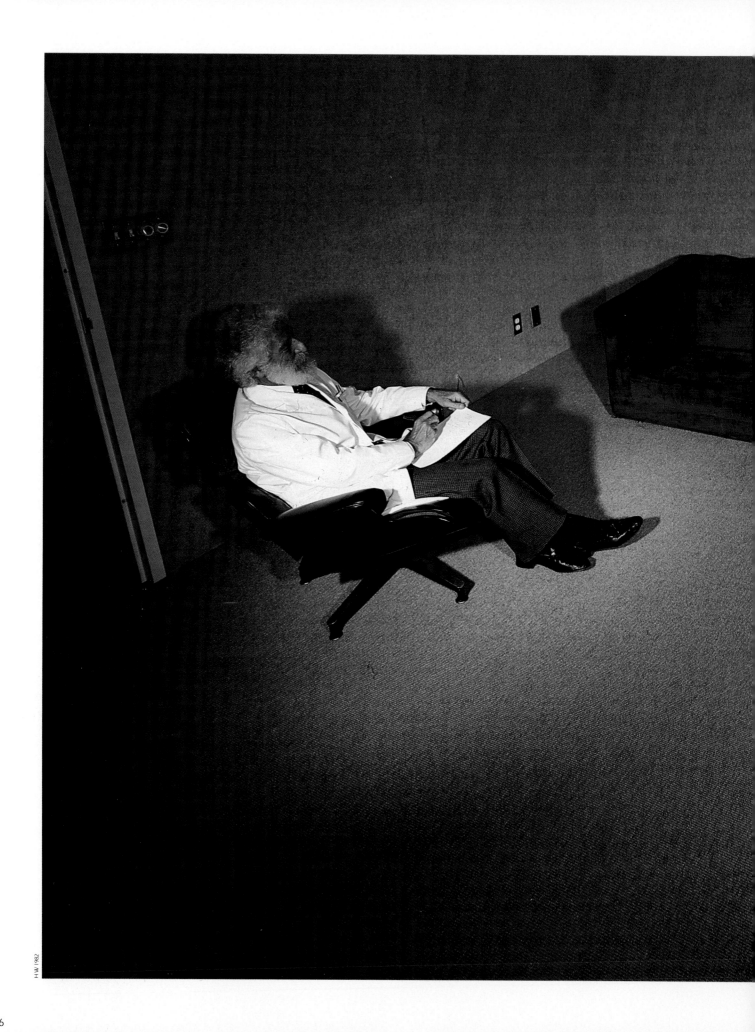

H.W. 1982

I began with the obvious—the psychiatrist lying on the couch. First, I tried including a lot of foreground to distort perspective—that made the couch seem to float. Things began looking surreal. Then I tried a double exposure of him on the couch *and* seated in the chair. We had to empty his office to get the merging of walls and floor. The cushions disappeared while the couch was in the hall-way. I thought a patient had taken them, and I was angry. After we finished photograph-ing, we found that another doctor had taken them into a janitor's room for a nap. The pic-ture, I see now, is better without them.

NATHAN S. KLINE
NEW YORK CITY

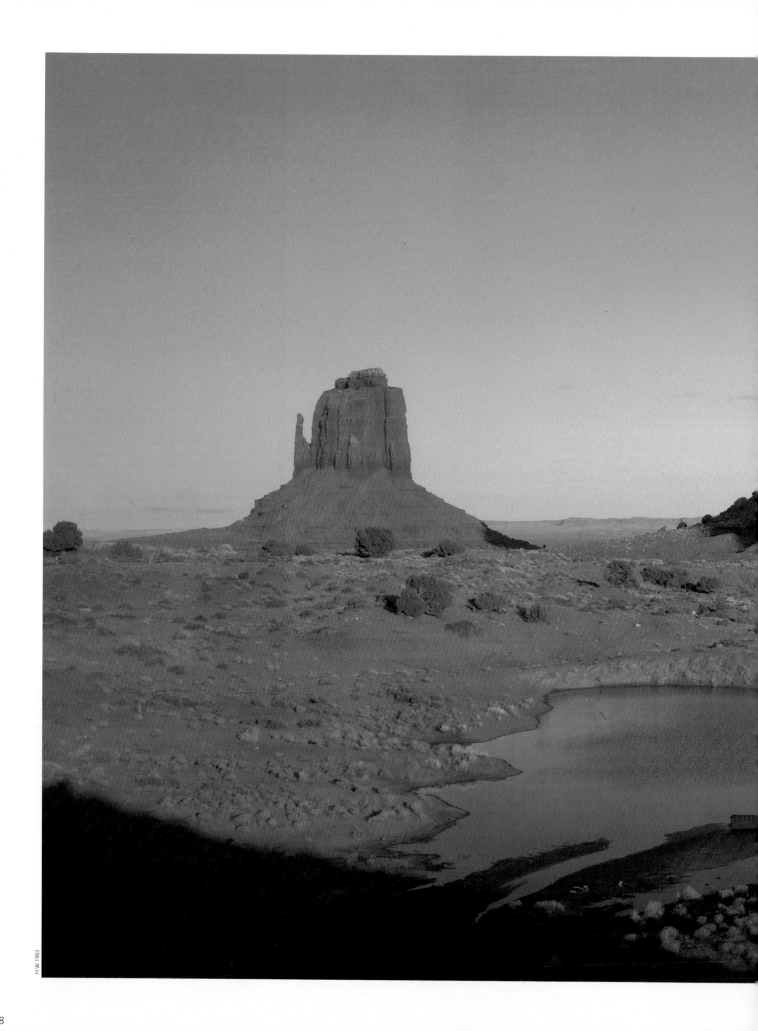

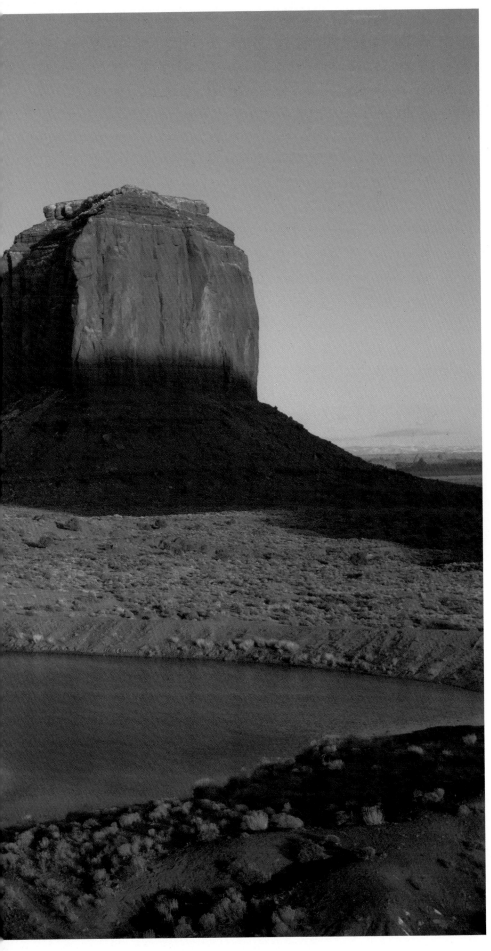

I have traveled in Europe, Africa, and Asia, where you must go many miles to see great changes from one area to the next. In America there is much variety in many fewer miles. In the West, I was impressed with the preservation of the wilderness in places. For these reasons I wanted a landscape picture that would work in an iconographic way. I tried many times, but this is one of the few photos that I think succeeded. I had to make the couch very small so it did not look stripped-in, like in a montage. The warm orange color of the buttes also helped pull the couch into the natural scene, even though it's still distinct.

Everything got muddy in the lake, and the van got stuck in the sand twice. The Navajo people who helped us asked if we would buy one of their beautiful rugs. We were so poor, we could only just thank them. I'm sorry for that.

MONUMENT VALLEY, ARIZONA

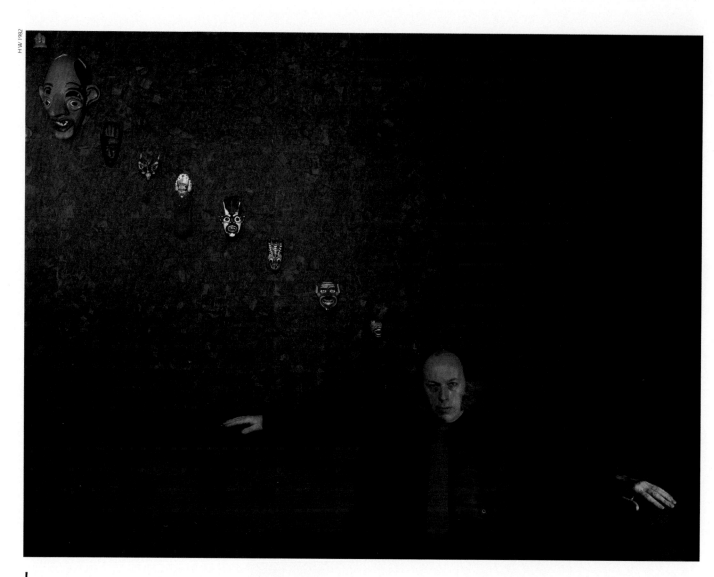

H.W. 1982

I called this advertising executive a "creative head"—something
of a joke between us. He wore the red tie and handkerchief by
chance, but his collection of masks on the wall I rearranged—
something a photojournalist should not do. But I work with design
and concepts, and that is quite different.

BARRY DAY
NEW YORK CITY

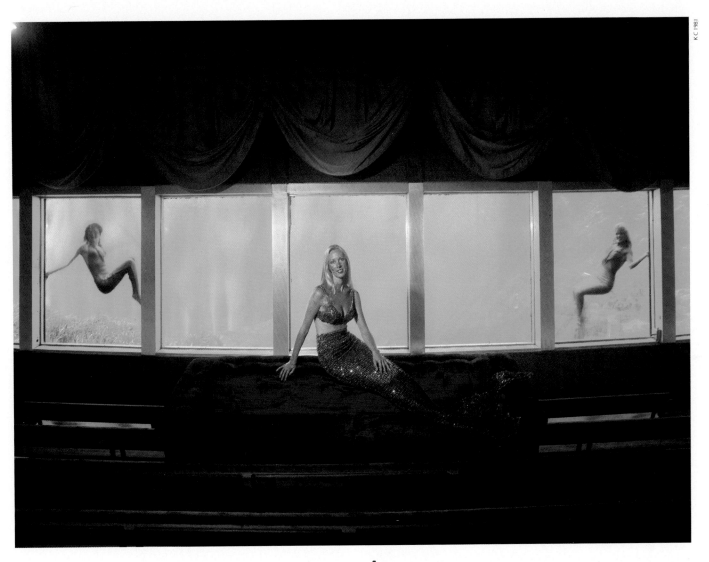

At Weeki Wachee, one of the old roadside attractions of America, this underwater performer walked to the couch in her body stocking and pulled on the mermaid costume. Once she was in it, she couldn't move off the couch except by falling.

LINDA SANDS
WEEKI WACHEE, FLORIDA

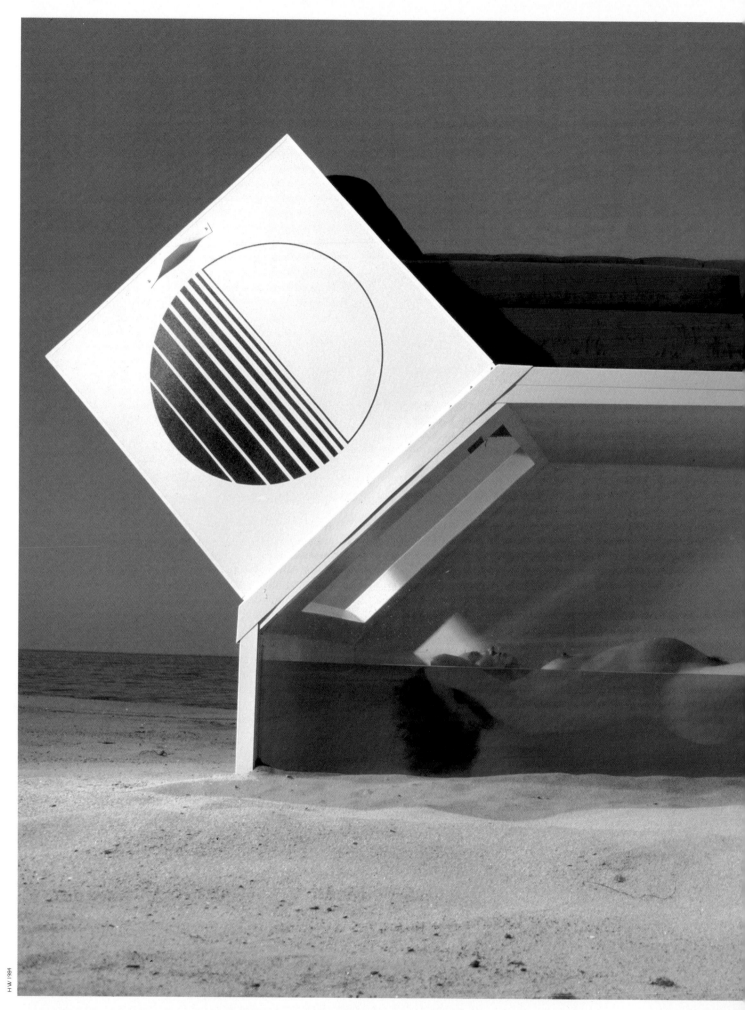

H.W. 1984

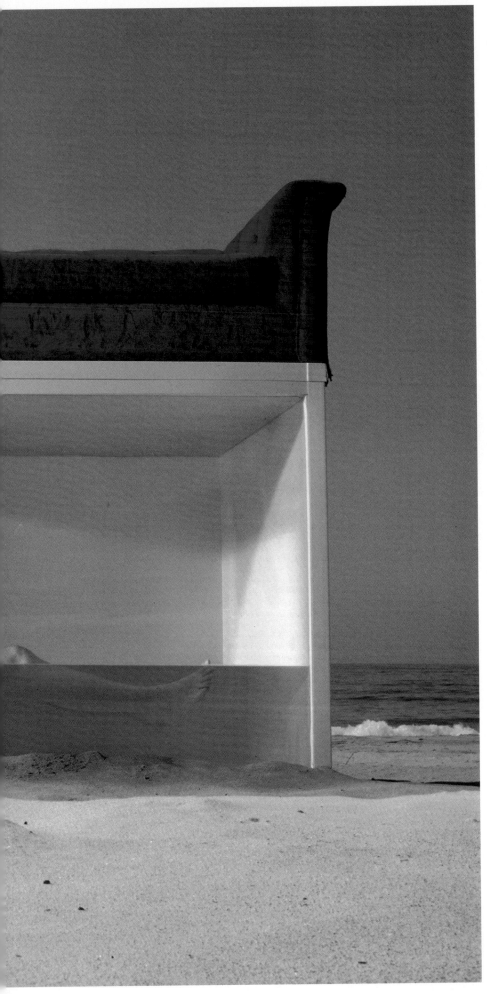

John Lilly invented this flotation tank, which provides a noiseless, lightless environment where the floater's senses seem to disappear. For the photograph, we had one side replaced with plexiglass to show how a person floats in water that has eight hundred pounds of Epsom salts added to increase buoyancy. I did not get in the tank. I never do what I photograph.

It's an ideal place for meditation. People seem to feel suspended closer to the sources of life. That's why we photographed with the ocean in the background. The sea is the big "tank" for the source of life. The womb is a little "tank" for the source of life. One person who saw this picture asked if the couch is also a source of life. Sure, life has been made there too.

JOHN AND ANTONIETTA LILLY

SUSAN RAGSDALE
MALIBU, CALIFORNIA

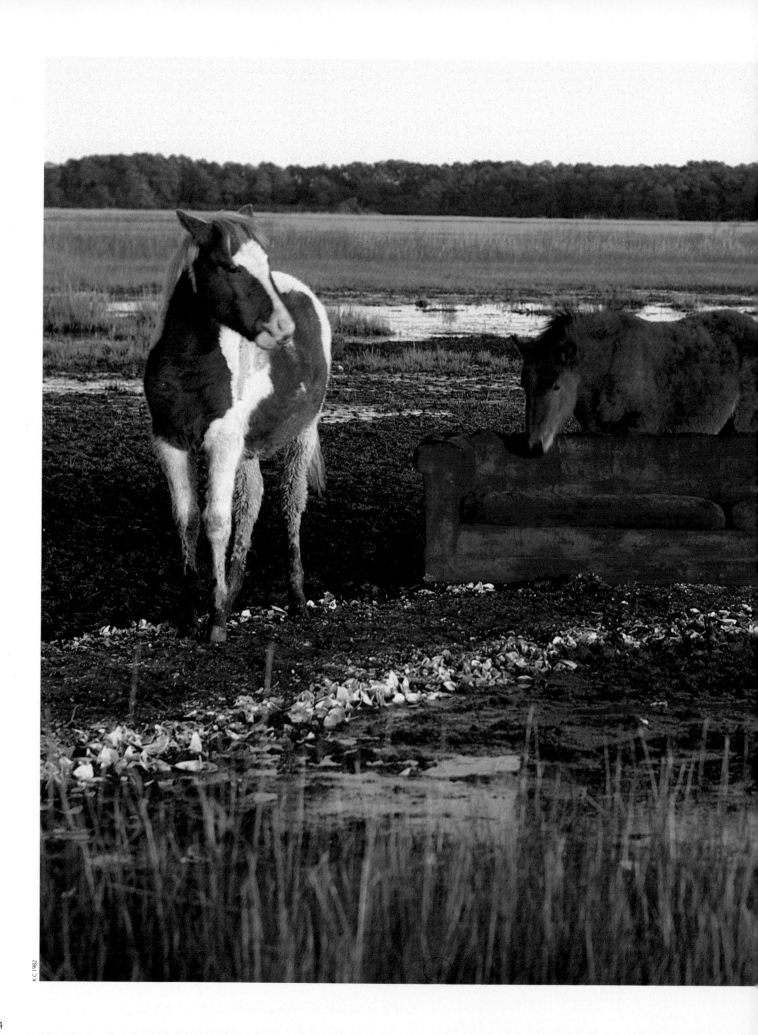

Reportedly, these ponies are descendants of animals that came ashore after a shipwreck in colonial times. They have a wild look to them, like they might have just trotted out of a cave painting.

We tried to chase them down for three days. Finally a motel owner went out with us. He dumped a bucket of oats on the ground and pounded on the bucket. The ponies came from nowhere. They ate the oats, sniffed the couch, and nibbled on the buttons, and two of them even walked behind the view camera to look through the ground glass. Several times during the project I saw human-animal communication. I could throw mind vibes out and the animals would respond.

WILD PONIES
CHINCOTEAGUE ISLAND, VIRGINIA

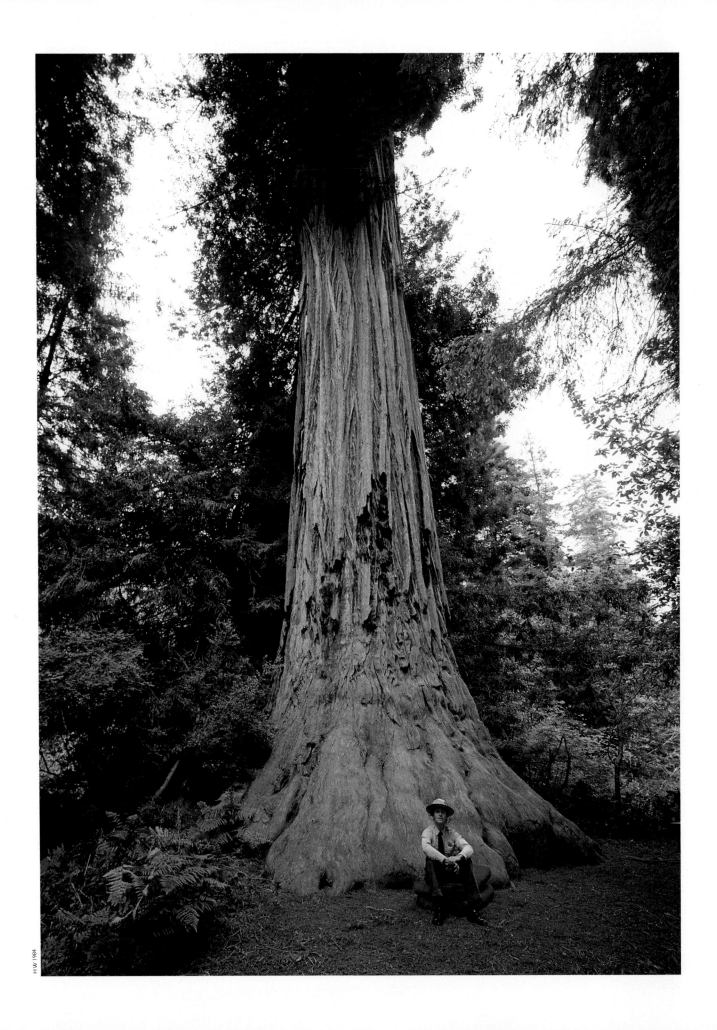

H.W. 1984

I don't like vertical compositions, but how else do you show an eight-hundred-year-old redwood? This is one of the last pictures I took for the project, and I was glad to find a composition where I finally could use the cushions without the couch. I always hated the restrictions the couch imposed.

MICHAEL J. BRADEEN
PRAIRIE CREEK REDWOOD STATE PARK,
CALIFORNIA

We were fifteen miles north of Juneau, just where Mendenhall Glacier comes down to a two-hundred-foot-deep lake it created fifty years ago. Mr. Hermley, a Juneau wedding photographer who paddled the couch into place, was nervous the lake would get the couch. But actually the couch stabilized the canoe. The ice in the floes from the glacier is thousands of years old.

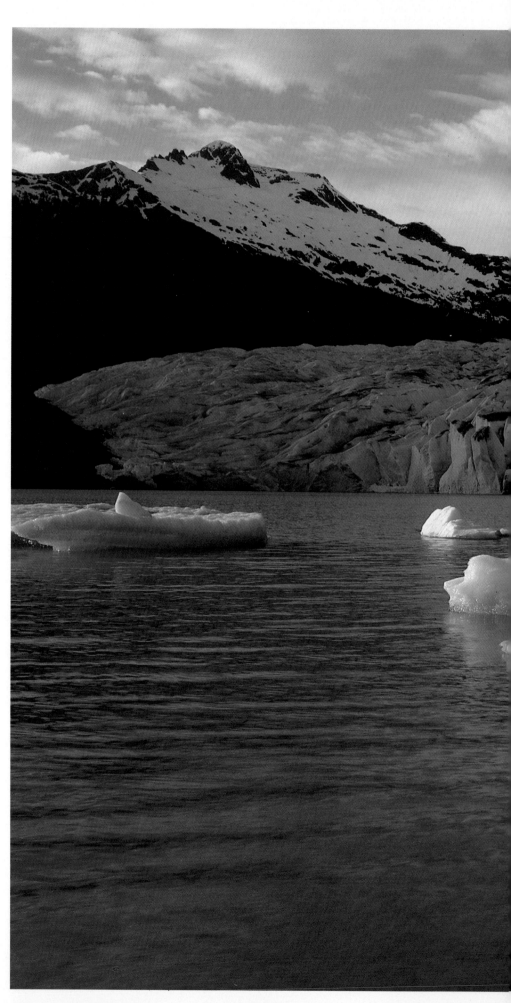

MENDENHALL GLACIER
JUNEAU, ALASKA

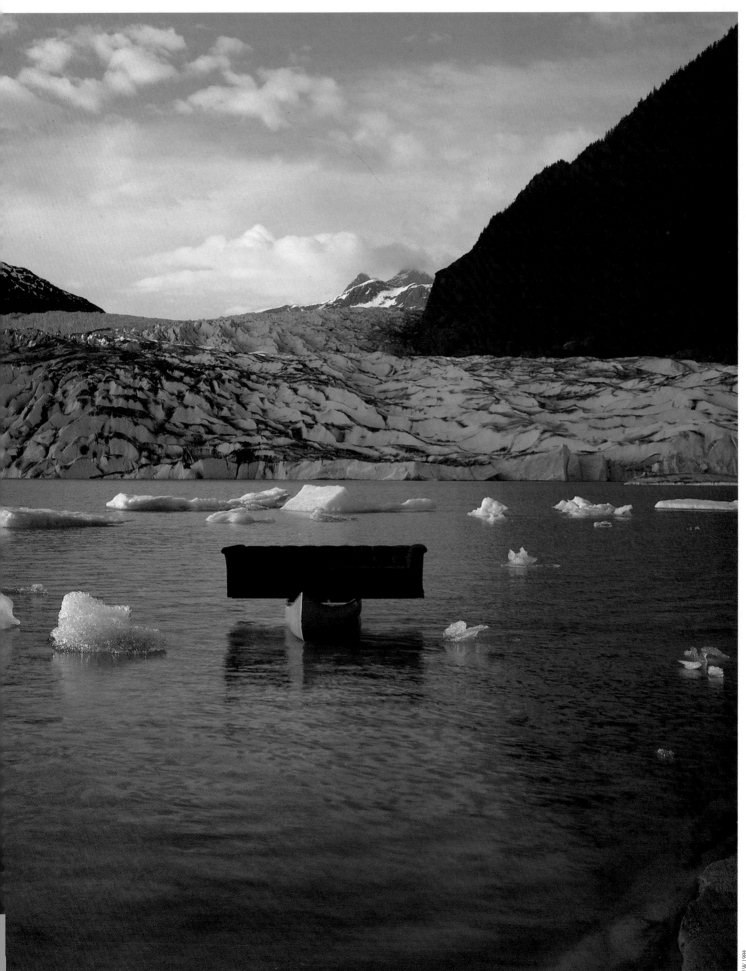

H.W. 1984

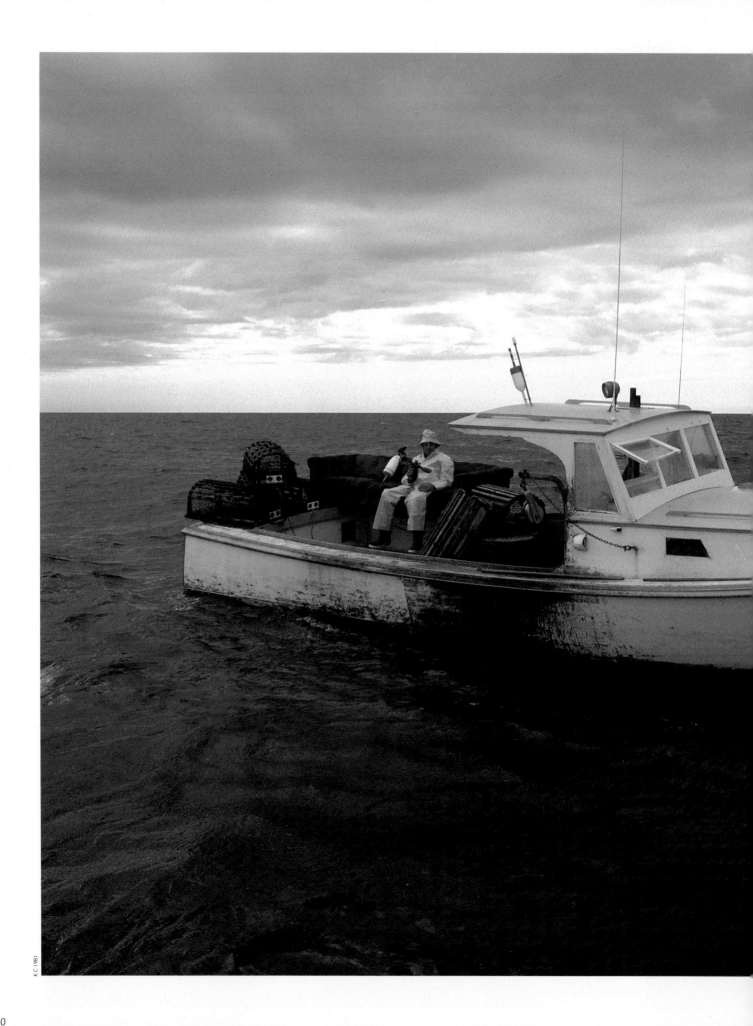

I photographed from one boat while Horst held the wheel of the lobsterman's boat. A storm was blowing in, and the rolling sea made shooting almost impossible.

PERLIE LANE, JR.
PEMAQUID HARBOR, MAINE

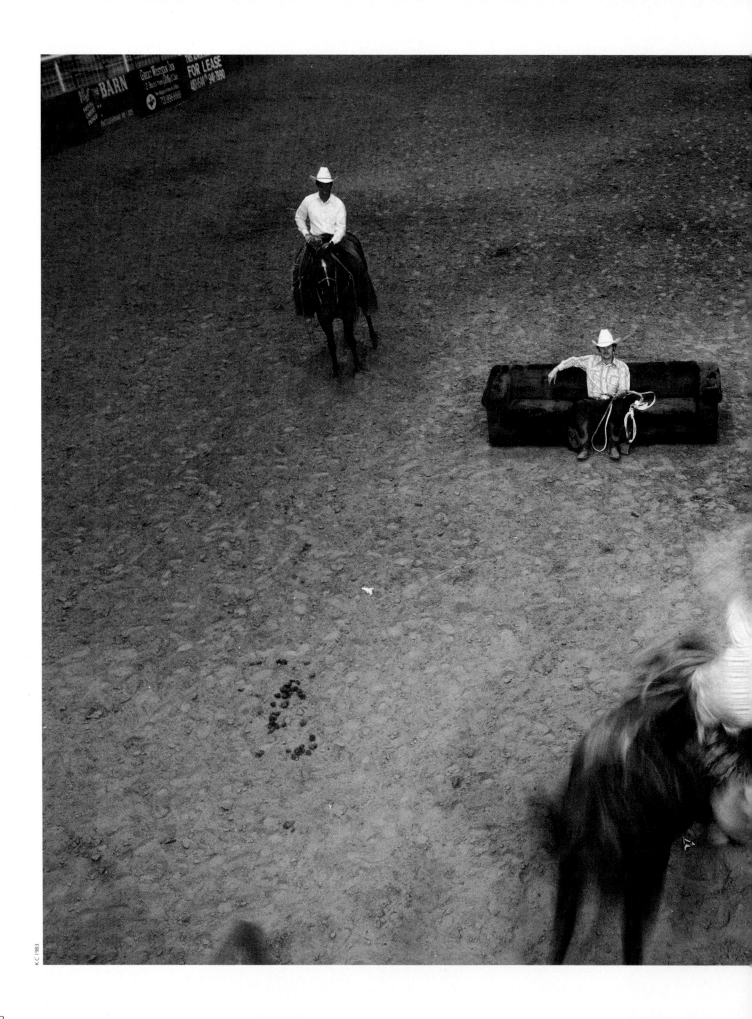

The owner of the biggest honky-tonk in the world stands on the right in the rodeo he built behind Gilley's. It took the one-ton bull twelve seconds to throw Kent Richard—a long time. Long enough for me to make ten fifteenth-of-a-second exposures. Although the couch is red, the bull was one of the few animals I photographed that did not attack or nibble on the couch.

GILLEY'S RODEO
PASADENA, TEXAS

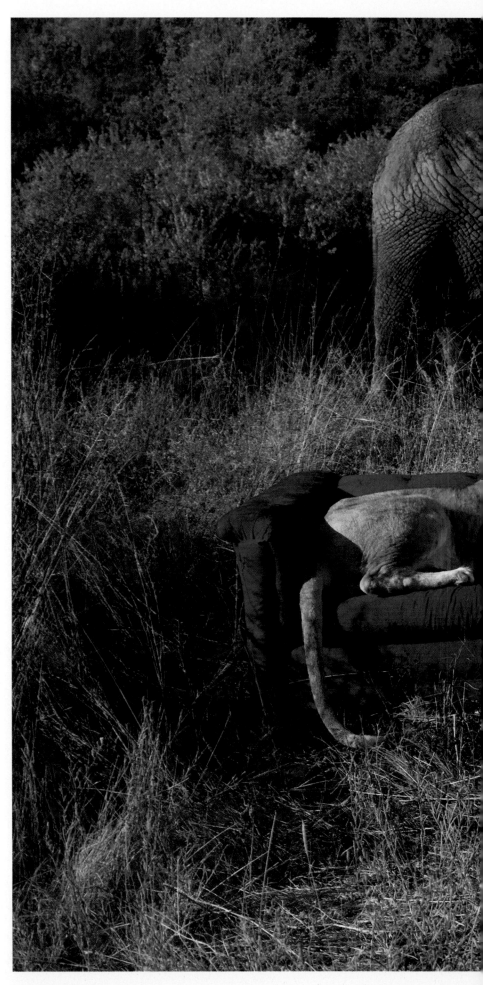

These trainers provide animals to filmmakers. The day after we photographed them, they went to Kenya to work on *Sheena, Queen of the Jungle*. At our session, the chimpanzees couldn't sit still, the leopard was nervous, and the lion couldn't stay awake. And the couch—it smelled for days.

HUBERT G. WELLS AND DOREE SITTERLY
THOUSAND OAKS, CALIFORNIA

34

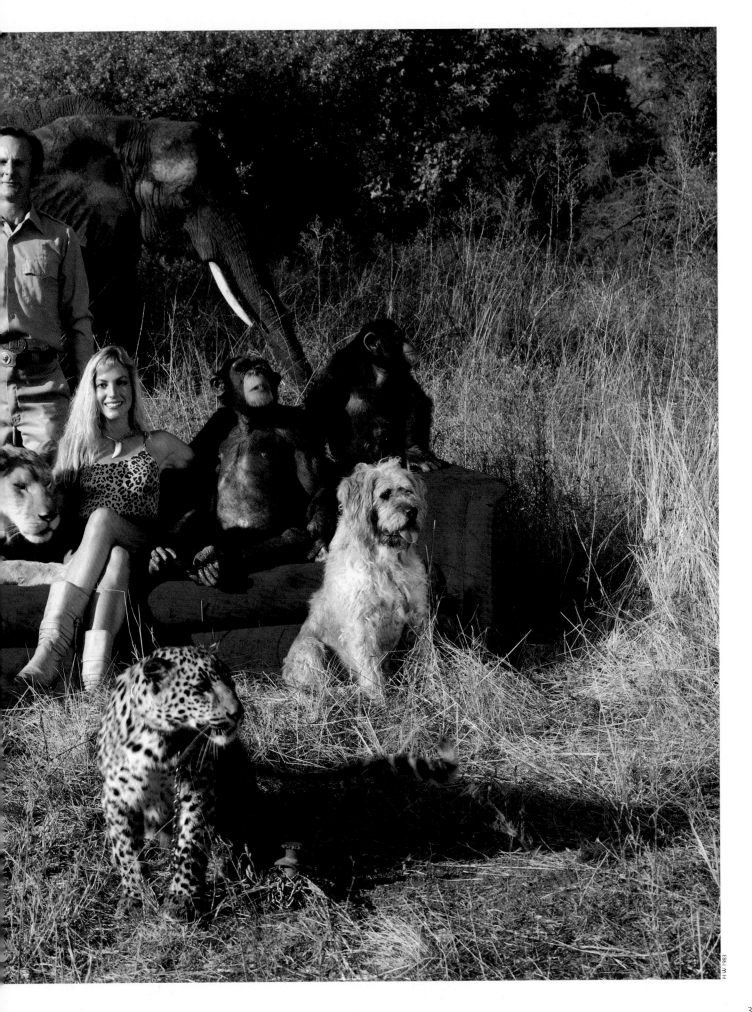

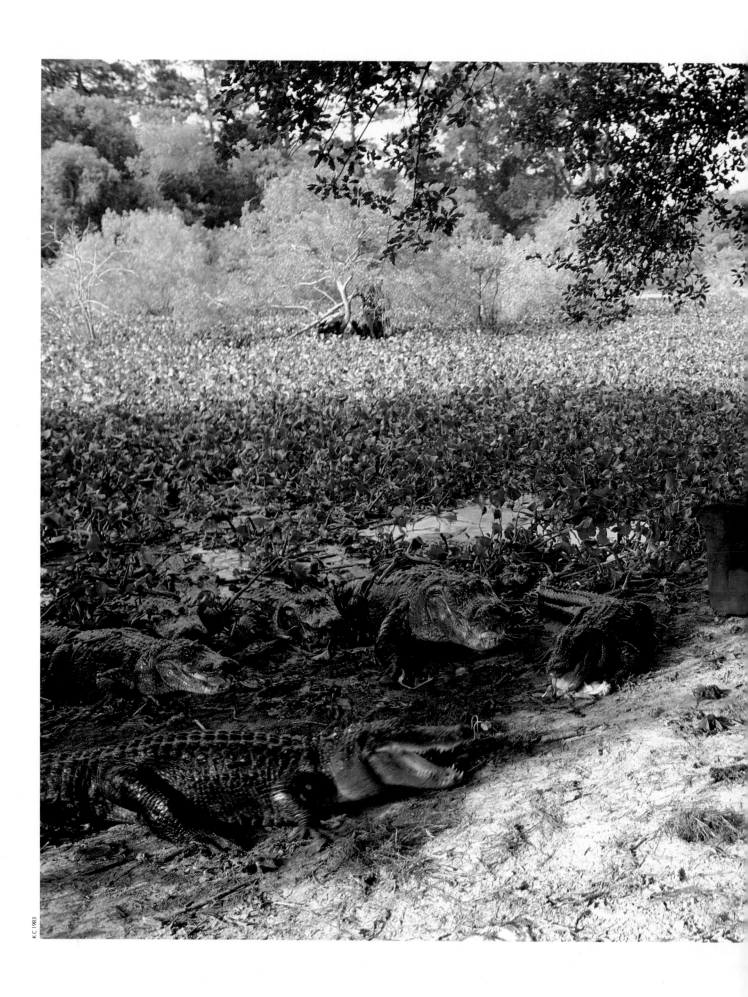

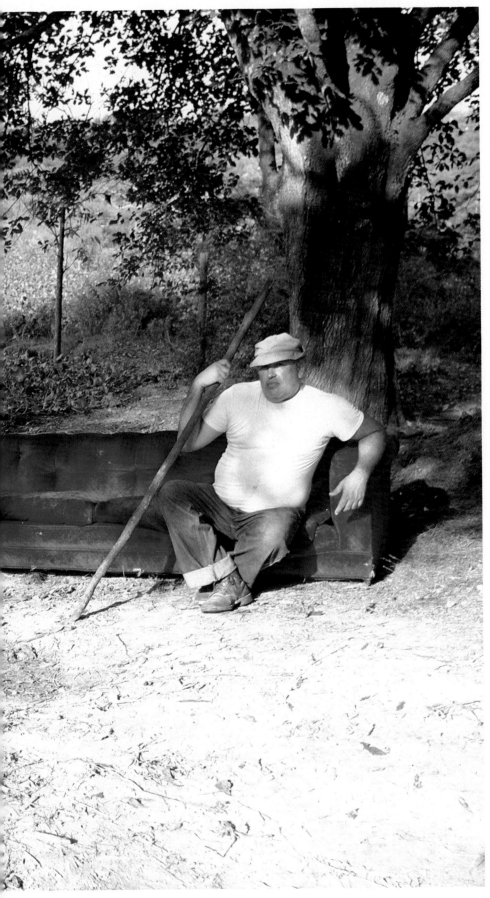

Mr. Kliebert says his alligator farm is the biggest in the world. Five hundred fourteen-to sixteen-foot animals are in this pond alone. He attracted these alligators toward the couch by throwing a dead chicken tied to a rope into the water and reeling the line in. After the gators were on the bank, when one tensed up, he would throw it another dead chicken. While we were photographing, the pond erupted in a thundering noise that made the ground shake. The males were giving mating calls.

ROBERT KLIEBERT
HAMMOND, LOUISIANA

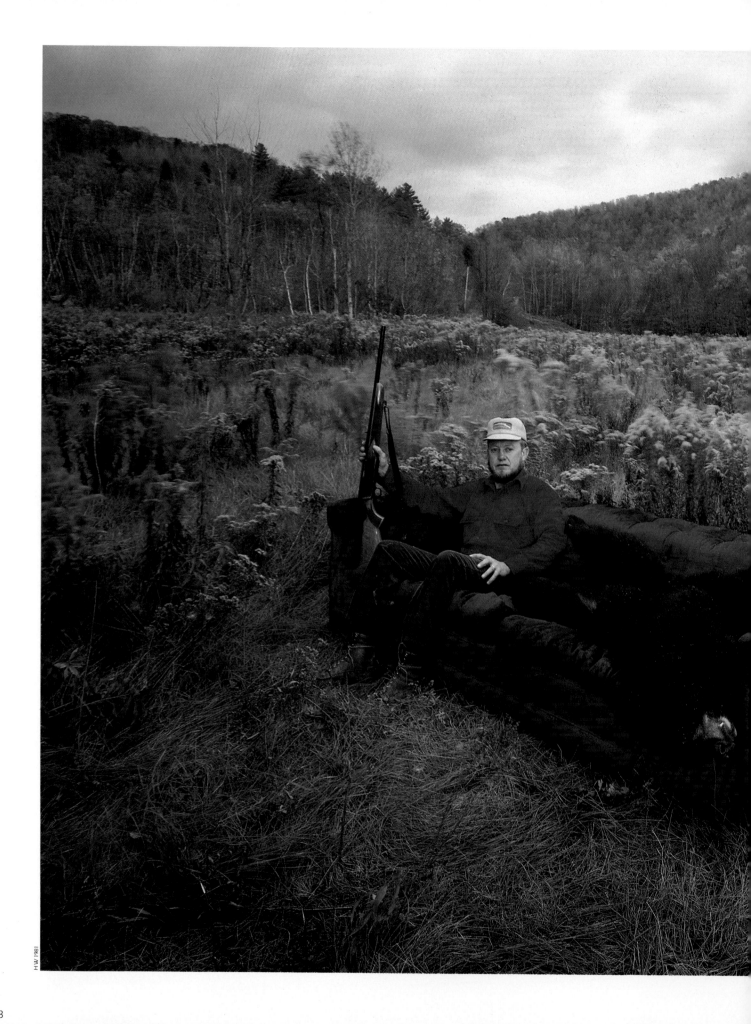

It took two days to find a location I liked and three more days before we found a hunter with a black bear he had just shot. Even though the animal had been gutted, it took two men to drag it a third of a mile into the valley. Getting the couch in was even worse.

ELMER GREENE
BEARTOWN VALLEY, VERMONT

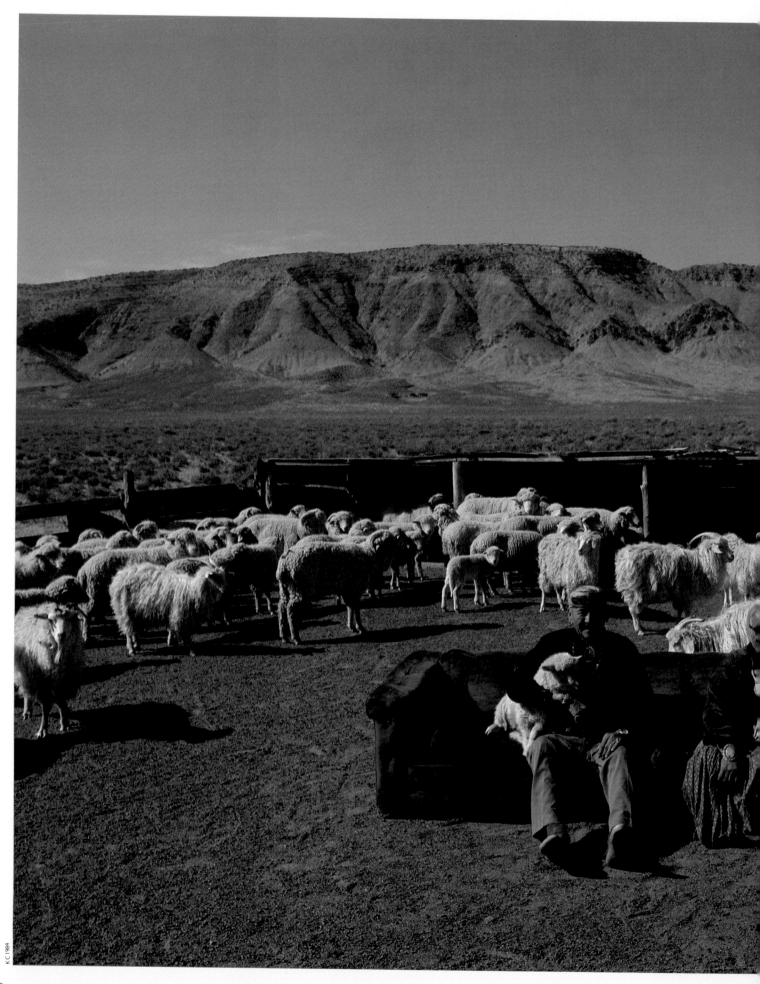

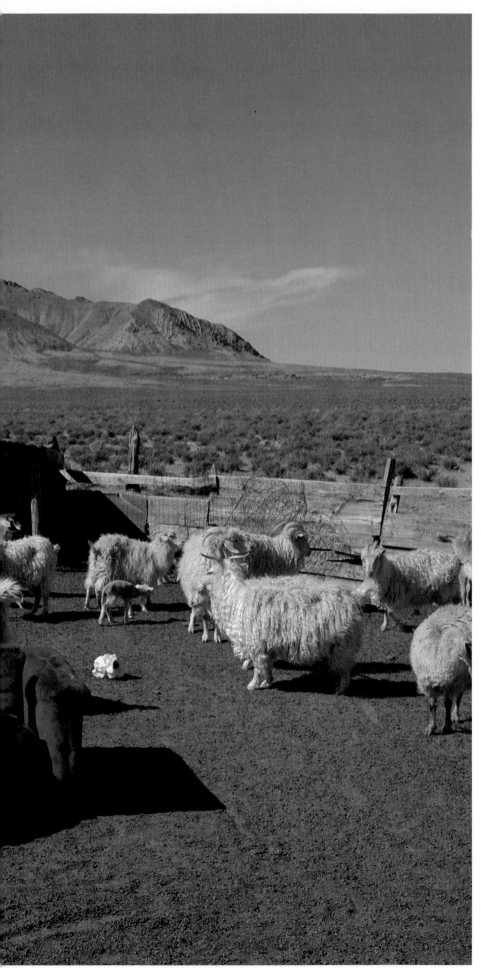

I met Orlando Yazzi at a roadside jewelry stand on state highway 64 and lived with his family a few days. His grandparents posed in their sheep corral at the foot of Gray Mountain so their grandchildren would have a photograph of them. I also gave them sixty dollars, which just happened to work out as one dollar for every year of their marriage.

ORLANDO YAZZI

FRANK AND GRACE JOHNSON
CAMERON, ARIZONA

41

The hogs went crazy when they saw the couch in their breeding barn. They attacked it. They ate a hole in the back and chewed up buttons. The first thing I did after we finished photographing was to buy upholstery cleaner. It didn't help much.

JACK LAYTON
FEDERALSBURG, MARYLAND

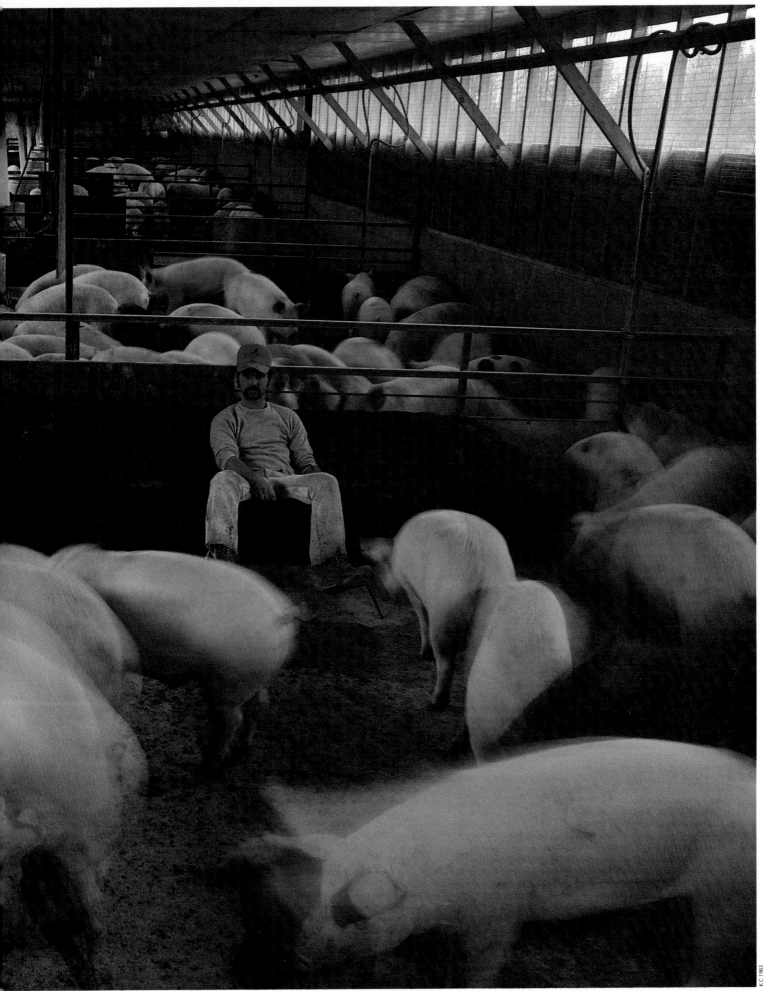

When I drove up to this couple's ranch in southeast Texas, they looked at the chain steering wheel and shag-rug upholstery of my van and figured I was another Charles Manson. After they relaxed, they were helpful, even to the point of dressing in tuxedo and evening gown. The Brahman bull behind the couch is The Millionaire—ten people have invested a hundred thousand dollars each for his semen.

HENRY CLAY AND MARY SUE KOONTZ
PLACIDO, TEXAS

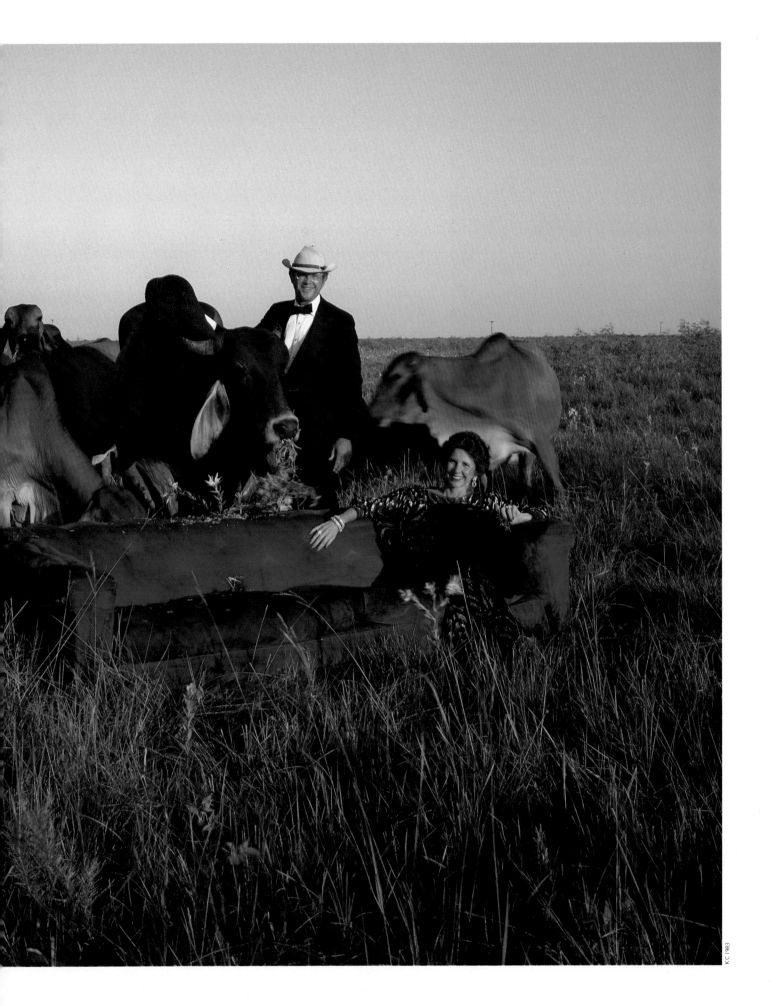

My first idea was to photograph Mr. Hagman by an oil well, but he isn't an oilman—he's an actor, and his world is the studio, with lights and wires and illusions. I wanted a confrontation between the actor and the character he plays. I watched hours of *Dallas* videotapes to find the right image of J. R. Ewing.

We had to provide Rolling Stones music and lots of champagne during the shoot, and *Stern* magazine had to pay for his makeup lady to take away his bald edges. Mr. Hagman's aides insisted on "kill rights" to our pictures. They gave me a choice: either they'd return the negatives with the faces burned out by a cigarette, or they'd keep them in a safe. I said to keep them. You don't destroy a negative.

Did I say I wanted a "confrontation" between man and character? I think the result is more of a parallel.

LARRY HAGMAN
LOS ANGELES, CALIFORNIA

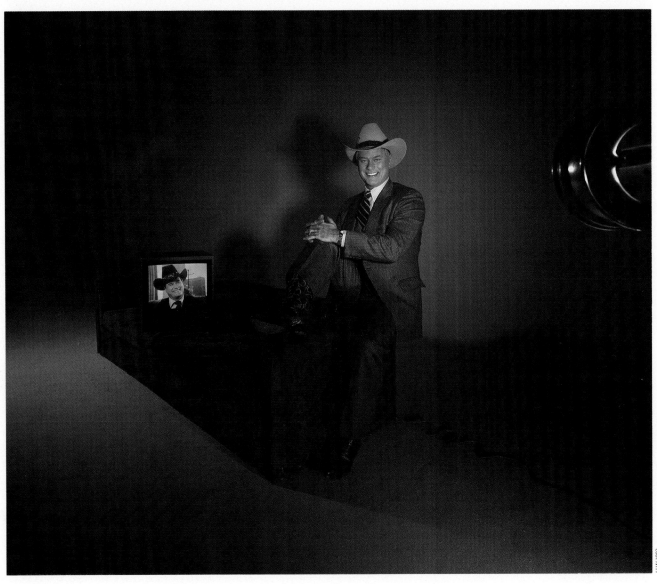

H.W. 1983

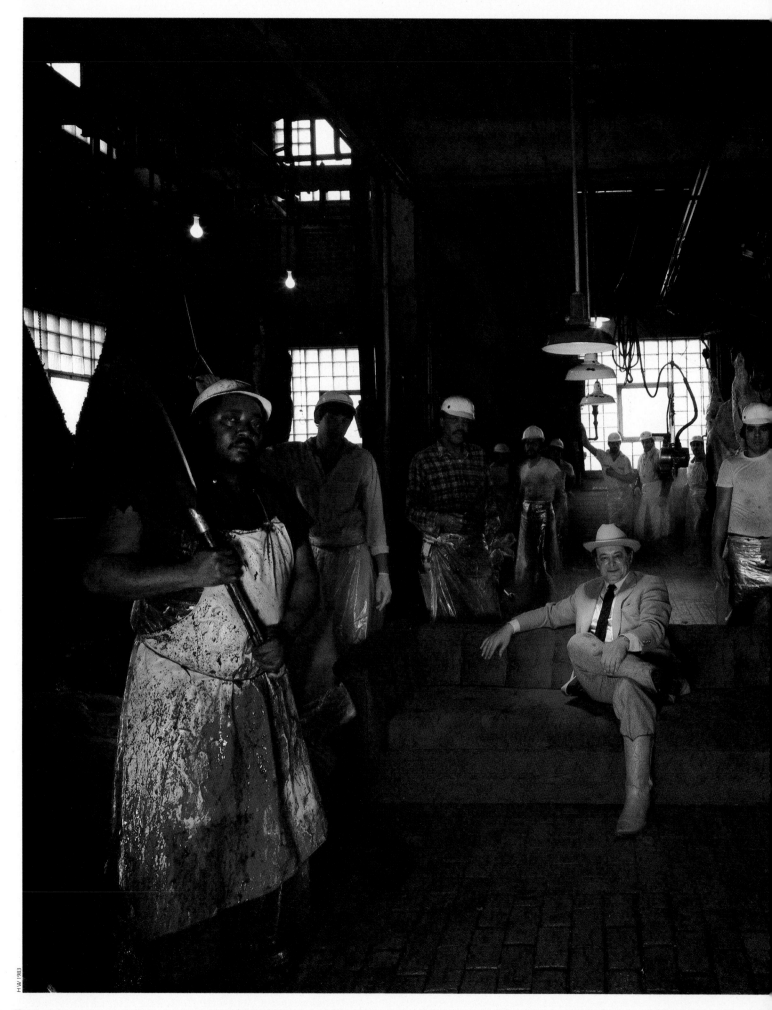

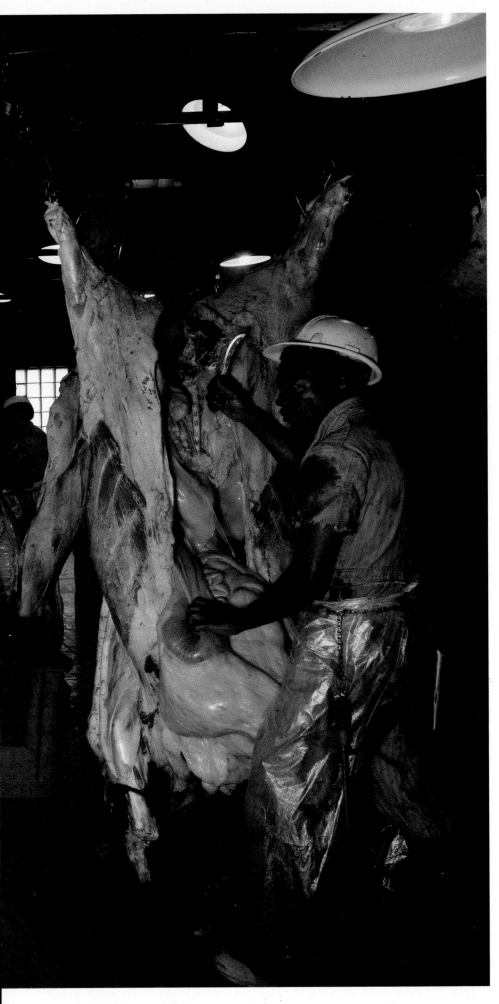

We photographed this wealthy owner of the last slaughterhouse in Chicago the day after our first encounter with the American Nazi Party [page 145]. Although Mr. Mander was uneasy about such a bloody picture, he was open and friendly and generous. The contrasts with the Nazis go even farther. Mr. Mander was born Walter Mandelbaum in southern Germany, where his ancestors had been cattle and horse dealers for three hundred years. He and his mother were the only ones of his family to survive the Nazi execution of the Jews. He escaped to England, where his name got changed. Later he returned to Germany to fight the Nazis. After the war, he came to America.

The slaughterhouse was a terrible place to work in—frightened animals, a horrible odor, bloody water on the floors where our electrical equipment was, the workers crowding up to get in the picture. Wally didn't want a gruesome photo, but he wanted one with impact. I wanted the hamburger in the reader's stomach turning around.

WALLY MANDER
CHICAGO, ILLINOIS

49

Here's an Old-World butcher shop in Little Italy. The brothers had the rent tripled on them to get them out so a boutique meat store with tripled prices could go in. The sawdust floors, enameled walls, stamped-tin ceiling, that's all gone.

THE PORCELLI BROTHERS
NEW YORK CITY

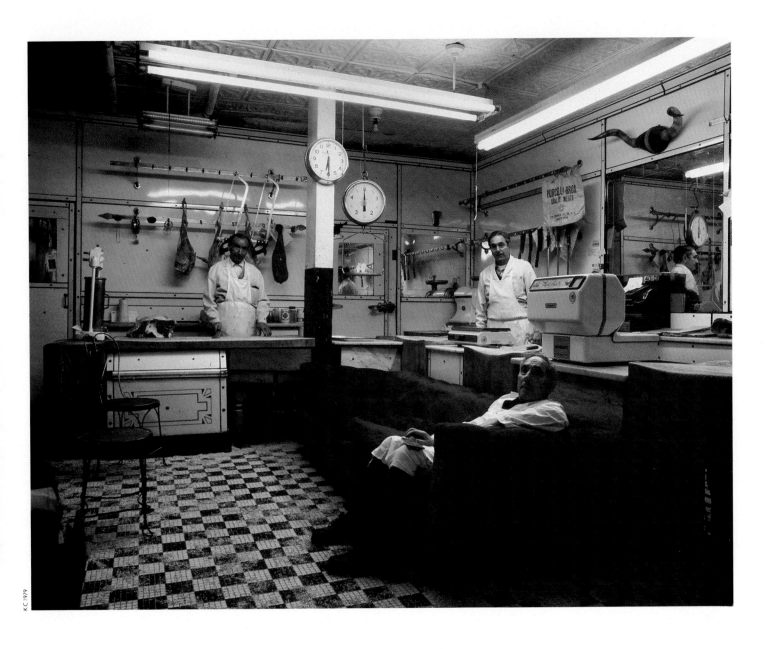

K.C. 1979

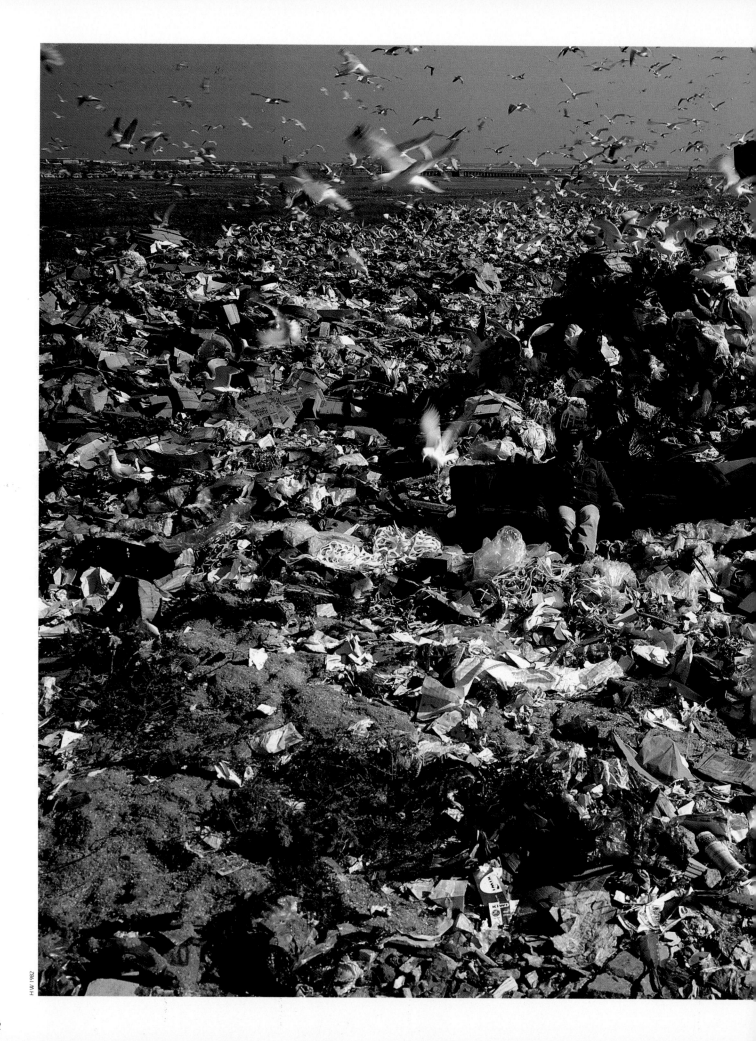

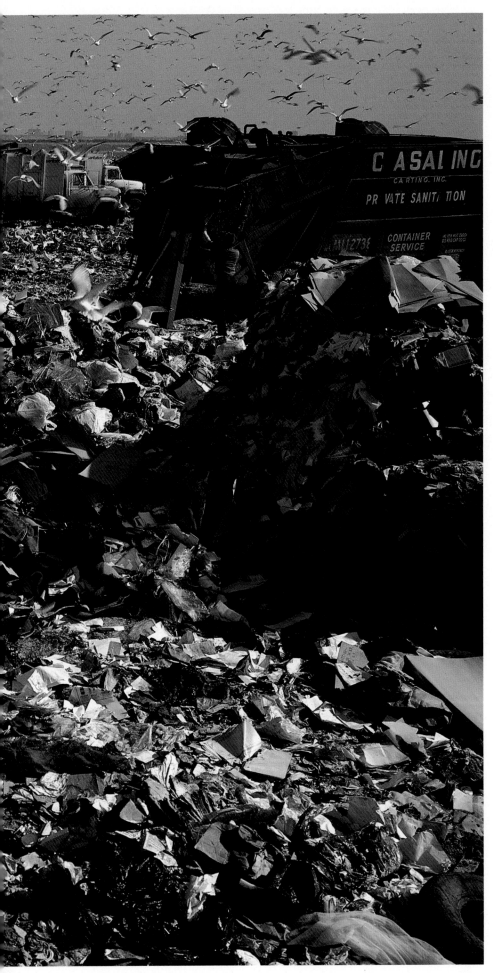

Another hauler first agreed to sit for a dump portrait, but when his teenage daughters found out about it, they made him change his mind. They were ashamed their father drove a trash truck. But Mr. Votta sits proud with his cigar. A private dump refused to let us photograph on their property—they were hiding something, I'm sure. The couch had to be totally cleaned afterward—not from the garbage but from the gulls. White was everywhere, including on the camera and us.

RALPH VOTTA
LONG ISLAND, NEW YORK

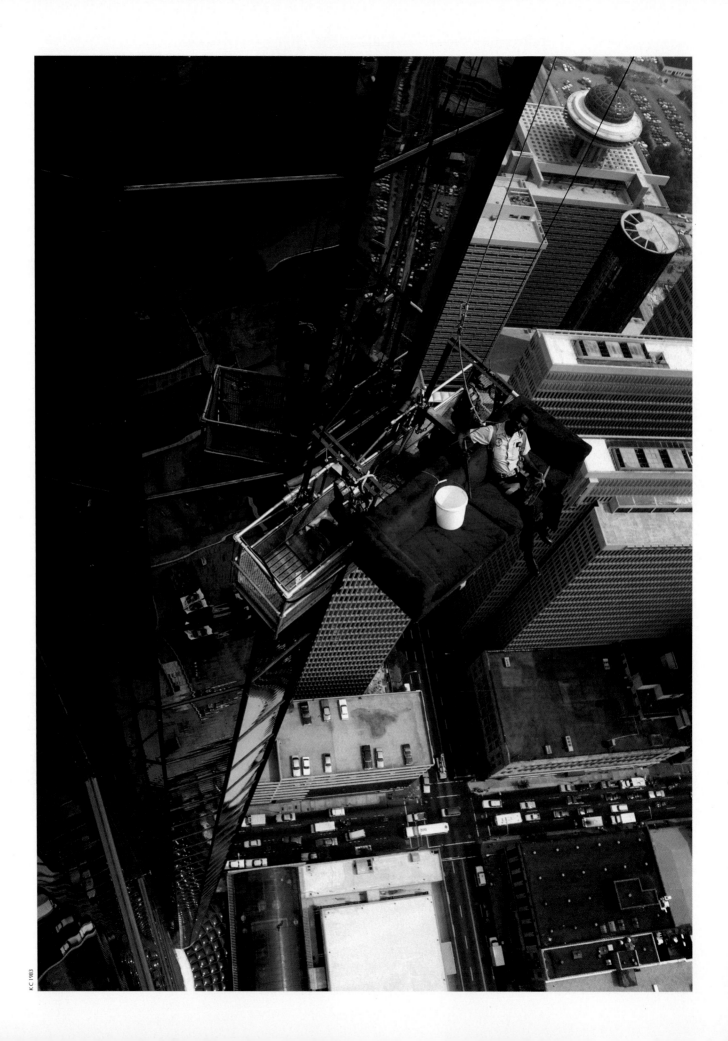

Most of the managerial staff of the Peachtree Plaza Hotel wanted to be in this photograph from the seventieth floor. I had to insist that only the man who actually worked on the scaffold belonged. He's a window washer and maintenance man. He was willing to sit on the couch without his safety line, but I said der-ring-do was not the point of the photograph. The point is to have the couch momentarily traverse an everyday environment— everyday for him. It almost seems natural up there above the X-marks-the-spot street intersection.

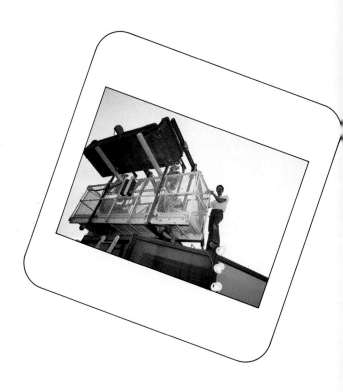

JAMES T. BRUNSON
ATLANTA, GEORGIA

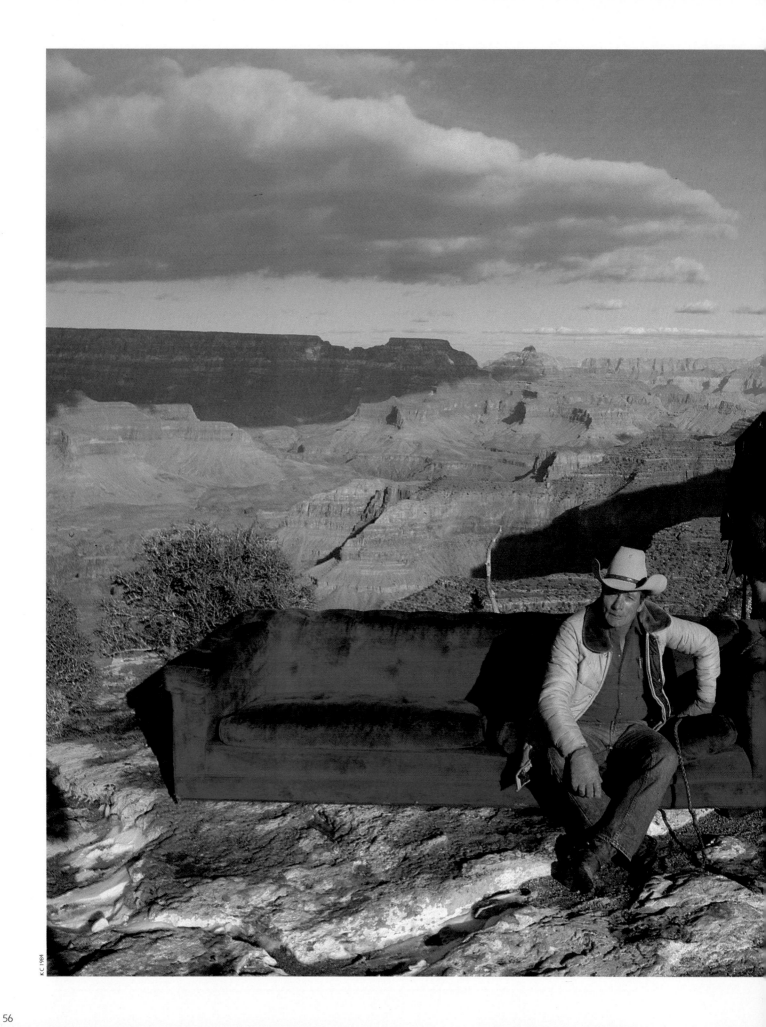

I paid fifty dollars into a federal park fund to get permission to put the mule and couch on Maricopa Point.

BUD RIPPY
GRAND CANYON, ARIZONA

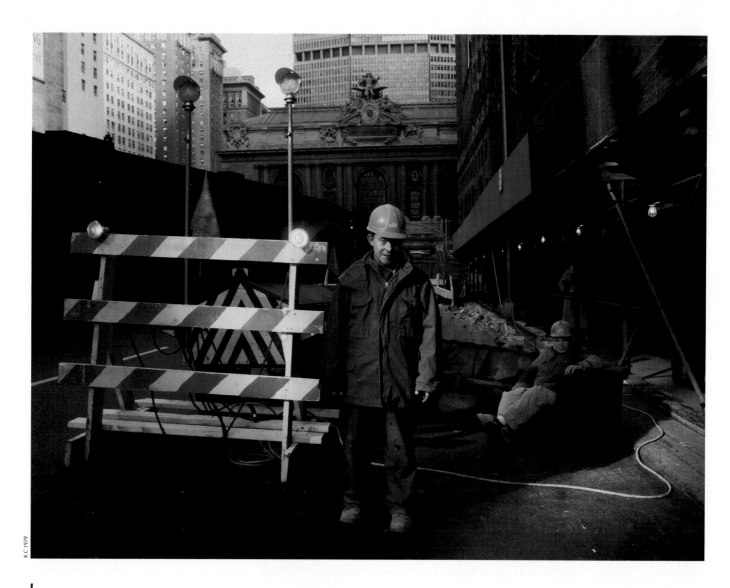

KC 1979

I met these Con Edison electricians on Park Avenue in front of Grand Central Station in the early street days of the couch project. They were both Irish immigrants, who spent their working hours at the bottom of manholes, hooking up thousands of volts, while they talked about the old home counties.

CON EDISON ELECTRICIANS
NEW YORK CITY

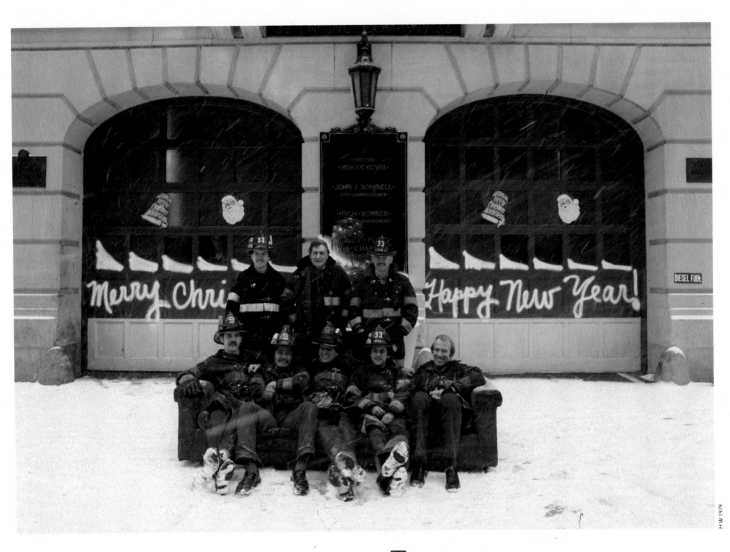

These firemen work on the East Side on Great Jones Street. The photograph reflects Neal Slavin's group portraits in his book *Where More Than One Are Gathered*. I think this photograph succeeds because of the snow—the way it contrasts with the reds and the idea of fire.

ENGINE COMPANY 33
NEW YORK CITY

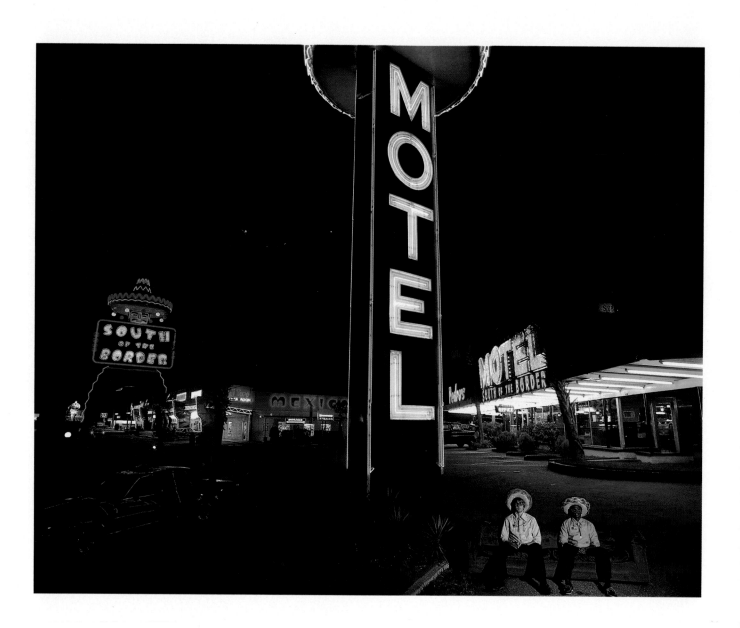

By selling fireworks, liquor, and "a hootin' good time" just south of the North Carolina state line, this service station and motel on I-95 developed into a sprawling entertainment complex. Since the management calls every bellhop "Pedro," I entitled this photograph "The Two Pedros."

TIM ANDERSON AND RONALD WASHINGTON
SOUTH OF THE BORDER, SOUTH CAROLINA

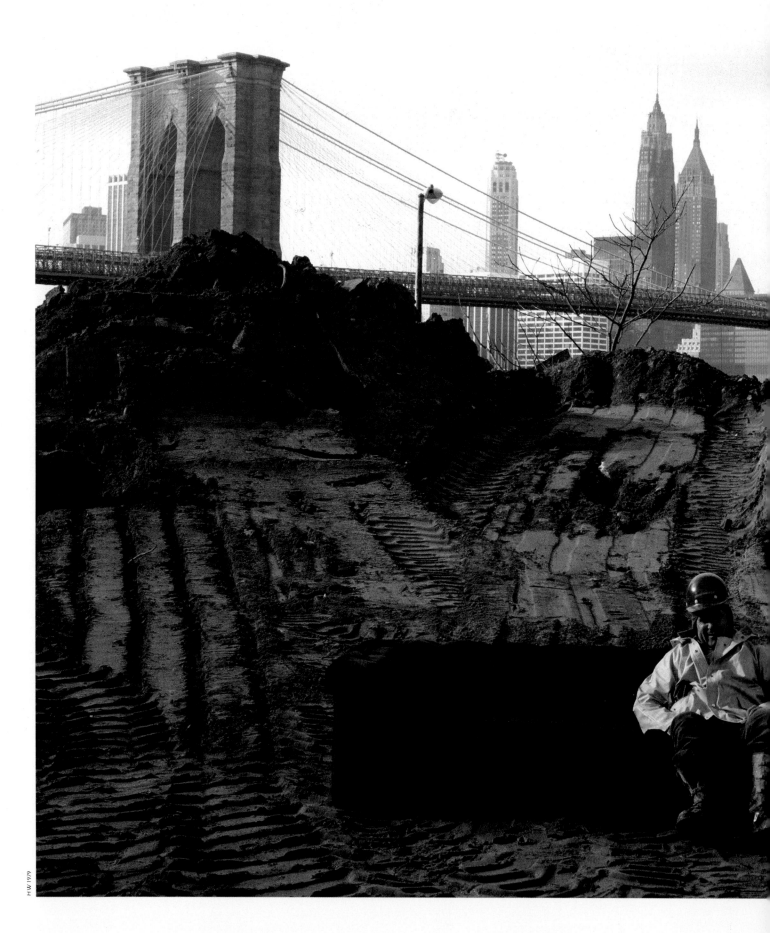

H W 1979

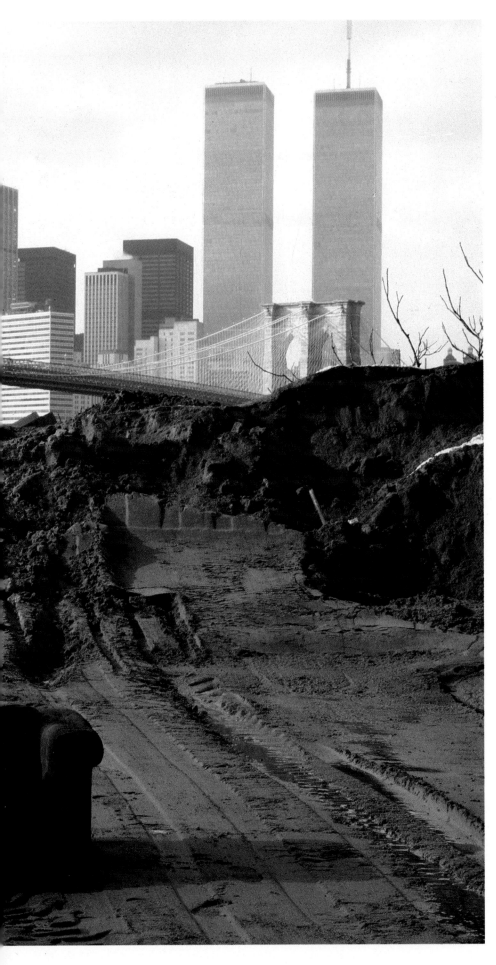

Kevin and I liked the horizon of this location because we wanted a construction worker's monument, and we wanted a worker like those who built the Brooklyn Bridge and the Wall Street area and the World Trade Center. The red hard hat belonged to the man. I almost never bring props to a location.

PETER PERNICIARO
BROOKLYN, NEW YORK ▬▬▬▬

It took three minutes to move two Datsun 280Zs and get the couch in position, but it took five days to get a union permit to move the cars.

SIMON BALTIERREZ
LONG BEACH, CALIFORNIA

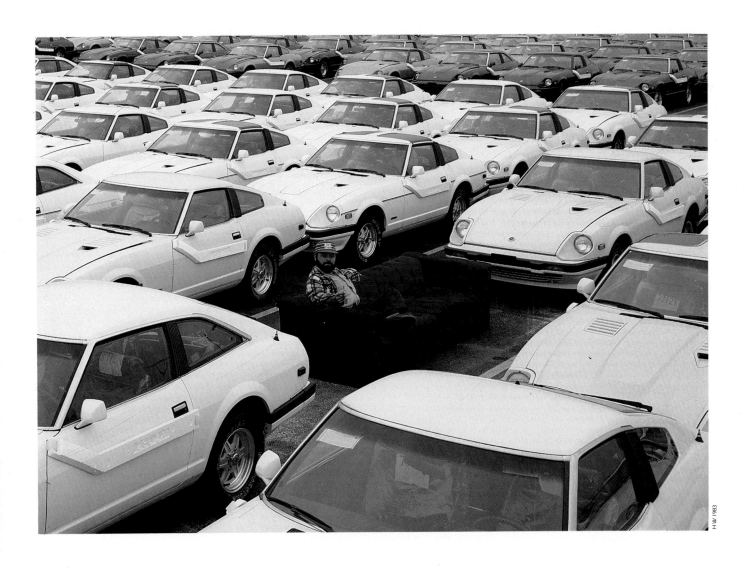

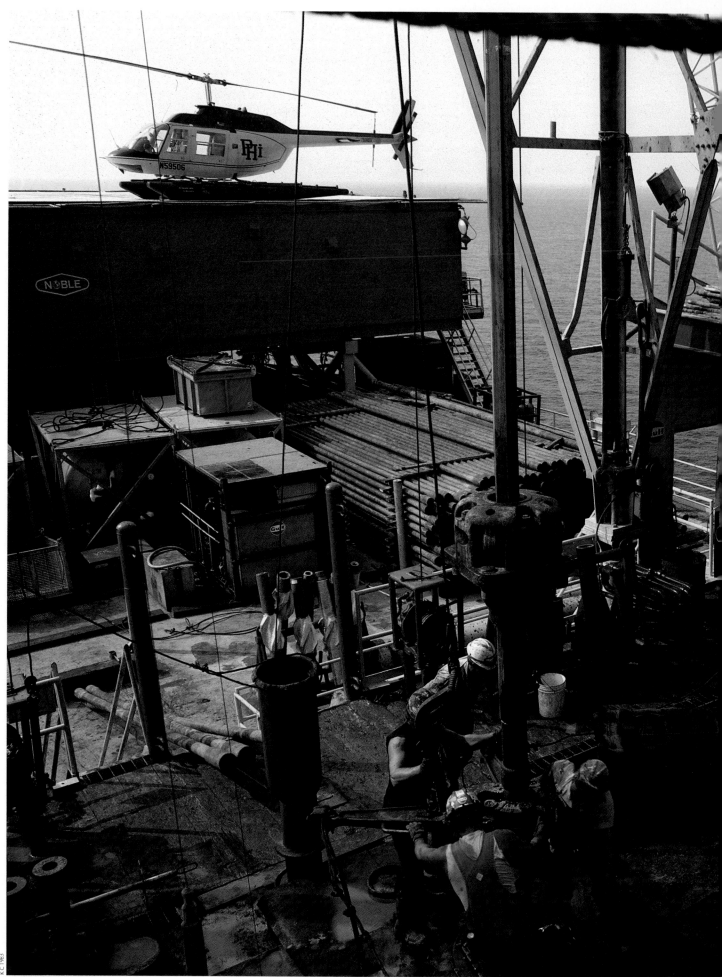

K C 1983

Gulf Oil Company took the couch to the offshore rig by barge and helicoptered the manager in. Several of the crew—the so-called "roughnecks"—wanted to buy stock in the couch project. I knew they were serious because they approached me separately.

DANNY YARBOROUGH AND OIL RIG CREW
GULF COAST, LOUISIANA

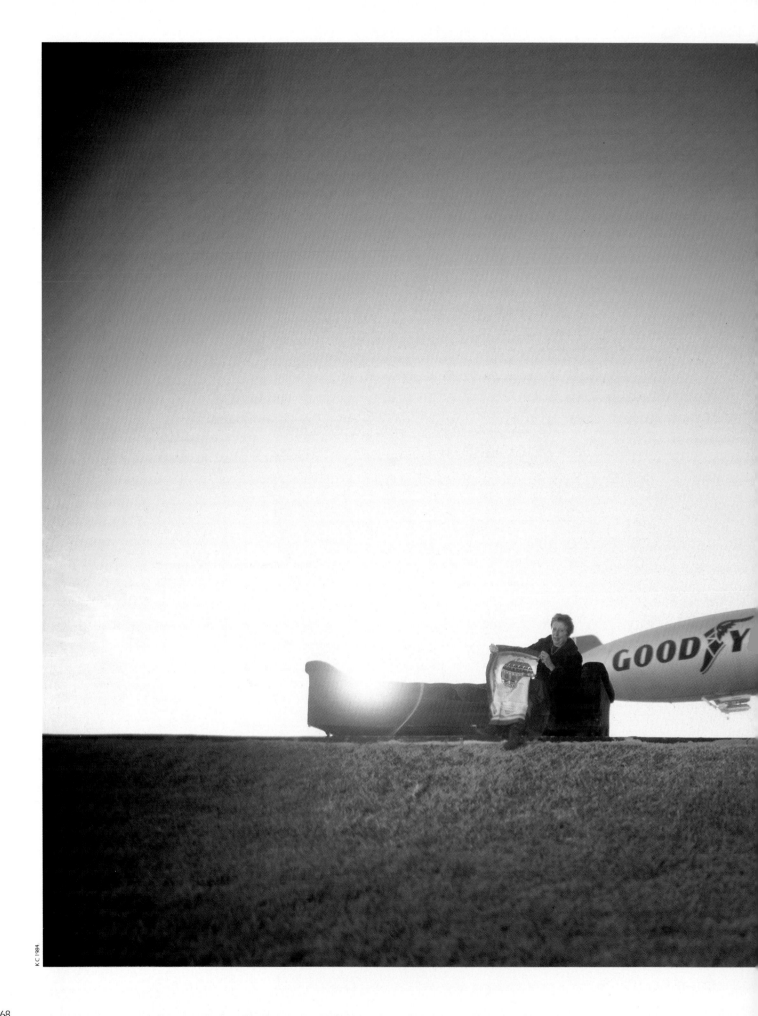

KC 1984.

One element that marks my pictures is what you might call "lift"—there's a sense of the airborne, both in subject and composition.

Quite coincidentally, Madame Hepp lives less than a half mile from the home airfield of one the Goodyear blimps. She's a seventh-generation granddaughter of Pierre Montgolfier, who with his brother made the first successful lighter-than-air flight, in 1783. Almost exactly two hundred years later, Madame Hepp holds a bicentennial scarf depicting that flight.

I rejected the idea of photographing the *America* on the ground. Instead, I tried to combine the rising ship with the setting sun to give a ghostly suggestion of some precursors to human flight—Icarus, Mercury, the Montgolfiers. I had in mind my space shuttle photograph and heavenly bodies and myths.

CHRISTIANNE HEPP
HOUSTON, TEXAS

69

I was looking for strip-mined land in southern Ohio that was ugly. Instead I found these nice coal piles at the R & F Coal Company. This company has won awards for their restoration of strip-mined land. All over the world, miners believe a woman in the mine brings bad luck. American women like Jo Ann Shirbish have begun to change that old idea.

BRUCE MORRIS, JO ANN SHIRBISH, JAMES SEFSICK, AND EVERETT FREEMAN
ST. CLAIRSVILLE, OHIO

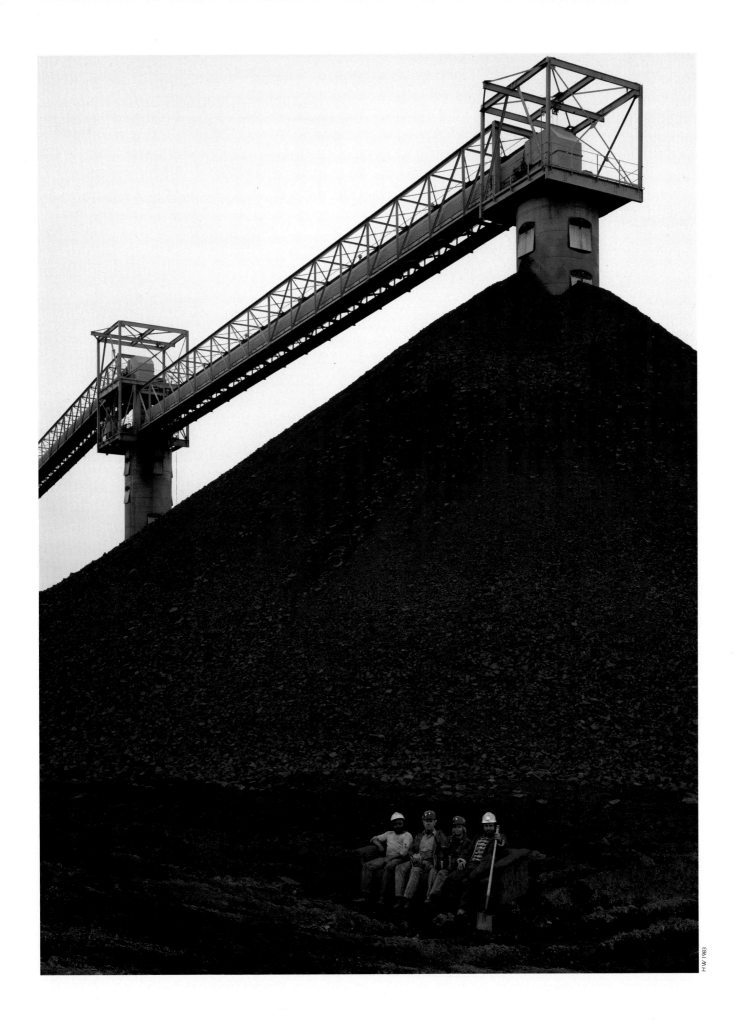

H.W. 1983

71

I saw this gravel pile as I was driving down the highway. Its graphics were perfect for a photograph. While I was looking at it to see where the portrait should be, the owner of the gravel company drove up in his Cadillac. All the time we talked, he kept his left hand out the window. The diamond ring caught the light so amazingly. Then my composition began to form. The gravel pile is what the man does, and its faceted shape is what he loves. Later, I remembered that in German the word *kies* means "gravel," and it's also slang for "money."

DONALD DAILEY
SHAFTSBURY, VERMONT

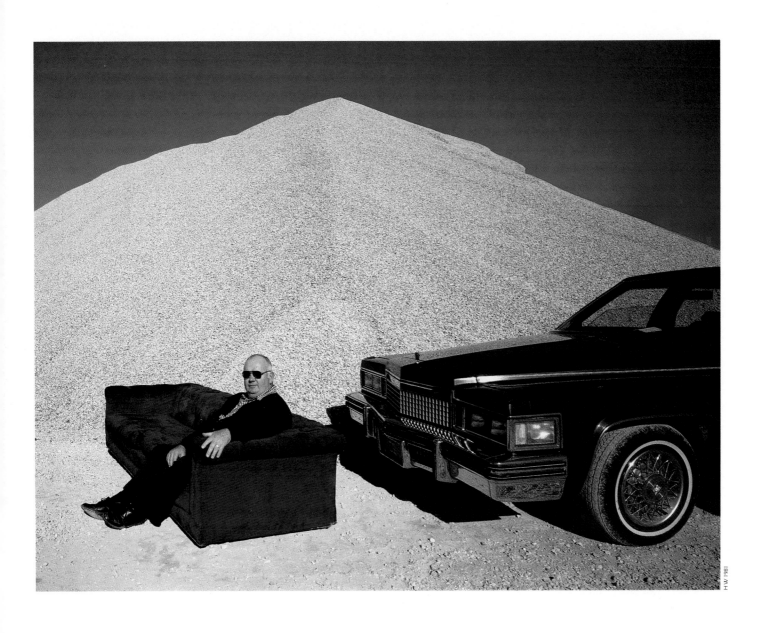

H.W. 1981

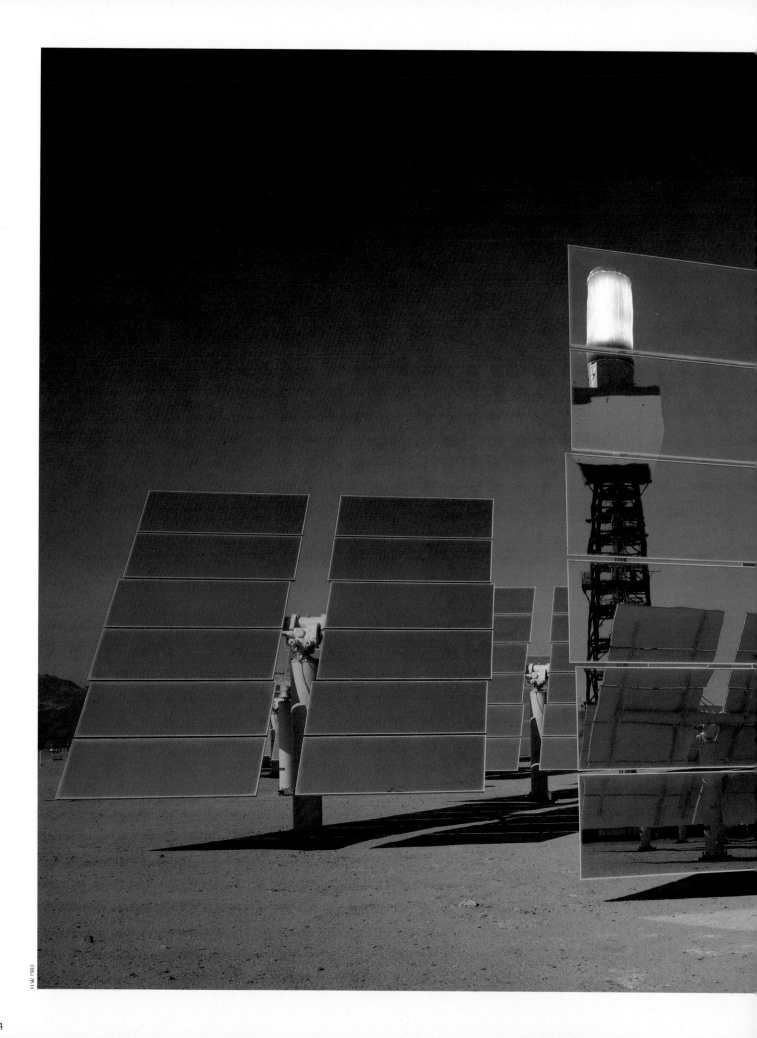

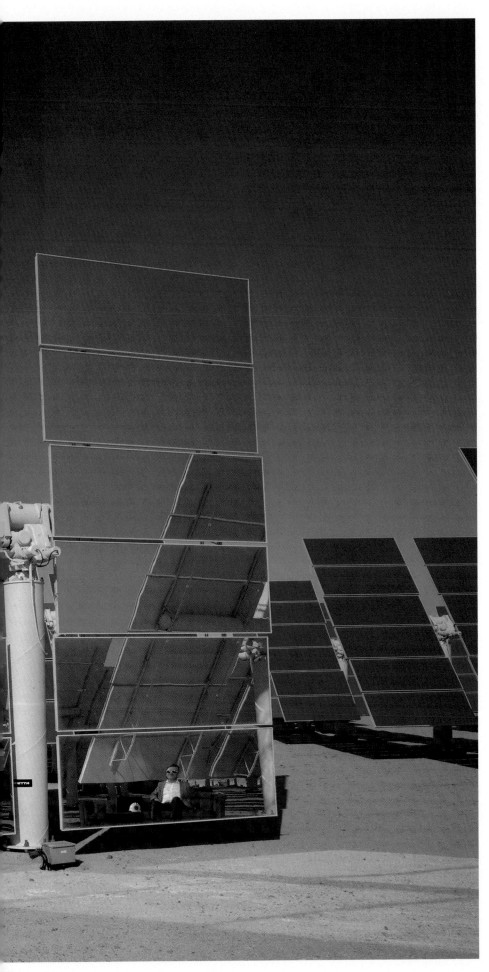

This man works at the Solar One Plant in the Mojave Desert. Computers control the mirrors to keep them focused on the tower that's reflected in the foreground mirror. This is not an experimental solar energy station—it supplies electricity to the area.

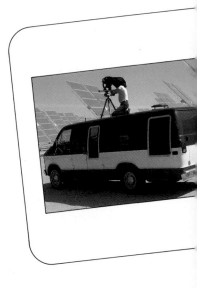

DOUG ELLIOTT
DAGGETT, CALIFORNIA

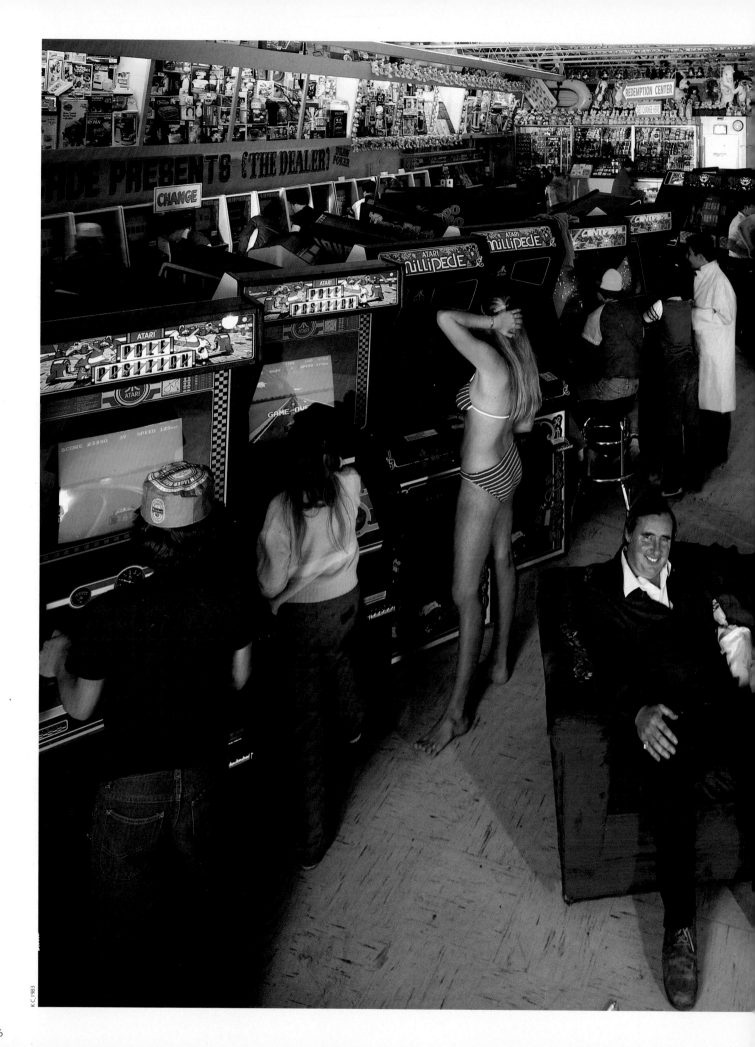

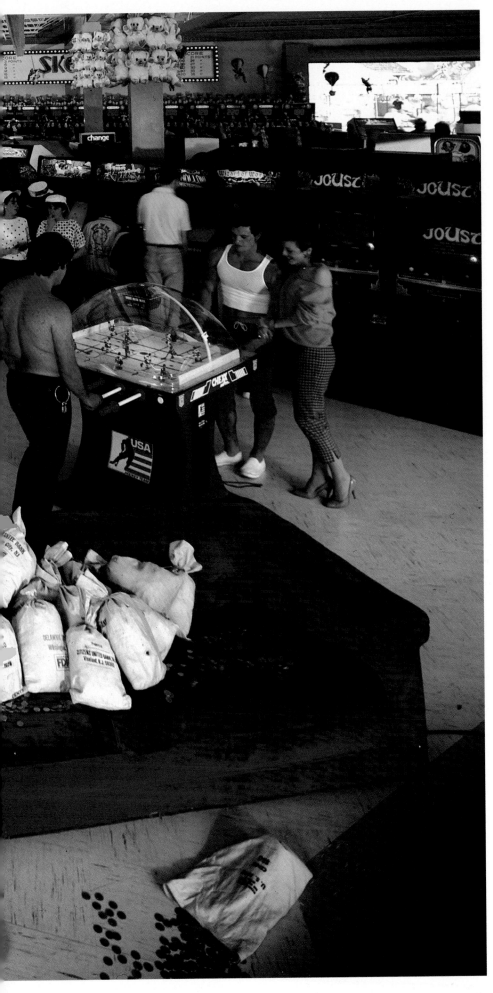

When we were carrying the couch along the boardwalk to the Mariner's Arcade, people kept calling things out to us like, "Where's your girl?" "Now all you need is a blonde." So I found a blonde along the boardwalk and asked her to stand at a video game. The owner is on the couch with bags of quarters that represent one good day's take—thousands of dollars.

TOMMY HUGHES
WILDWOOD, NEW JERSEY

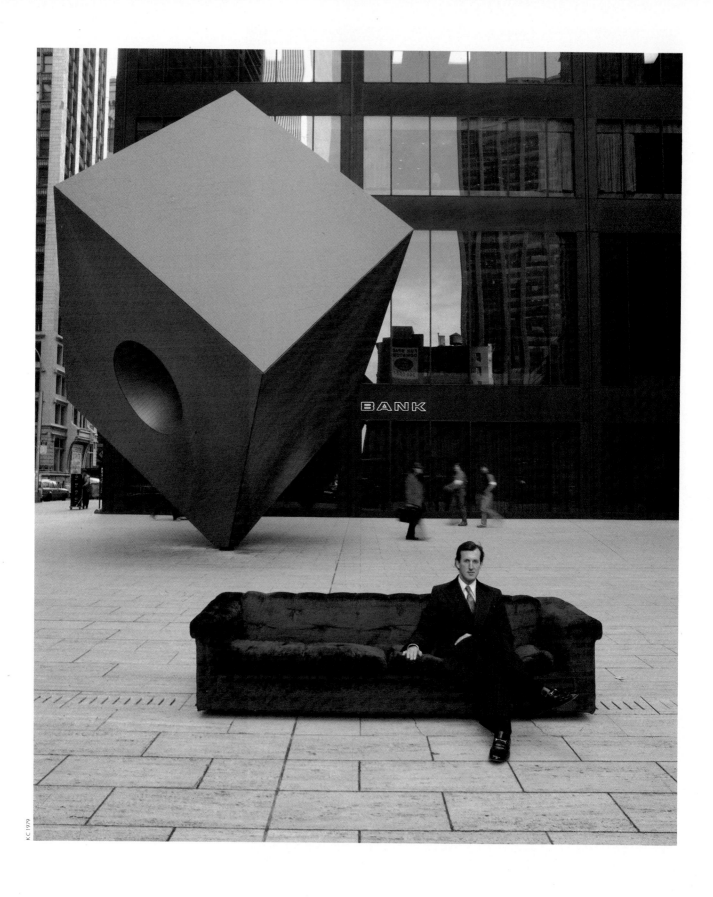

The couch is in the plaza of the Marine Midland Bank in the Wall Street area during the early, spontaneous street days of the project. I randomly asked pedestrians to sit for a portrait. Mr. Burley, a third-generation investment banker, passed by, and I asked him to sit. He said, "I'll be back in twenty-two minutes." In twenty-two minutes he was back, just as manual laborers in blue uniforms started working behind Noguchi's *Red Cube*. The bars on Mr. Burley's Gucci loafers are solid gold.

CHESTER C. BURLEY III
NEW YORK CITY

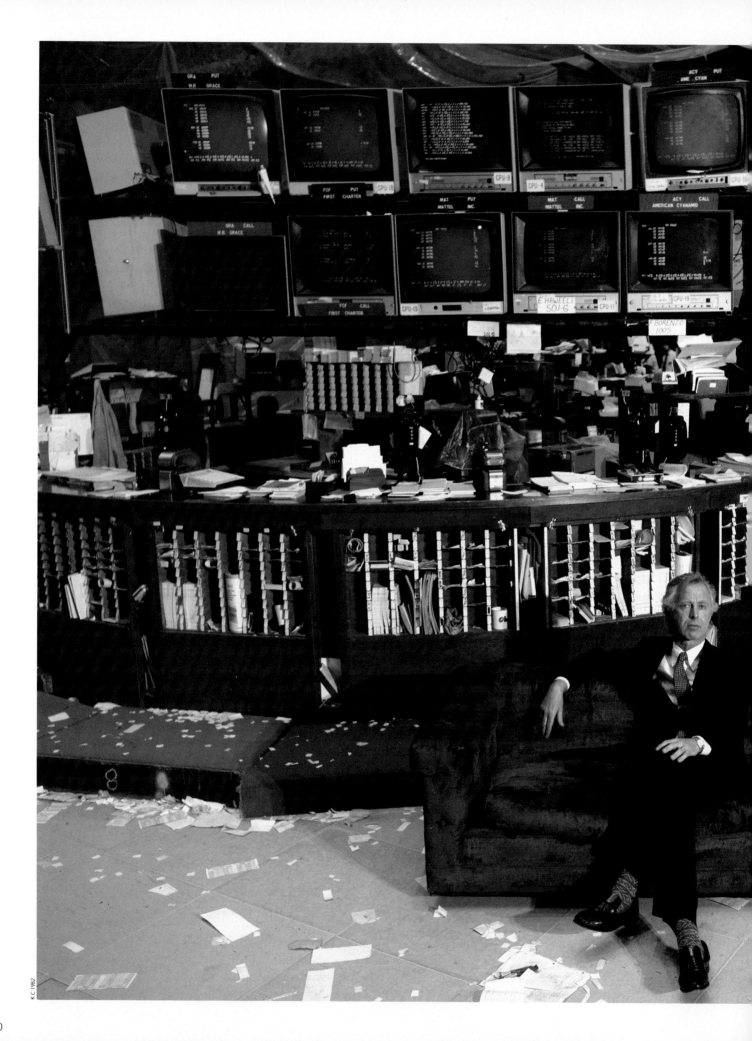

We had from 4:10 PM when the American Stock Exchange closes, to 4:45, when the lights on the trading floor go off automatically, to make the picture. As we carried the couch past the stock traders rushing out, they made obscene remarks. They had the loudest and most ribald mouths of any group I encountered during the five years of carrying the couch around.

Mr. Levitt is the Chairman of the Exchange and Chairman of the American Business Conference in Washington, D.C. He took his position on the couch, a pose almost identical to investment banker Chester C. Burley's [page 79]. After a few years of watching people sit on the couch, I learned how to tell a social class by the way its members sit.

ARTHUR LEVITT, JR.
NEW YORK CITY —————————

81

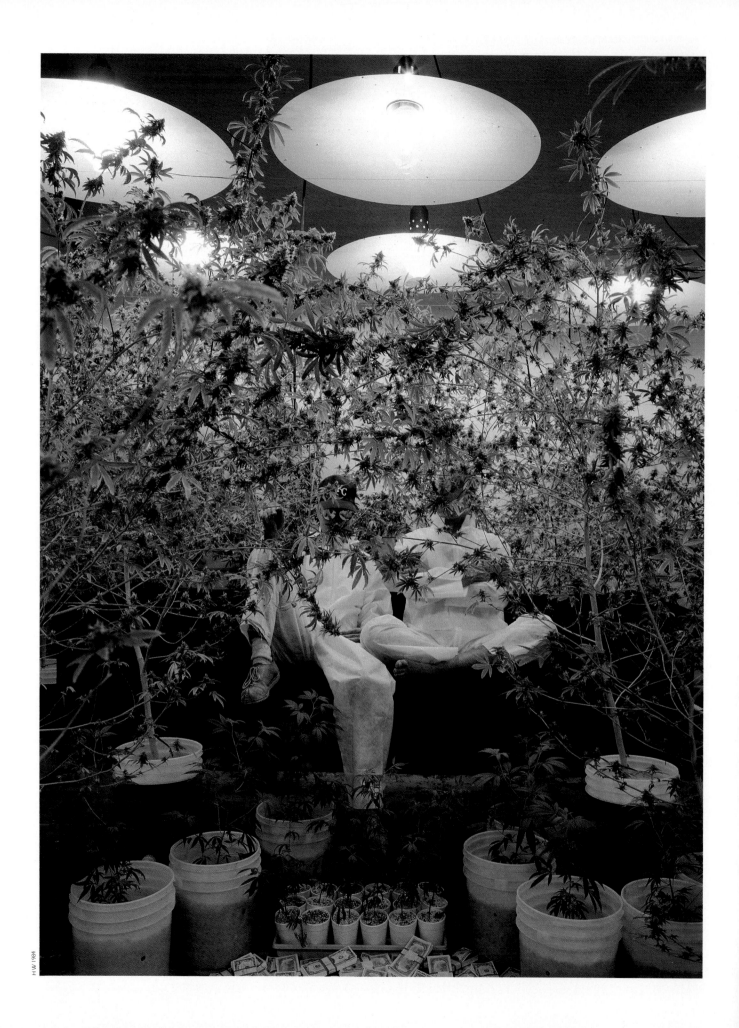

President Reagan asked for tighter enforcement of marijuana laws, and the growers moved inside where they can't be spotted from the air or be stolen from by hikers. The high-density halide lamps and the wet-gravel hydroponics culture also gives them six harvests a year instead of two outdoors. This greenhouse is in an industrial area of Los Angeles, where the very high electrical bill won't draw attention. One plant needs about thirty dollars of electric light every month. There is one halide lamp dealer who sells almost two hundred lights a week—that's an indication of how many growers there are in this one area.

It took six months to arrange for the photo session. These men with stockings over their heads finally agreed to be photographed because they had no criminal conscience and because they wanted to make a political statement about the futility of stopping growers.

The plants in this picture are worth about fifteen thousand dollars. The growers brought the money to illustrate the biggest cash crop in California. Every night before these men go home, they have a "leaf check"—they look each other over for leaves clinging to clothes.

MARIJUANA GROWERS
LOS ANGELES, CALIFORNIA

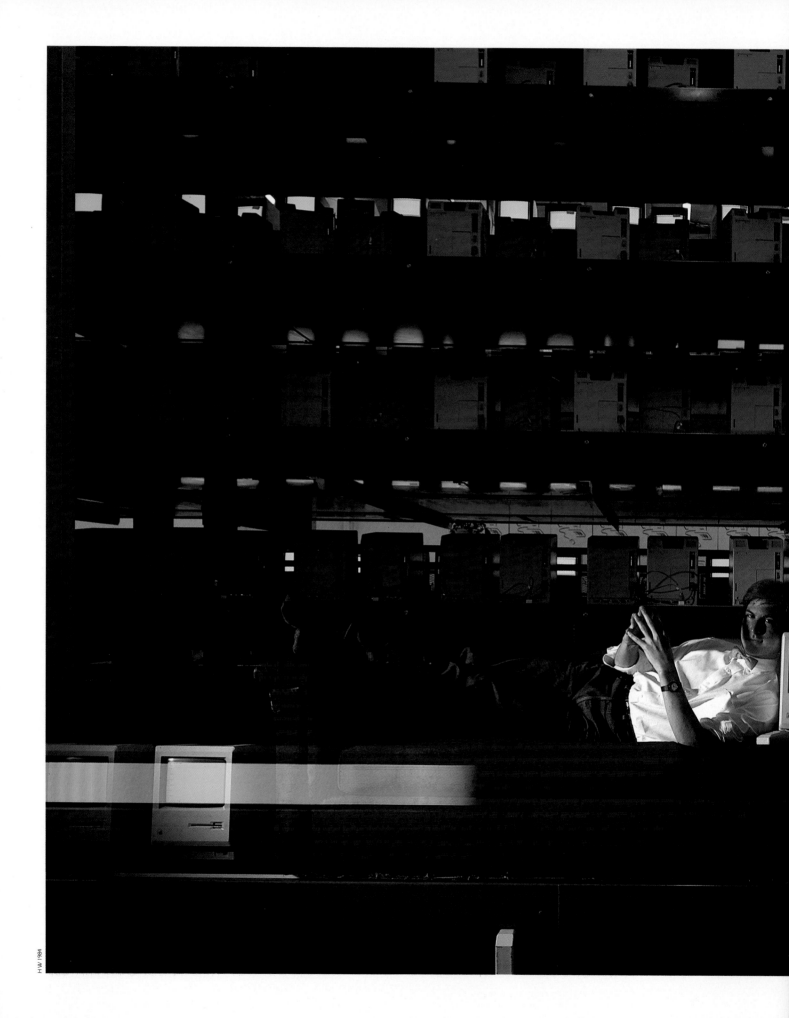

The Apple computer president turns down most requests for photographs, but he liked the project, so he agreed. Everybody but Steve agreed that a picture with movement was illustrative of this company. When he doesn't like an idea, he says, "Why should I do this? That's stupid." We made a deal: four pictures his way and four mine. He finally picked the location on the Macintosh assembly line.

STEVE JOBS
FREMONT, CALIFORNIA

This geneticist, working with a research team at M.I.T., has postulated the existence of a specific gene structure and mapped it with a recently developed "gene alphabet," which I projected above him for the portrait. He holds a petri dish, the basic tool of his trade.

PAUL R. SCHIMMEL
CAMBRIDGE, MASSACHUSETTS

With a world-class hurdler you would expect him to be jumping the couch. I tried nine exposures like that, but they were too literal. On the tenth, I brought the couch back to its original function—furniture for rest. To make it a hurdle is a gimmick. Three months after our picture at the University of California at Irvine, he won a gold medal in the Olympics.

EDWIN MOSES
IRVINE, CALIFORNIA

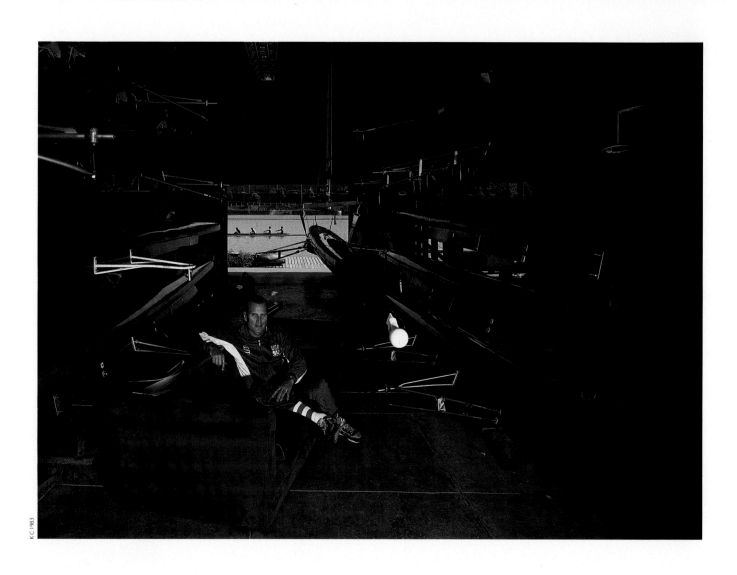

K C 1983

Mr. Kelly, Grace Kelly's brother, is vice president of the United States Olympic Committee. He was on four Olympic rowing teams after he got the A.A.U.'s 1947 Sullivan Award for amateur athlete of the year. He sits in the Vespers Boathouse on the Schuylkill River.

JACK KELLY
PHILADELPHIA, PENNSYLVANIA

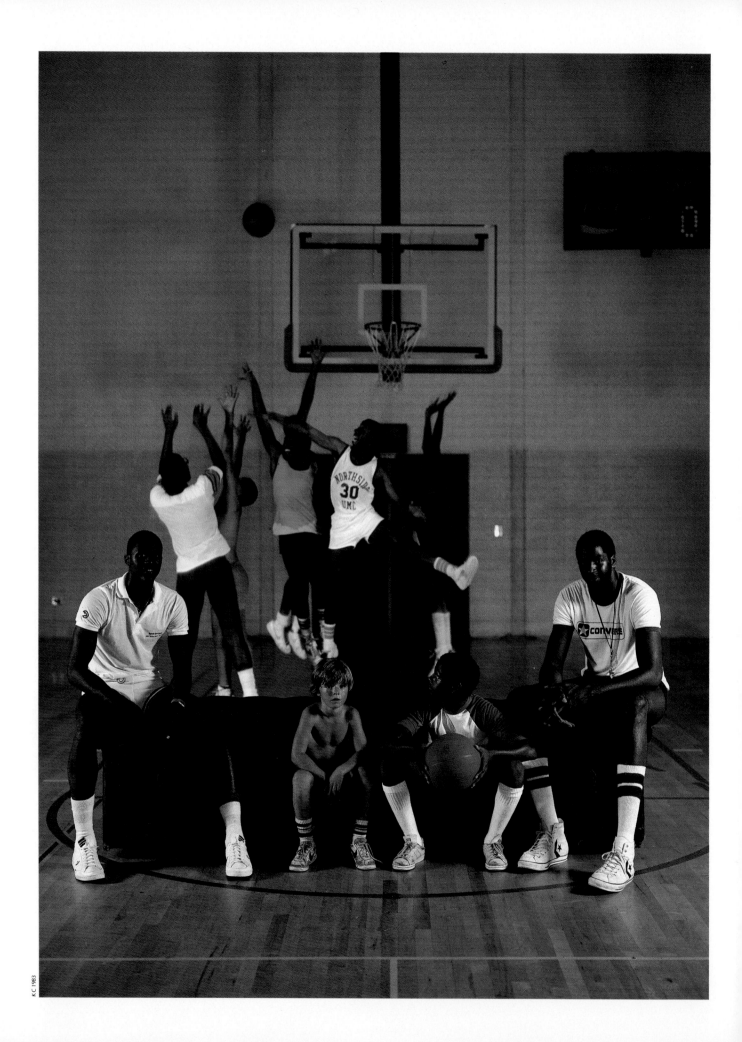

These two professional players run a basketball camp at the Northside Methodist Church gymnasium.

TREE ROLLINS, DOMINIQUE WILKINS, AND PLAYERS
ATLANTA, GEORGIA

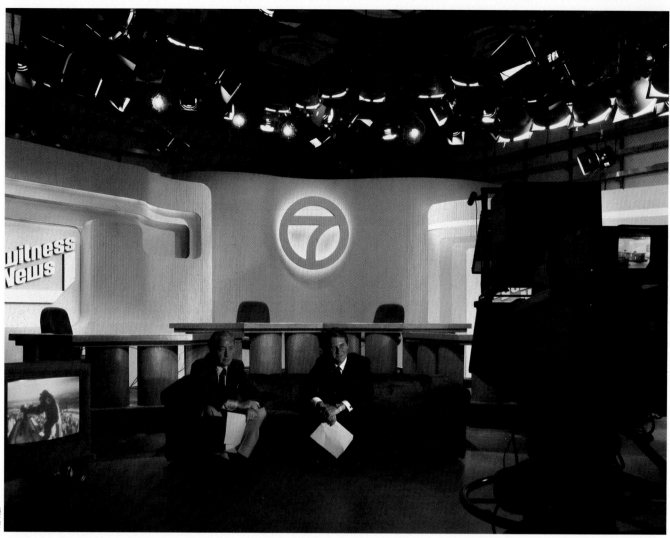

As we photographed WABC's *Eyewitness News* anchormen, a network film clip of the 1933 King Kong climbing the Empire State Building flashed on the television very briefly. Today, the top of the building is one of the highest TV broadcasting antennas in the country. A photographer can previsualize all he wants, but he still has to work with an instantaneous medium, and instants can mean luck—good or bad.

ROGER GRIMSBY AND BILL BEUTEL
NEW YORK CITY

The woman just walked by late at night. She saw the couch and said, 'Wow!' She put down her highball, took off her coat, and stretched out. She totally possessed the scene on White Street. I don't know how to describe her work—she's a part-time actress, model, secretary—things like that. The police are not watching her. They were interested in the operation of the view camera.

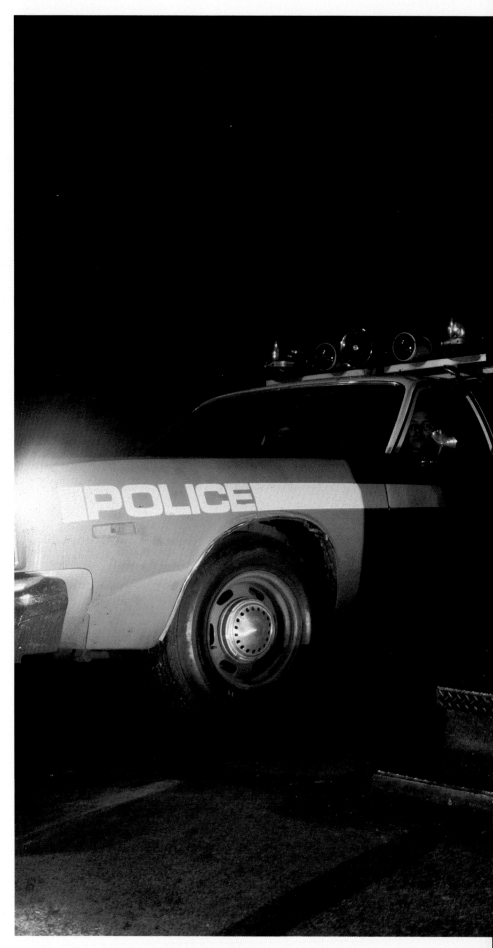

TINA L'HOTSKY
NEW YORK CITY

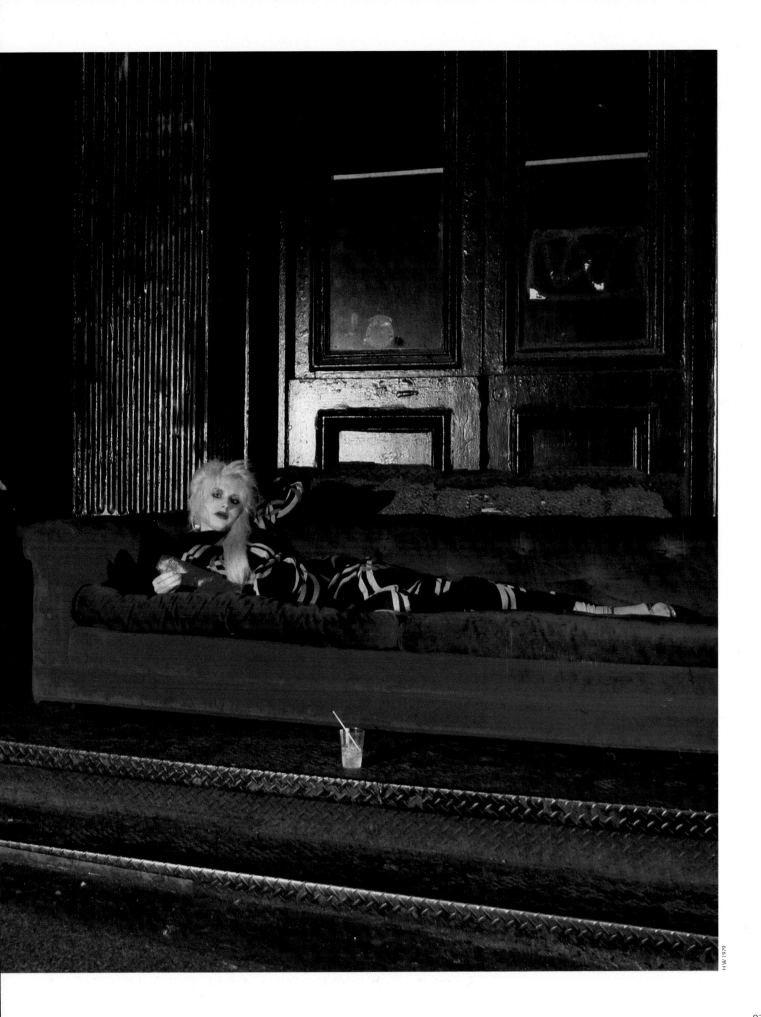

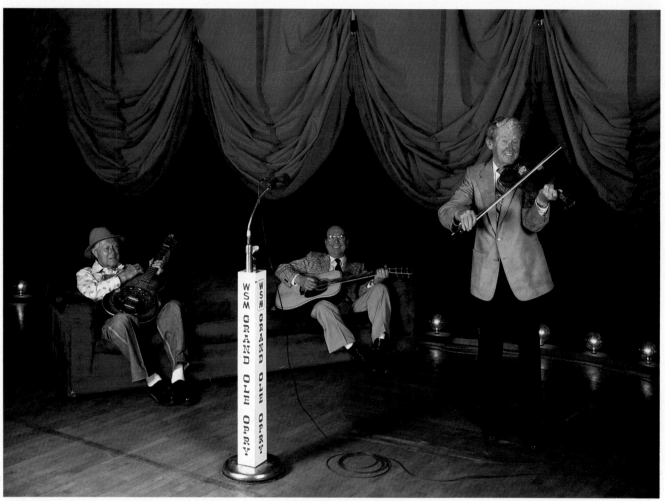

The grand old man of the Grand Ole Opry stands with his group in the Winner's Circle, part of the original stage that was moved to the new building. Charlie Collins said, "It's a blessing to play and do what's in my heart."

ROY ACUFF, OSWALD KIRBY, AND CHARLIE COLLINS
NASHVILLE, TENNESSEE

It was Mrs. de Kooning who convinced her husband to sit for a portrait in his studio, although I had photographed him a few years earlier for a Berlin museum. He thought the couch was a little ratty and wanted to sit in his favorite wooden chair. He said photographers always love his chair.

WILLEM AND ELAINE DE KOONING
SPRINGS, NEW YORK

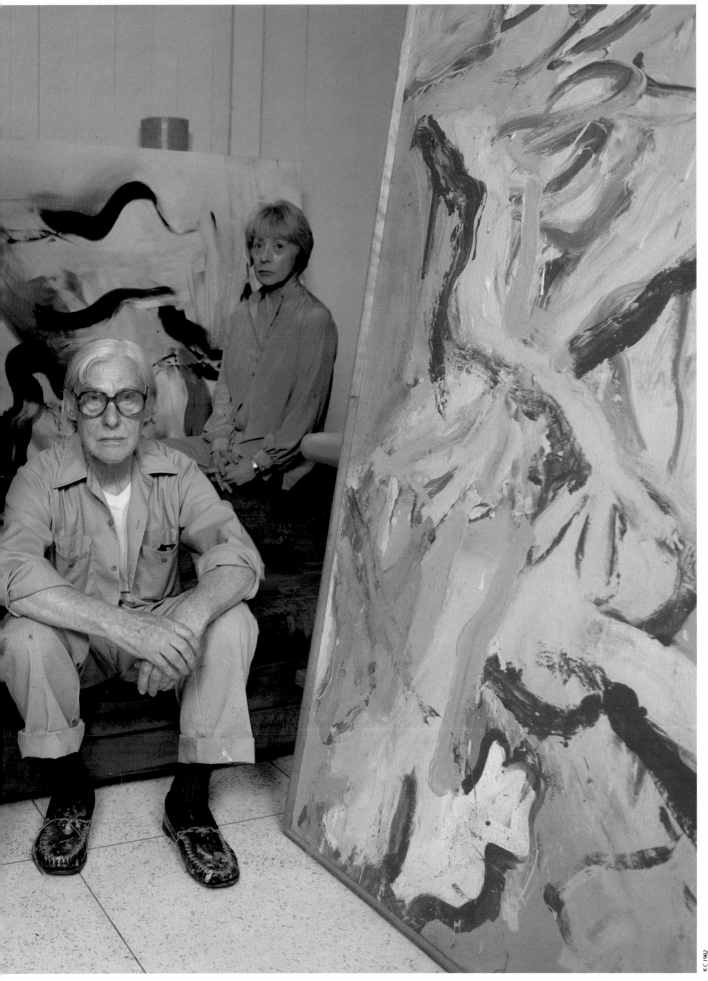

I wanted a tightly composed photograph to suggest the formalist approach of this dancer to his art. It was his idea to go into a controlled, articulated fall. I reduced the colors to three and turned the couch around for a simplicity of line.

MERCE CUNNINGHAM
NEW YORK CITY

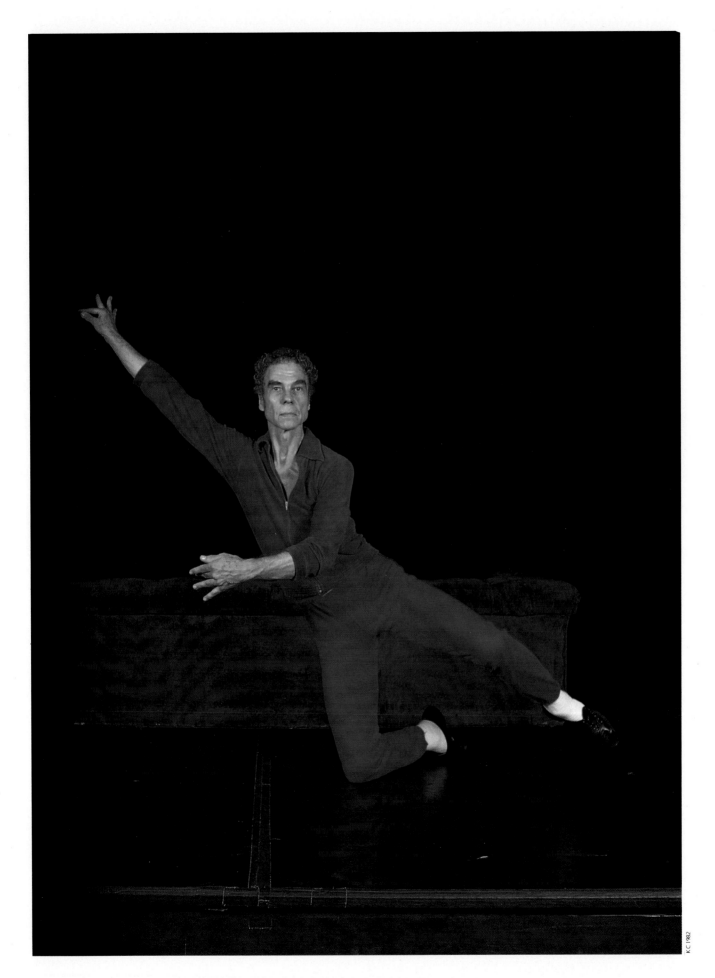

K C 1982

I wanted to photograph Bujones because many people believe him to be the premier American-born classical dancer. He was dressed for the role of the Prince in *Sleeping Beauty.* His jeté turns the couch into an exclamatory statement.

FERNANDO BUJONES
NEW YORK CITY

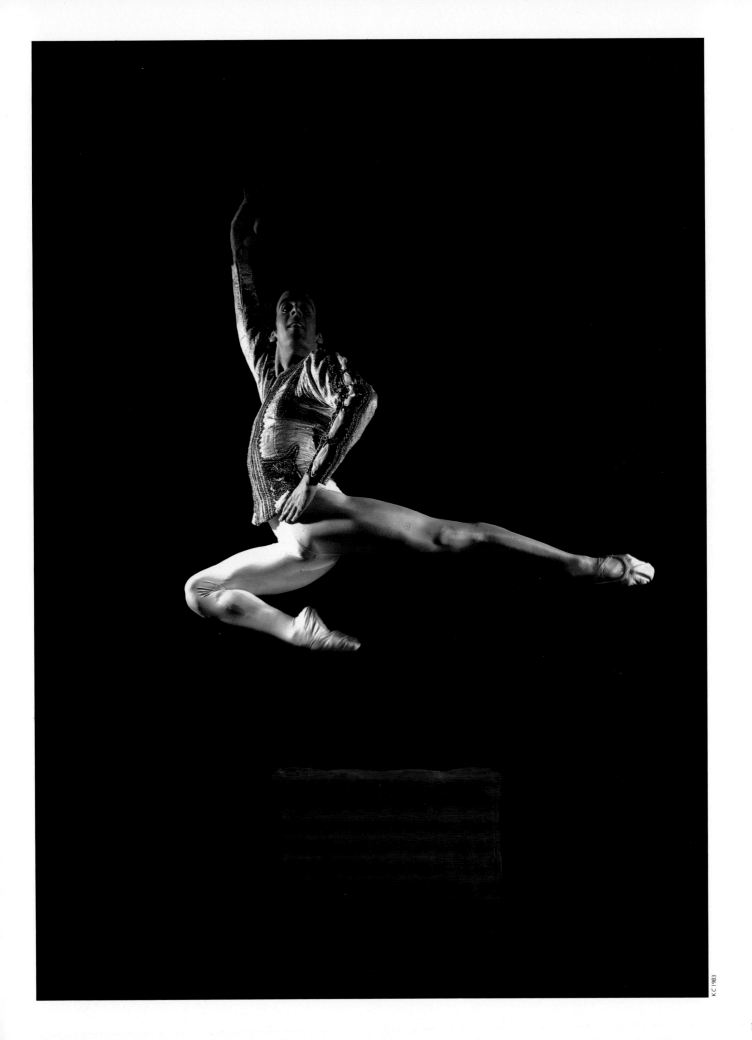

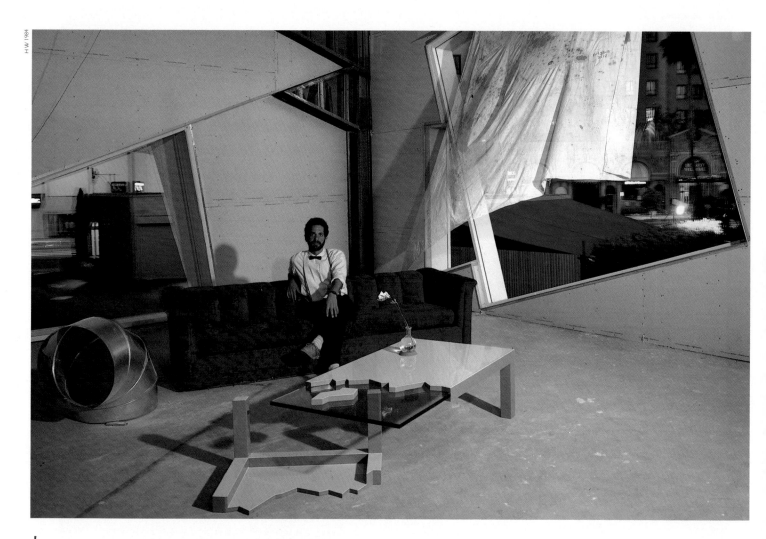

I thought this picture might not work because they usually didn't when the couch was inside a normal room. But the strange window and all the other things somehow make it all right. I photographed Felderman and his award-winning Broken Table at the Triangle Construction Site. He's one of the new "total designers" who do everything from the building down to its furnishings.

STANLEY FELDERMAN
BEVERLY HILLS, CALIFORNIA

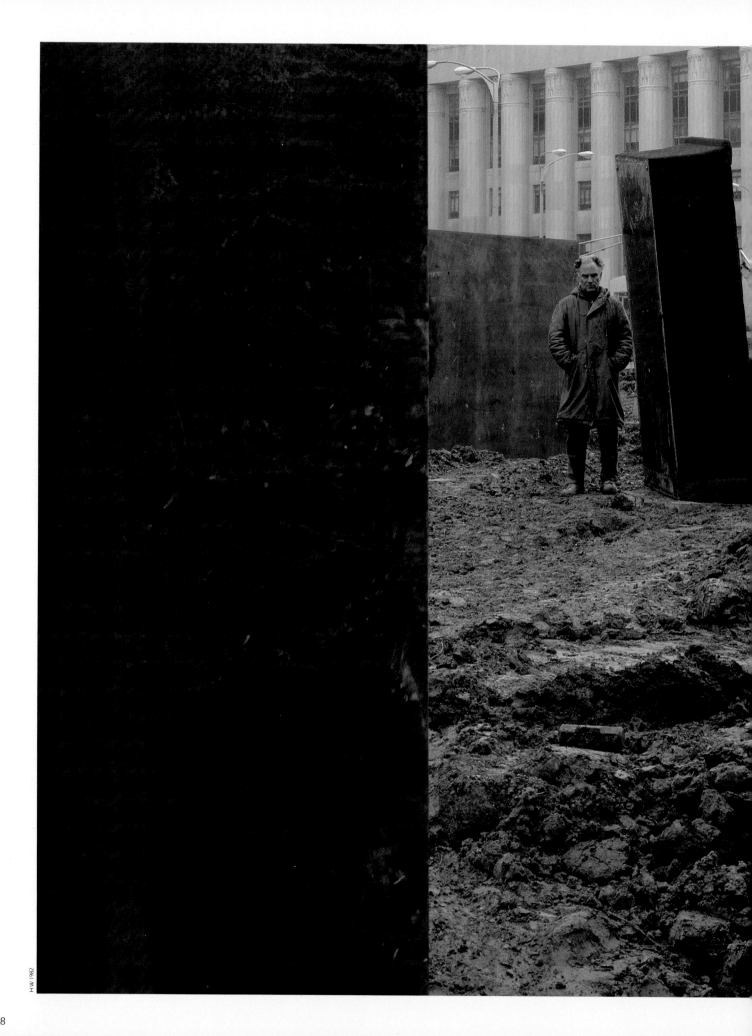

The sculptor was supervising the raising of his new piece *Twain* at Tenth and Market streets in downtown St. Louis. He's known for his leaning upright steel constructions. It was his suggestion to turn the couch on end, though I had been looking for a logical opportunity to shoot it vertically. The composition is homage to an artist whose work I admire.

RICHARD SERRA
ST. LOUIS, MISSOURI

Since 1970 the great Chilean pianist has made a political state-
ment by refusing to return to his country. This picture breaks the
rules by portraying the pianist with an inverted reflection. He was
eighty-one when I photographed him—his piano tutor was a
pupil of Franz Liszt's.

CLAUDIO ARRAU
PHOENIX, ARIZONA

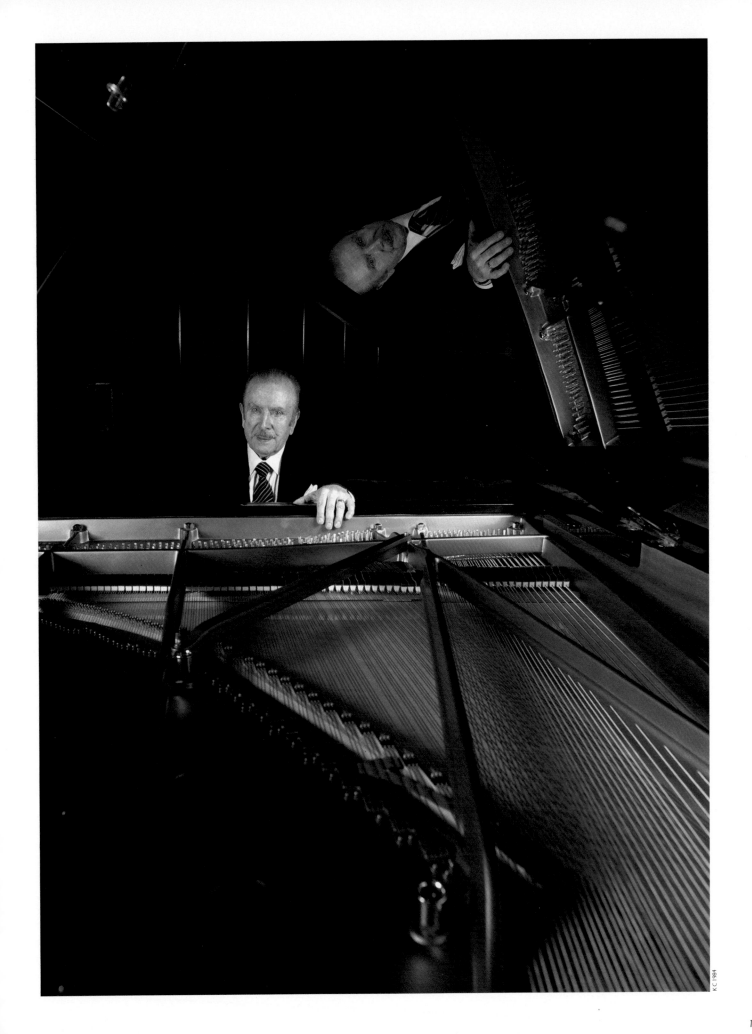

K C 1984

111

While I photographed in this oat field that covers four different Indian burial grounds, I kept remembering Horst's picture of Fool's Crow and the sorrow in his eyes [page 179]. Here are descendants of the new people. They sit back on the couch with confidence and in total possession of it. The cactus is a plastic stage prop for their music and comedy act.

RIDERS IN THE SKY: TOO SLIM, RANGER DOUG, AND WOODY PAUL
NASHVILLE, TENNESSEE

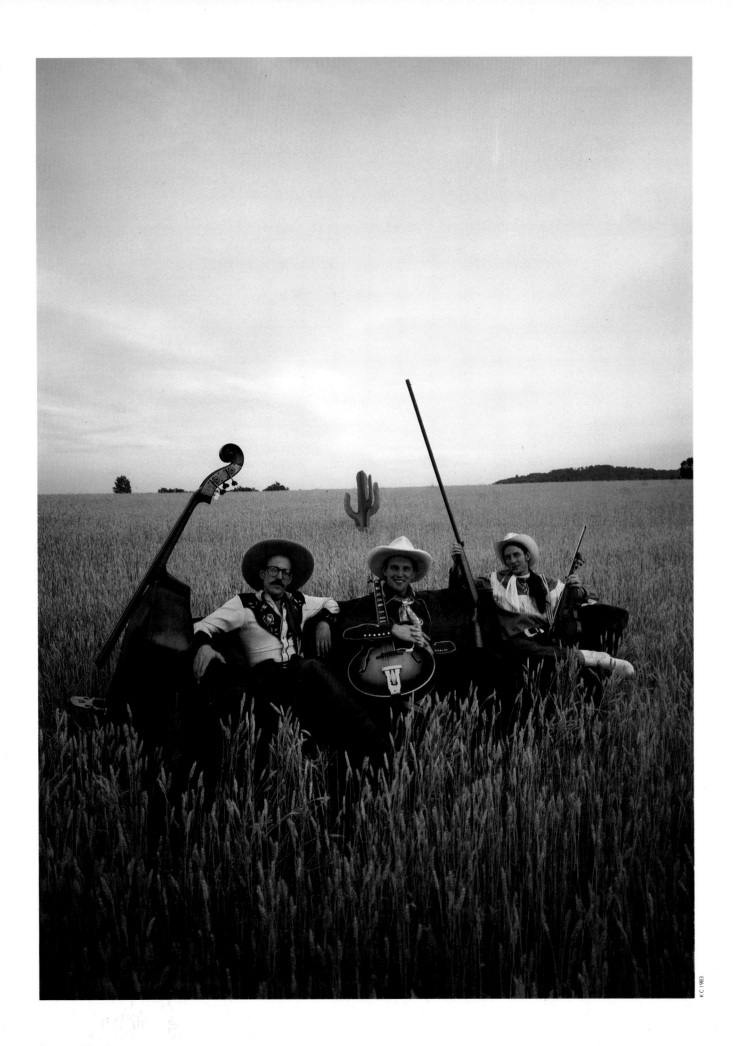

113

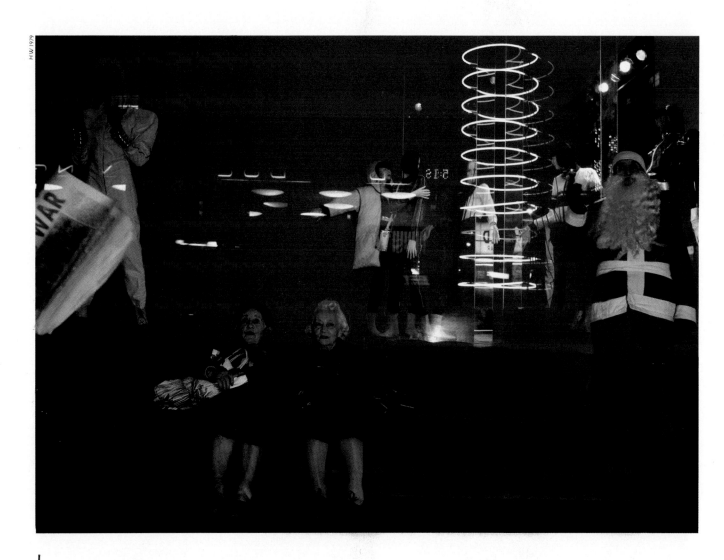

In the early days of the project, when the idea was to make street photographs of happenings on the couch, Kevin and I met these twins shopping the day before Christmas. They were more interested in getting off their feet than in having their portrait made. It was late in the day, as the clock reflected in the store window shows.

We liked the contrast, almost a tension, between the youthful, high-fashion mannequins in Bloomingdale's window and the sisters in their old European widow's black. This is a sidewalk picture about change. It's also about things that don't change, like the headline on the newspaper of the man about to walk in front of the camera. I didn't notice the words until the film was processed. Five years later, I don't even remember what war it was.

BLOOMINGDALE TWINS
NEW YORK CITY

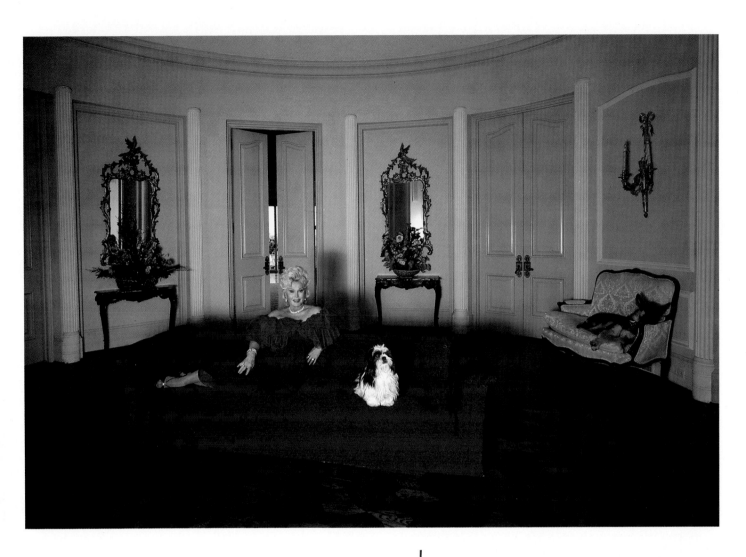

I'll be honest, if the person wasn't Zsa Zsa, this would be no picture. We photographed her in the foyer of her mansion. She lives in one small wing, which was unsuitable for a picture she would consent to. *Stern* magazine paid five hundred dollars for her makeup man and hairdresser.

ZSA ZSA GABOR
BEL AIR, CALIFORNIA

Miss Rubenstein woke up one morning a few years ago and decided to become an actress. She appeared in *Poltergeist*.

I was interested in the idea of relative sizes and distortions, and I wanted to use the couch in a transfigured way. She holds a small photographic cutout. I did not consciously choose the canvas backdrop to suggest a circus, although for so long that was the only place little people could find work. The subconscious is also a tool of the photographer.

ZELDA RUBENSTEIN
LOS ANGELES, CALIFORNIA

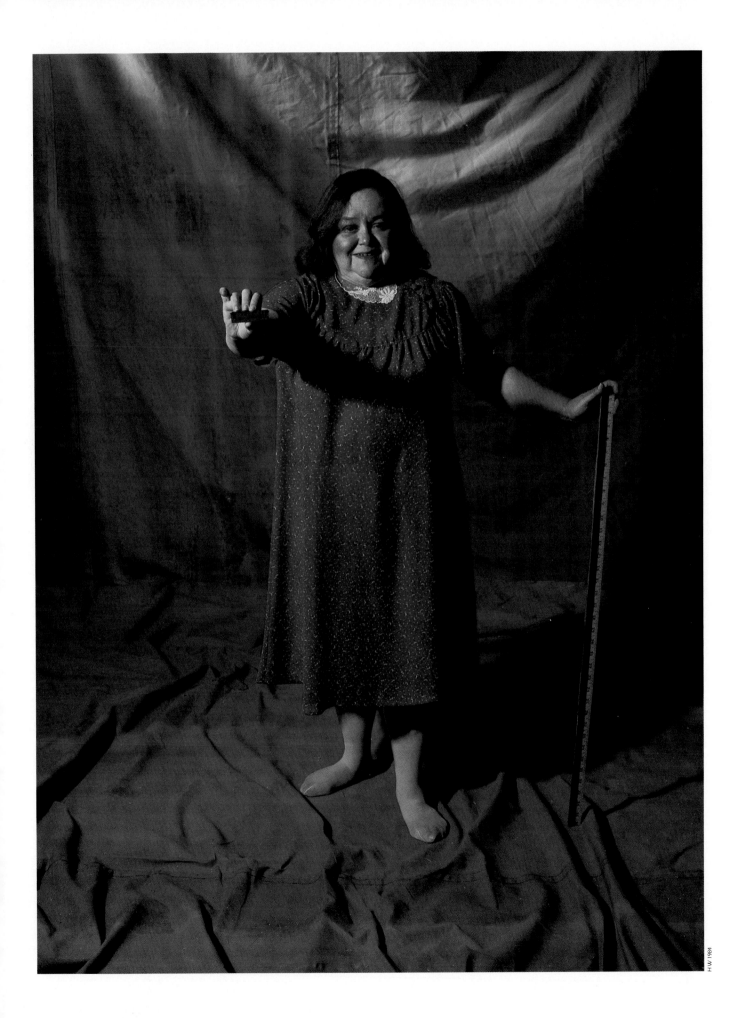

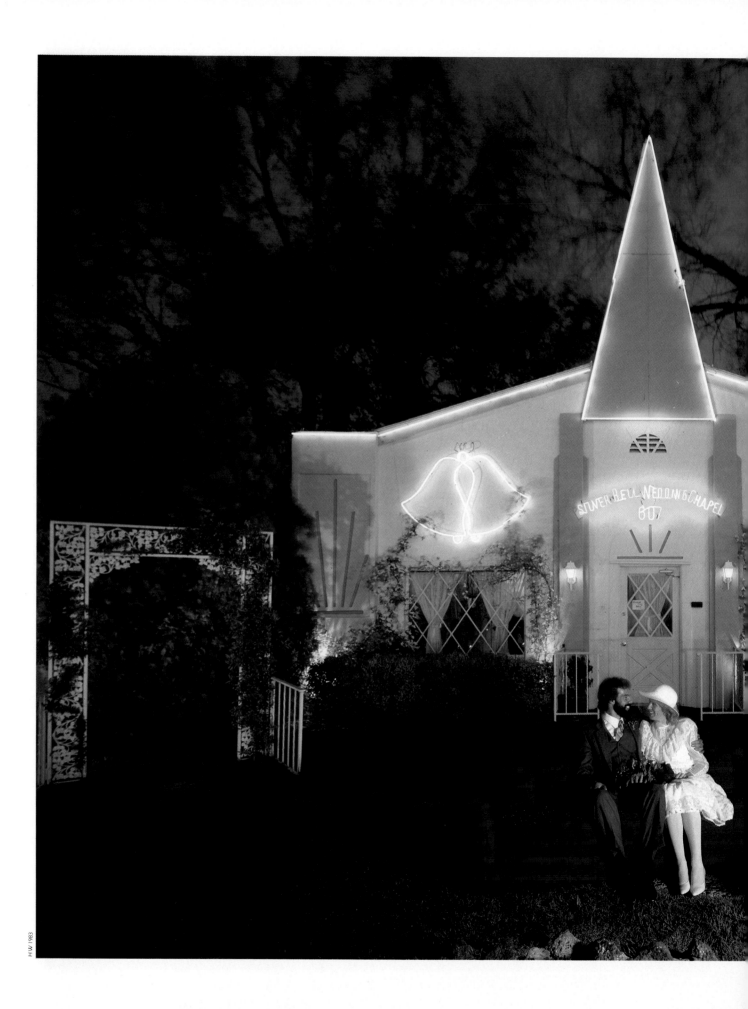

SILVER BELL WEDDING CHAPEL

HW 1983

The Silver Bell Wedding Chapel is open twenty-four hours a day. It has a florist on duty, and it will videotape weddings. It even has an artificial brook under the little bridge. One hundred thousand marriages have been performed under the neon steeple. The Silver Bell record for the most marriages in one day is sixty-seven.

6:15
RANDY AND KELLI RYAN
LAS VEGAS, NEVADA

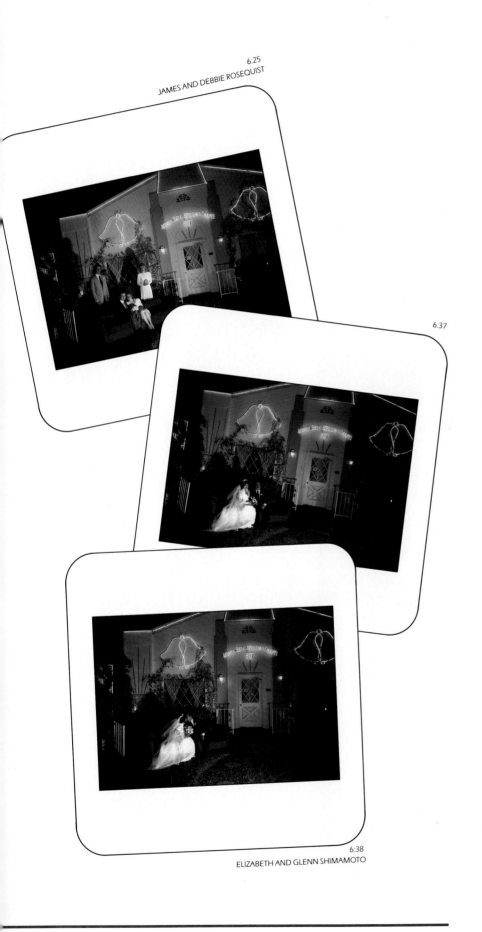

6:25

JAMES AND DEBBIE ROSEQUIST

6:37

6:38

ELIZABETH AND GLENN SHIMAMOTO

H.W. 1981

I tried not to make a pornographic picture of the homosexual men. I wanted only to portray another element of American life. We photographed in an abandoned warehouse on West Street near Greenwich Village. It was a place where men visit to solicit other men. These two were in the warehouse at my request. I paid them fifty dollars, but their deepest motivation for appearing in the book was to see homosexuals represented.

We photographed by the headlights of the van. It was cold and the men took their clothes off only at the last minute. All the time we photographed, other men were having sex in the dark corners. All the time we heard their noises.

SAM AND ROBERT
NEW YORK CITY

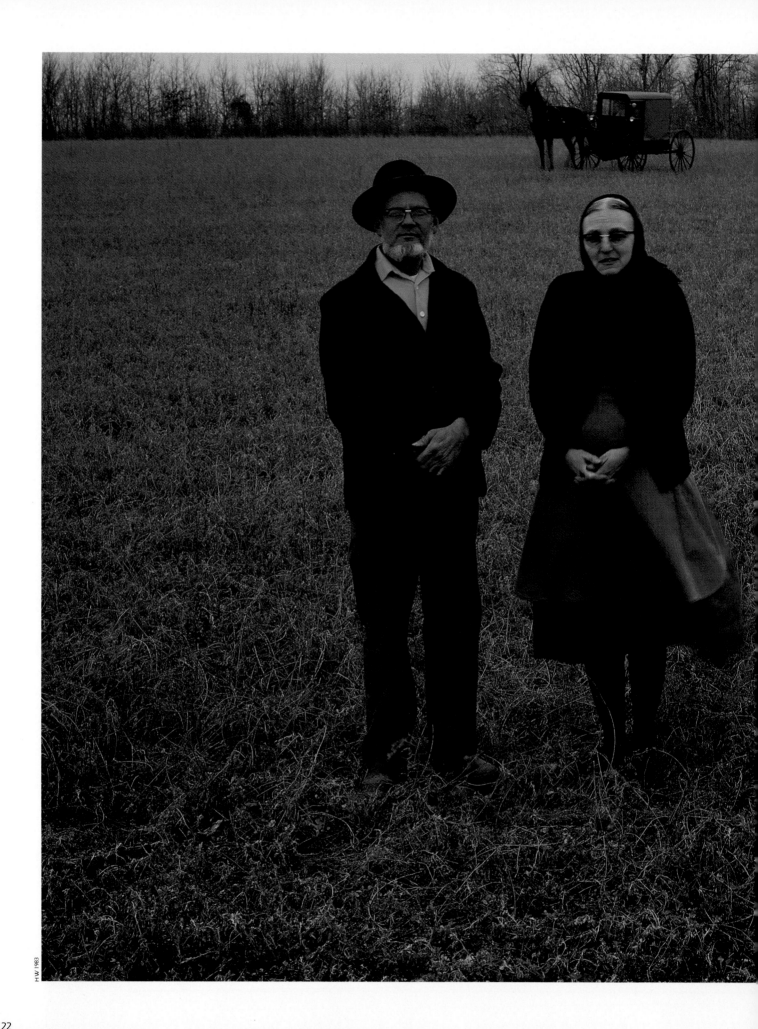

Usually the Amish resist photographers, but we found this couple who had more current ideas. They even had just bought a car to go along with their buggy. The red couch was something else—they weren't comfortable with its flashiness, but they'd already agreed to do the picture. I moved it away to put them at ease. More than that though, I was feeling constrained by the couch. I wanted emphasis on the people.

JOHN AND SARAH KING
LANCASTER COUNTY, PENNSYLVANIA

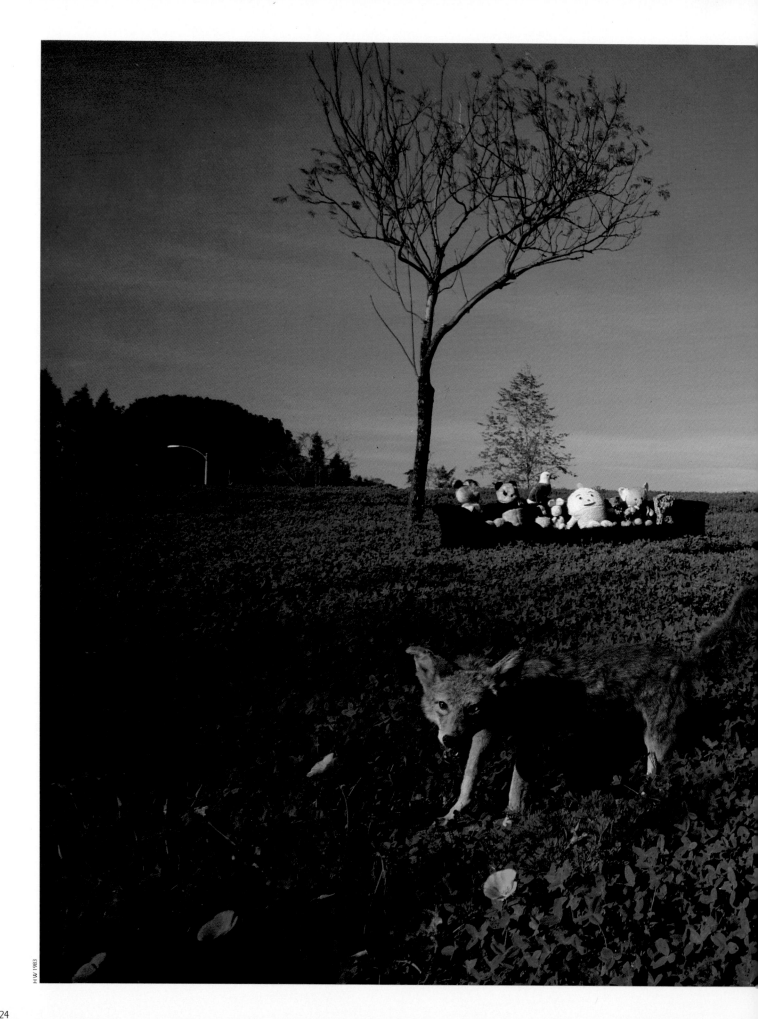

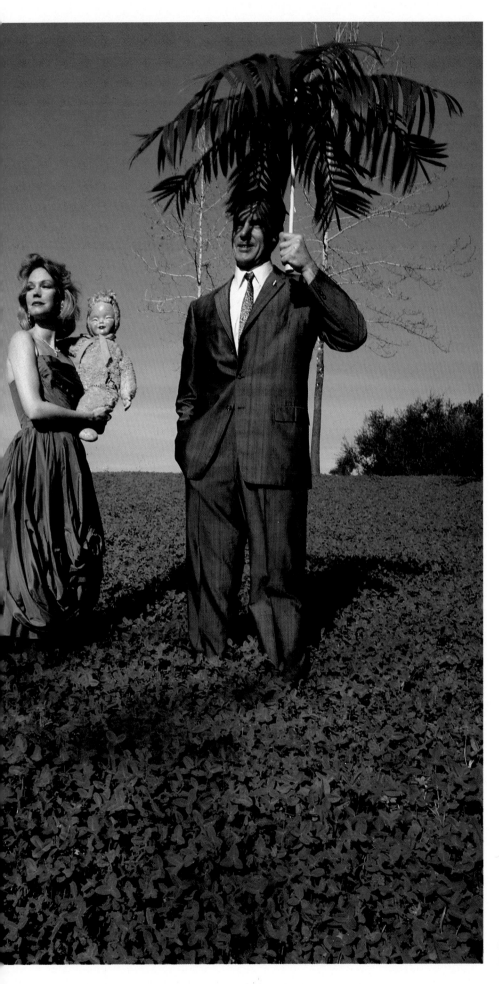

Things here are imitation or artificial—dolls and the stuffed coyote. It's a plastic family of Southern California. She's a painter, and he is the author of *The Better Living Catalog* and a sequel, *Utopia*. He creates crazy things like a glass-bottom bus so passengers can see interesting manhole covers. Here he's holding another invention, the palmbrella.

NANCY REESE AND PHIL GARNER
BEVERLY HILLS, CALIFORNIA ━━━━━

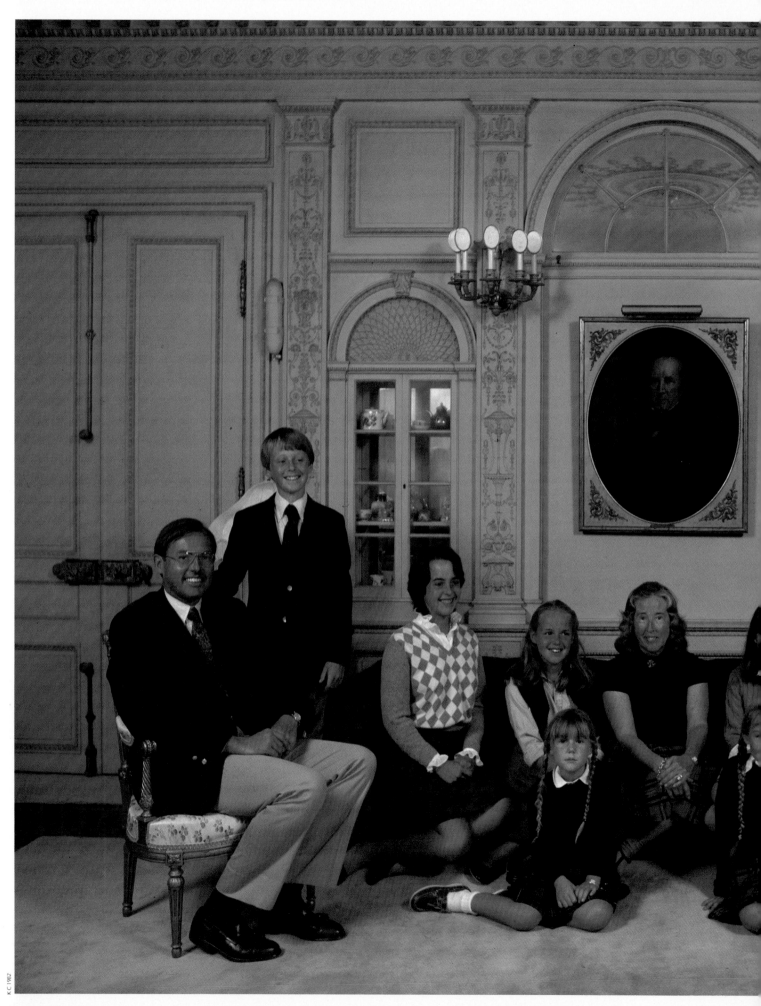

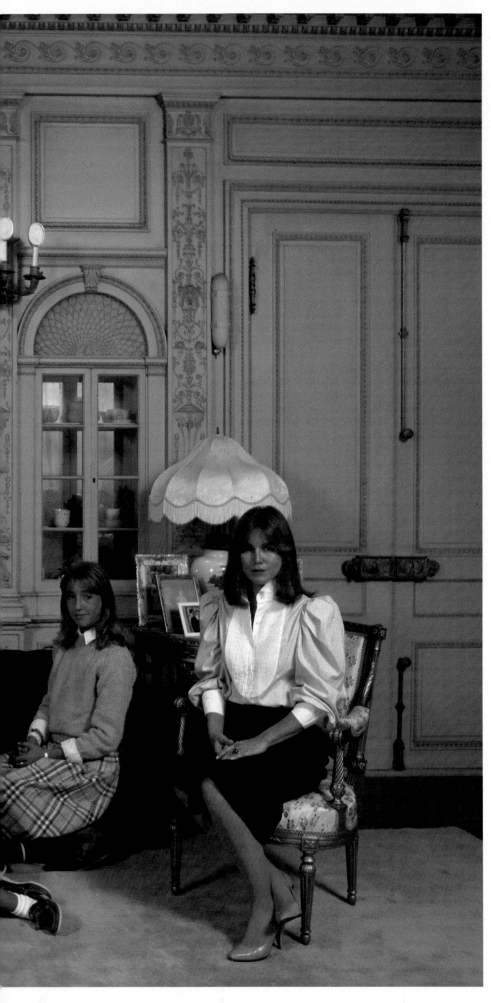

The wealth of this old Yankee family came from clipper ships and the China trade. The portrait above the couch is of Sam Houston, who was their relative. I wanted to do a domestic picture of three generations of people who "have."

THE SLOCUM FAMILY
NEWPORT, RHODE ISLAND

127

After my father retired, my parents moved to a house in Florida that's adjacent to the Brooksville Country Club. They're part of that migration of older people from the Northeast. I'm teasing the checkered-pants and tasseled-shoes group.

HUGH AND CATHERINE CLARKE
BROOKSVILLE, FLORIDA

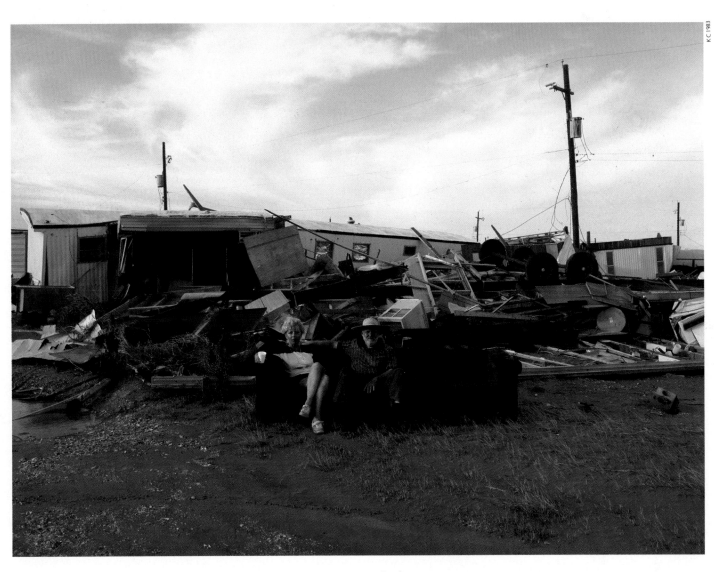

Horst faced the problem of appearing unfeeling when he followed a squad car around New York City [page 192]. It happened with me after hurricane Alicia hit coastal Texas. The first family I approached thought I was incredibly indecent in the middle of a disaster. But the Knights, even with their trailer upside down, were more concerned about getting shot by the National Guard as it closed down the beach area at sundown to keep looters out.

CHARLES AND DIANA KNIGHT
GALVESTON, TEXAS

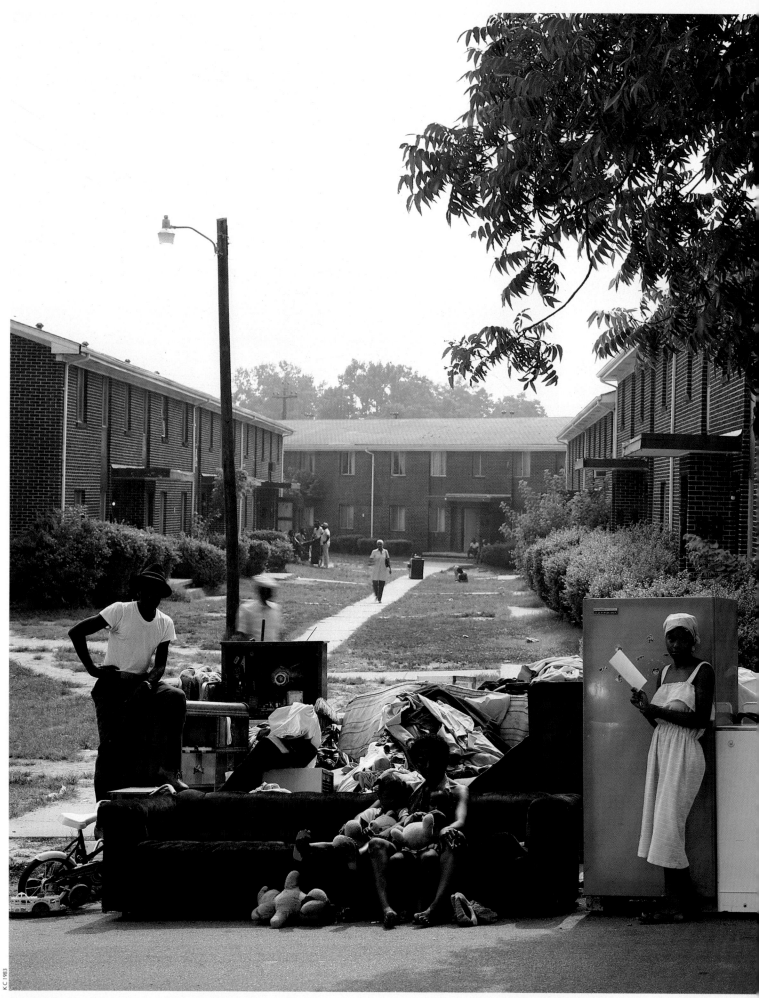

KC 1983

130

I had spent one morning with a city marshall as he served eviction papers. The removal of this family bothered me because they were powerless to stop the process. They had withheld rent payments to protest horrible plumbing problems and no locks on their doors, but they made the mistake of not putting the money in an escrow account.

The black men who worked for the white landlord, the ones who moved the furniture onto Mason Turner Road, were hooted at by other blacks and called "Oreos." I photographed the rotten conditions of the Bass apartment for their court case.

Mrs. Bass sits on the couch with her two youngest children. Her daughter is next to the refrigerator. She's eighteen, unmarried, and pregnant. Mrs. Bass's brother-in-law, Willie Calhoun, is at the left. He is nearly illiterate and a minister in the Free Church of Tomorrow.

BERTHA BASS AND FAMILY
ATLANTA, GEORGIA

We started shooting at five in the afternoon, when Mr. Hefner was just beginning his day. He always works in pajamas. I got to select the color of the pajamas and also the women, who work in the Los Angeles Playboy Club. The birds and rabbits live on the grounds of his estate.

Mr. Hefner's an interesting man. For two decades his magazine changed ways of living, not just in America, but all over the world. But the pipe and pajama style that he chose in 1954 he still follows.

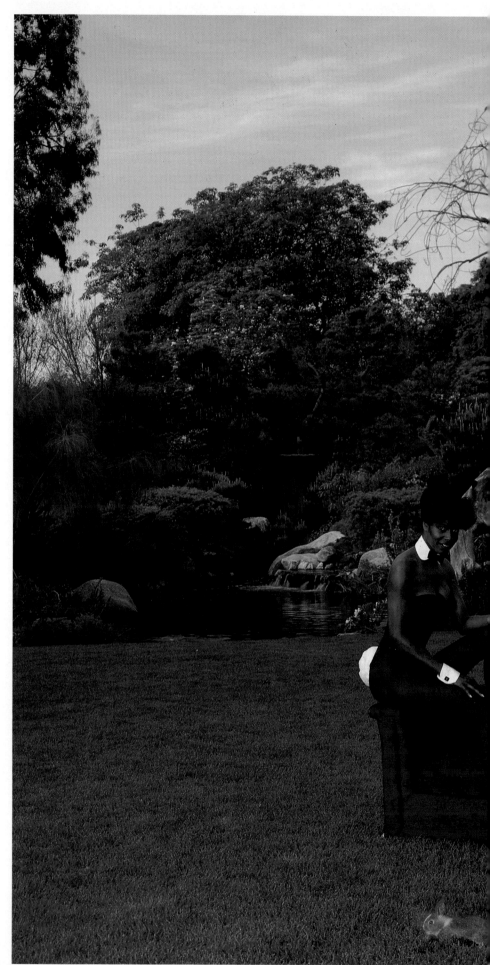

HUGH HEFNER WITH NELIA, JEANNIE, AND PAULA
HOLMBY HILLS, CALIFORNIA

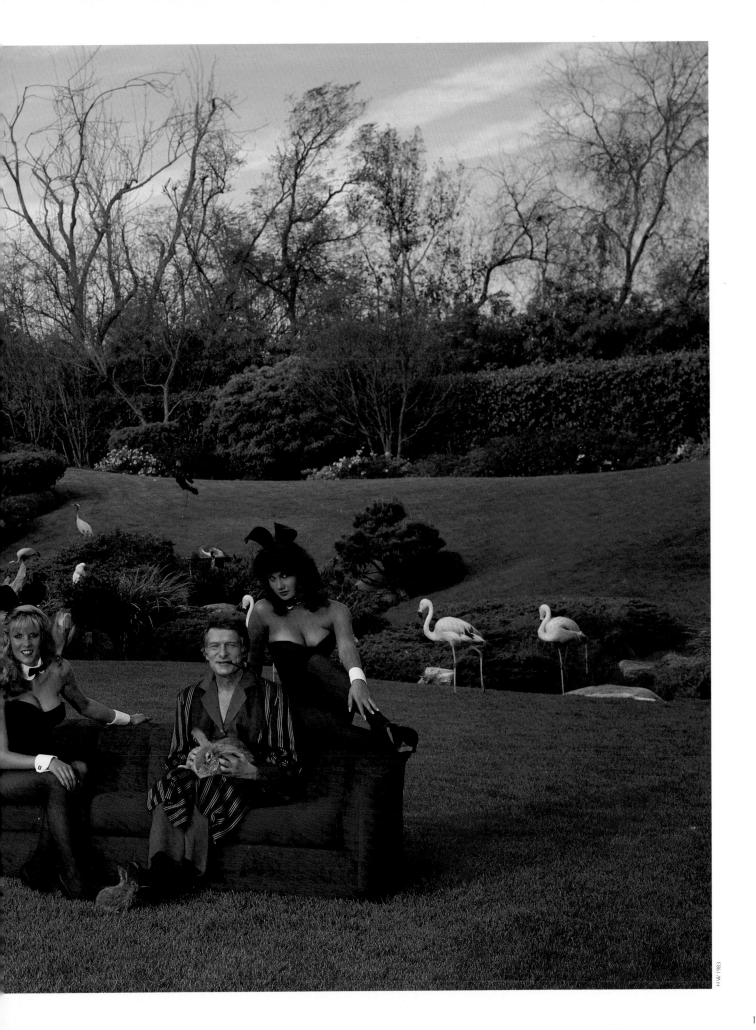

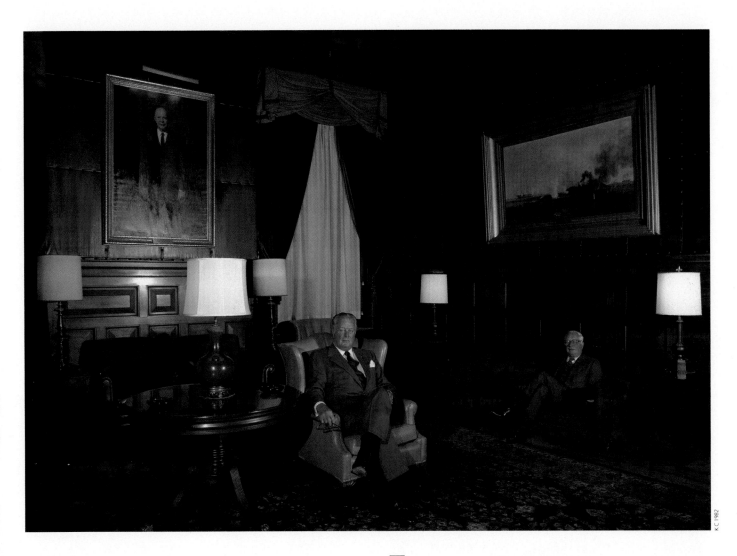

These men are powerful corporate figures and members of the Union League of Philadelphia, which was established during the Civil War to support Abraham Lincoln's struggle to maintain the union between North and South. The league published hundreds of pamphlets and worked to improve the white attitude toward black people in the North. Their motto is "Love of country leads."

J. PERMAR RICHARDS AND CHARLES K. COX
PHILADELPHIA, PENNSYLVANIA

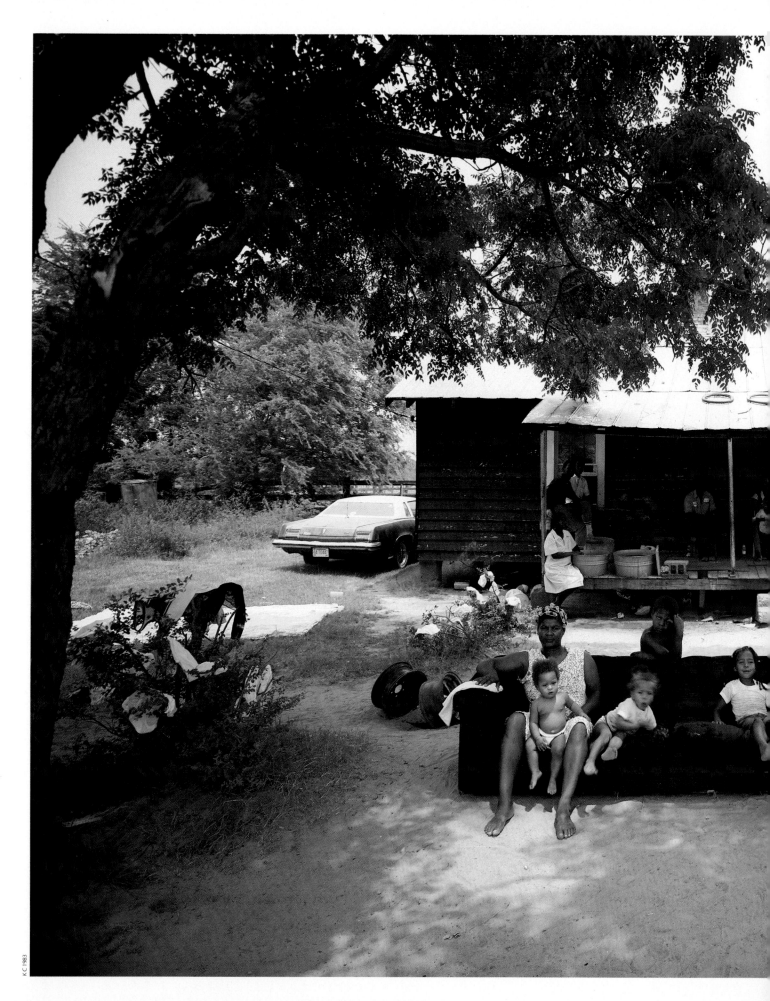

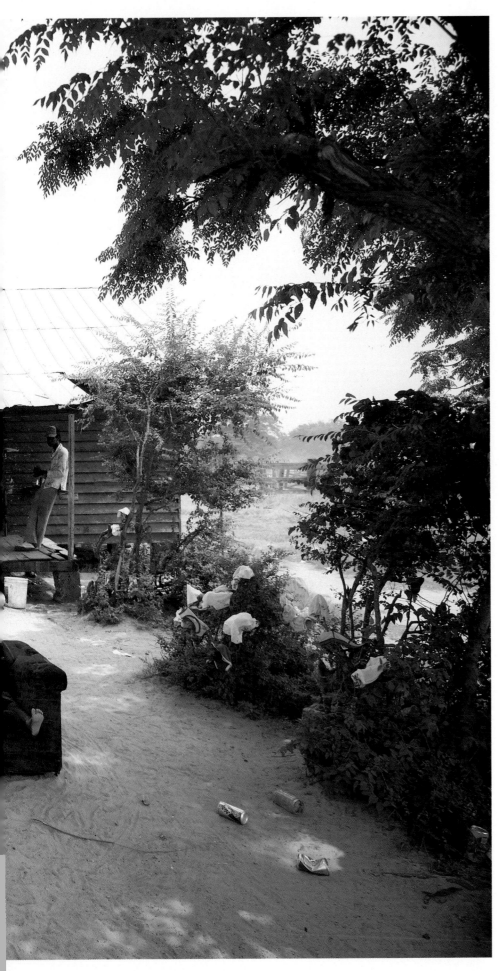

The Gaines live in this three-room house that's adjacent to the Westover Plantation, where Mr. Gaines works in the cotton fields. It was wash day—laundry on the bushes, tubs on the porch. In 107-degree heat, it was unbearable inside their tin-roofed house.

They didn't ask a single question about the oddity of some guy driving up with a red velvet couch. They had the washing done, so they just went along with it. I gave them twenty-five dollars when I left.

IDA GAINES AND FAMILY
EUFALA, ALABAMA

Behind these deans of Tuskegee Institute is a statue of Booker T. Washington, who is lifting the veil of ignorance from a black field hand. I spent several days in Macon County, where 85% of the population is black. It was the first time in my life I felt what it was like to be from a minority race. That's another kind of veil.

VASCAR HARRIS, OLLIE WILLIAMSON, BENJAMIN PAYTON, AND ROSETTA SANDS
TUSKEGEE, ALABAMA

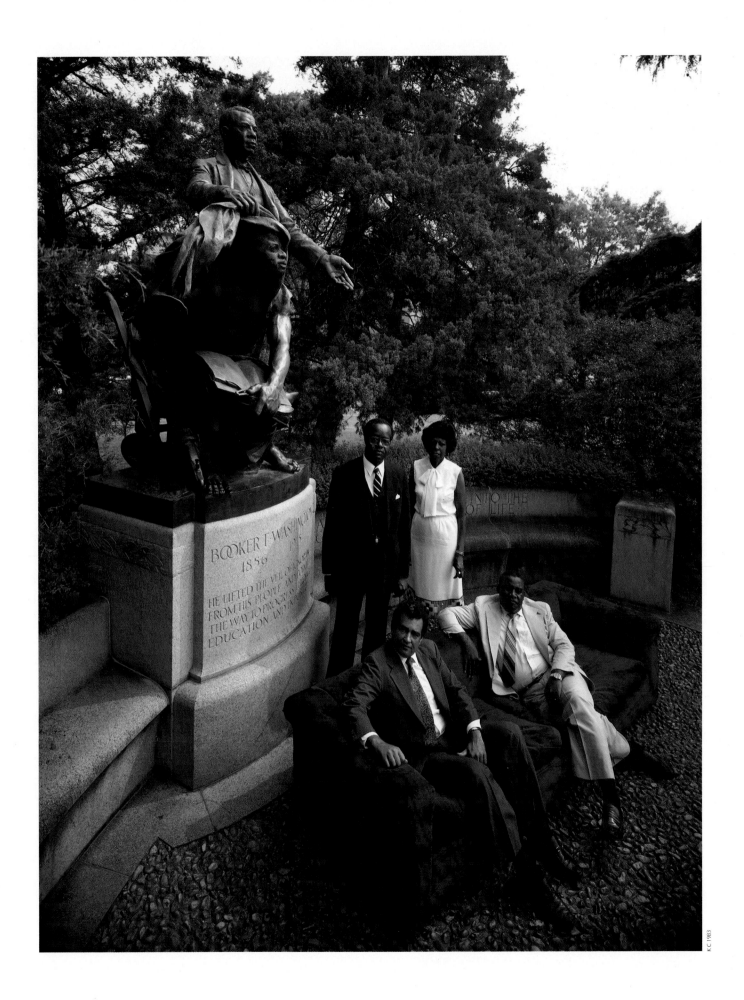

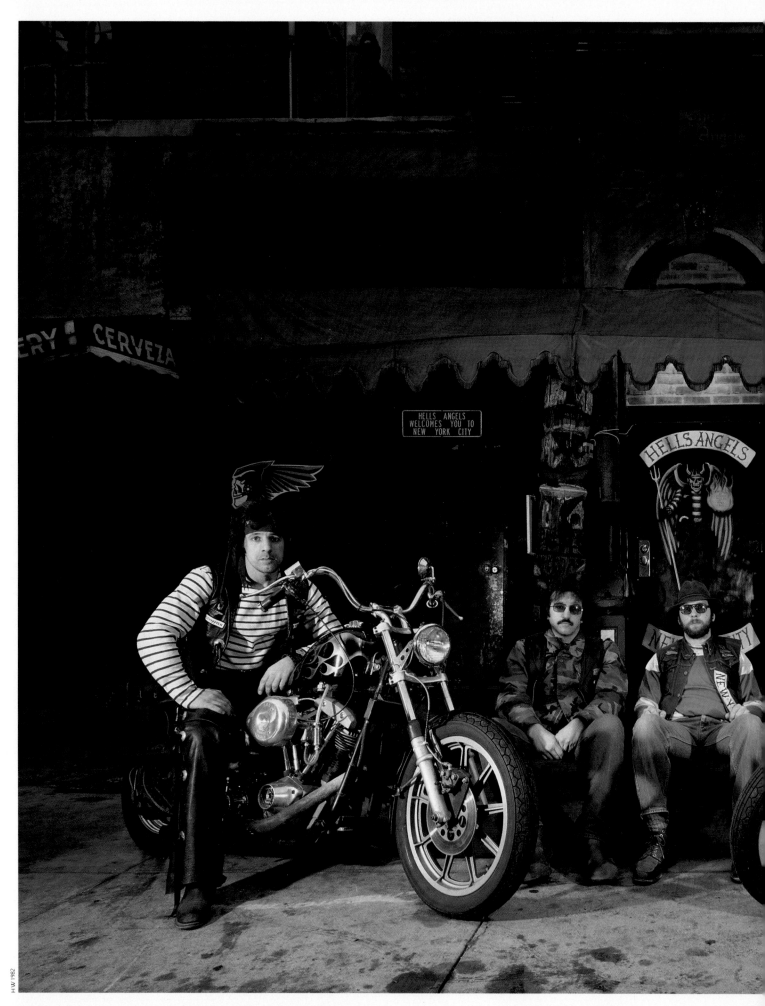

The bureaucratic maneuvers we had to go through to get this picture were equal to anything the federal government put in front of us. We had advance meetings, calls from corner phone booths, presentations to make, possible payment to them. We even had to sign an agreement on how we would use the photograph. The bikers were friendly, but there was no kidding around.

I wanted to shoot them on a highway, but they said only in front of their Eastern Section headquarters. They agreed to just one composition. During the session, each man demanded a look through the view camera—they were nervous to see they were upside down.

The couch and their motorcycles blocked the sidewalk. After two exposures, a black man came along and said to them, "Do you own Third Street?" One Angel got up and said, "We'll show him who owns Third Street." One of them knocked the man down and kicked him. I asked why this must be. One said, "Do you have niggers in Germany?" The man got up slowly and staggered away. Later, an elderly white lady came along. They ran to help her cross the street. All of it was done to impress me. They told me if I ever misuse the photograph, they will come and cut off my shutter finger.

HELL'S ANGELS
NEW YORK CITY

K.C. 1983

On the couch is Dana Beal, president of the Youth International Party; Bruce Anderson, lobbyist against marijuana laws; and Aron Kay, who made a name throwing pies in celebrities' faces. This was the most undisciplined, uncontrollable group I photographed. Mr. Anderson points a toy pistol at the photographer, the authority figure here. Around the upside-down flag and the banner with the black star of anarchy, the crowd members all turn in different directions.

YIPPIE ROCK AGAINST RACISM RALLY
WASHINGTON, D.C.

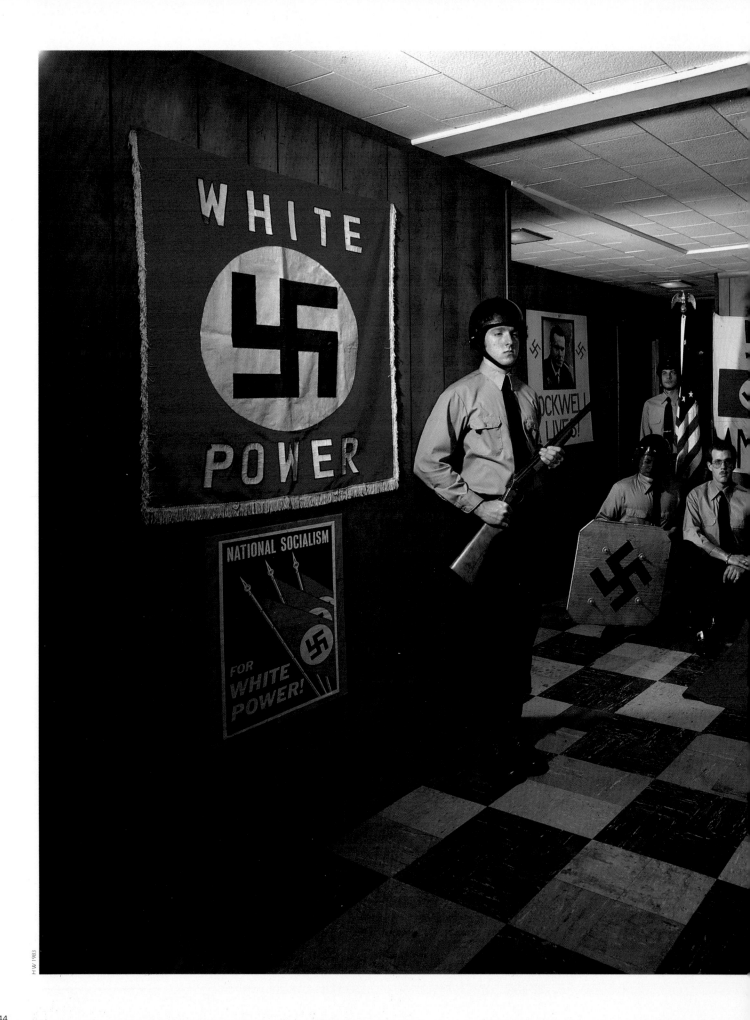

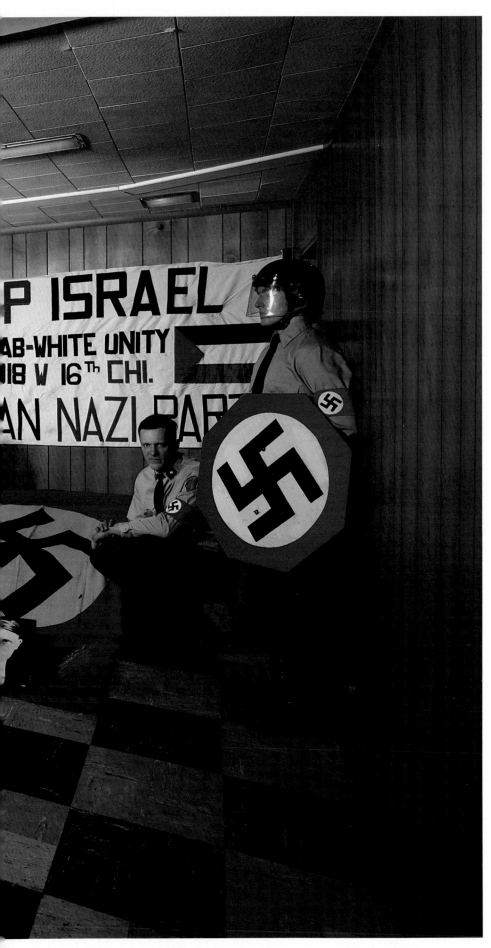

After a ten-day search, we finally were able to meet Major Milam in a boarded-up auto-parts shop. He never gave his first name. After very tense negotiations, the so-called major agreed to a photograph of his group on neutral ground—a sympathizer's house. During these negotiations I was careful to show only couch photos they would like: the space shuttle, the bear hunter, the aircraft carrier. It helped that I'm German because they assumed certain things.

Always, my question is how to deal with people like this. I'm an antifascist. It would be slimy and dishonest to tell them I'm a supporter. So I tried to speak as little as possible. I only asked questions.

At the shooting session, Mr. Milam made things easier by talking rat-a-tat-tat about his doctrine. During the video interview, he said, "When things get bad enough, when crime gets bad in the streets, when immoral conduct becomes commonplace, when American soldiers are off to fight in Jewish wars, this will be a situation where we'll find the opportune moment to take political power. America will get so bad off that the people will ask us to come in and change things, because we stand for order and what's proper."

He made it clear that his new order does not include blacks, Hispanics, orientals, Indians, Jews, or anyone of any background with differing views. During the shoot, he controlled the subject matter and composition completely. If any camera pointed away from him on the couch, he would ask what we were photographing. He demanded to see Polaroids as we worked.

Except for Mr. Milam, the other members were so young their complexions had not even cleared. The boy beside the flag had to have his blue jeans hidden. I asked why. Mr. Milam said, "The name Levi Strauss should explain it all."

When the session was over and I was on the street, I kept feeling I had just dreamed it all.

AMERICAN NAZI PARTY MEMBERS
CICERO, ILLINOIS

145

The people of this Hindu religious community go to this stack of hay bales every sunset to pray. They bow and bow, as the slow shutter speed shows. The blur also suggests the active way they have transformed a used-up farm into productive land in just a few years. They use some interesting methods in farming, like the big emu birds they keep with their chicken flocks to scare away coyotes.

BHAGWAN SHREE RASHNEESH SANYASSINS
RASHNEESH PURAM, OREGON

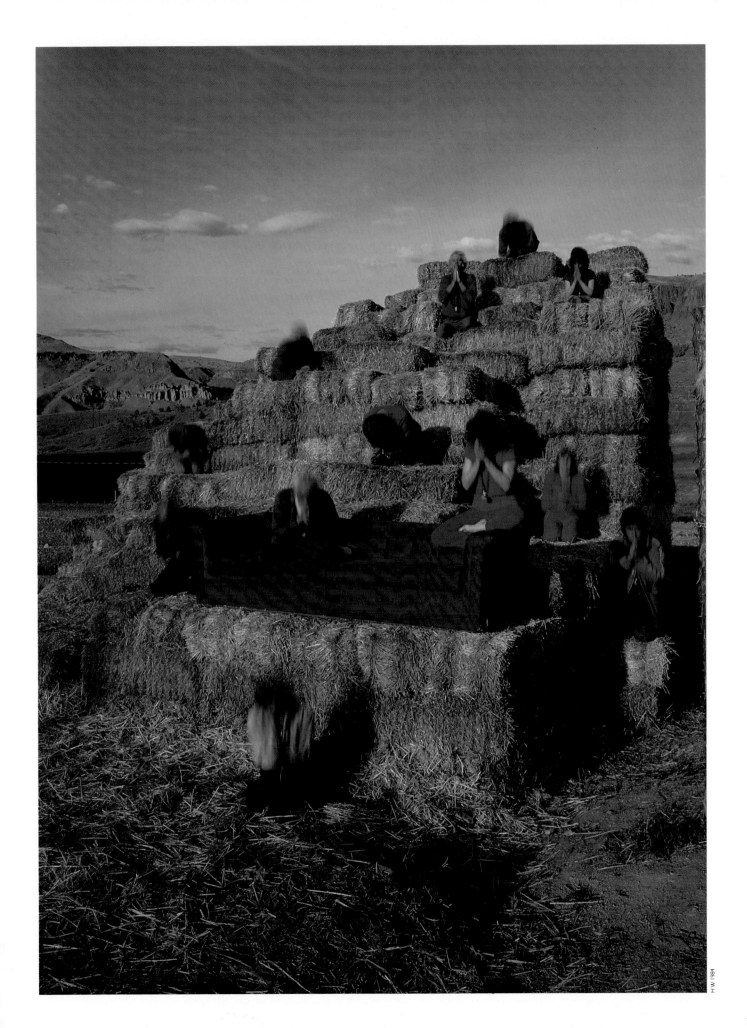

Touro Synagogue was founded in 1763 by Portuguese immigrants. It's the oldest synagogue in the United States. I chose a high angle, almost a celestial point of view. To keep the couch from intruding on the quiet and classic lines of the temple, I asked Rabbi Lewis to lay his tallis over the cushions. It fit precisely—just like the couch between the railings of the bima.

I photographed on the day a stamp commemorating a visit to the synagogue by George Washington was issued. In 1782 he thanked the congregation for their help during the war. He also promised that the new government would give "to bigotry no sanction, to persecution no assistance."

RABBI THEODORE LEWIS
NEWPORT, RHODE ISLAND

149

These state DAR members are in front of Rosalie, an 1820 mansion on the east bank of the Mississippi River. It was the home of a cotton merchant. The members wanted to know why they had to sit on my old couch when they had an even older red sofa inside. "Ours is so much more beautiful," one said.

DAUGHTERS OF THE AMERICAN REVOLUTION
NATCHEZ, MISSISSIPPI

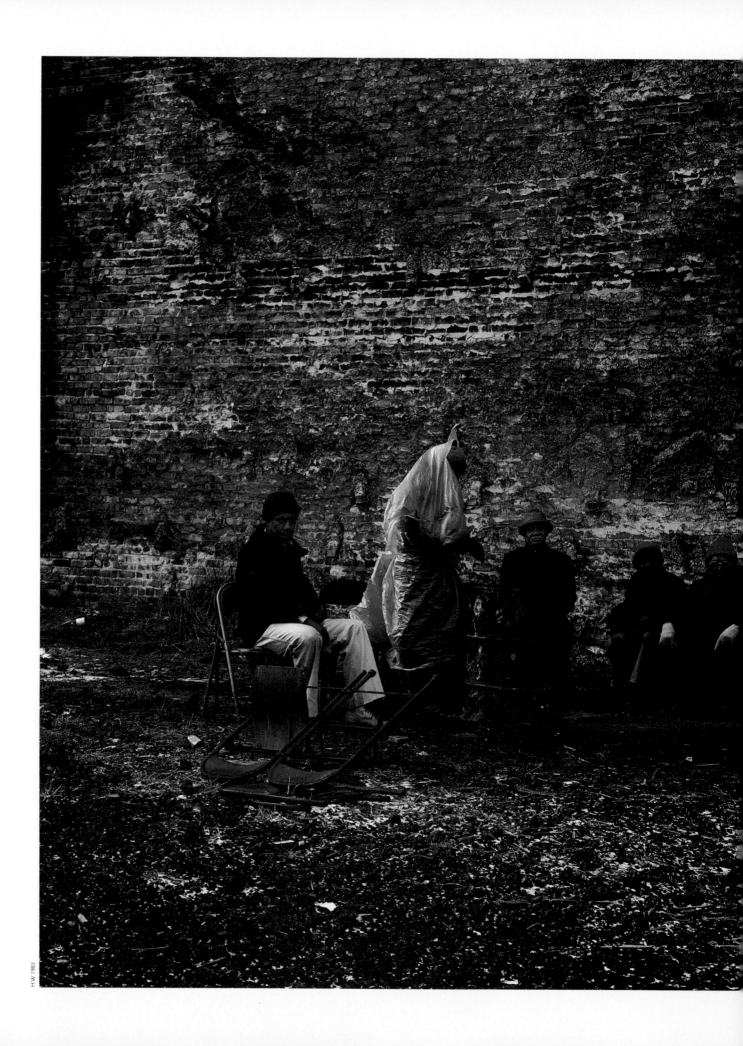

My girlfriend, Hedy, saw these workless men in their red stocking caps against the brick wall and told me to take their picture. She knows brick walls are always photogenic. I didn't want to.

The men received the caps from a church charity. We gave each man four dollars. The one nearest the fire barrel is wrapped in plastic for warmth, but no one complained about conditions. They even said Reagan was a great guy. The idea of going from dishwasher to millionaire is so strong in America, even the down-and-out believe it.

UNEMPLOYED MEN
CHICAGO, ILLINOIS

153

These jewels are a part of Miss Powell's collection of historical and European court jewelry. The security guards are around when the collection is on display. They were her idea, but her pose was my idea.

Miss Powell is a descendant of John Wesley Powell, the white explorer of the Colorado River. She lives in the former Harold Lloyd mansion, which she saved from developers and then restored. Now she uses it to raise funds for various civic and political groups. Thirty thousand people have been entertained there in four years. She believes there is no shortage of patrons for restoring old master paintings, but very few people who will underwrite the rescue of landmark architecture.

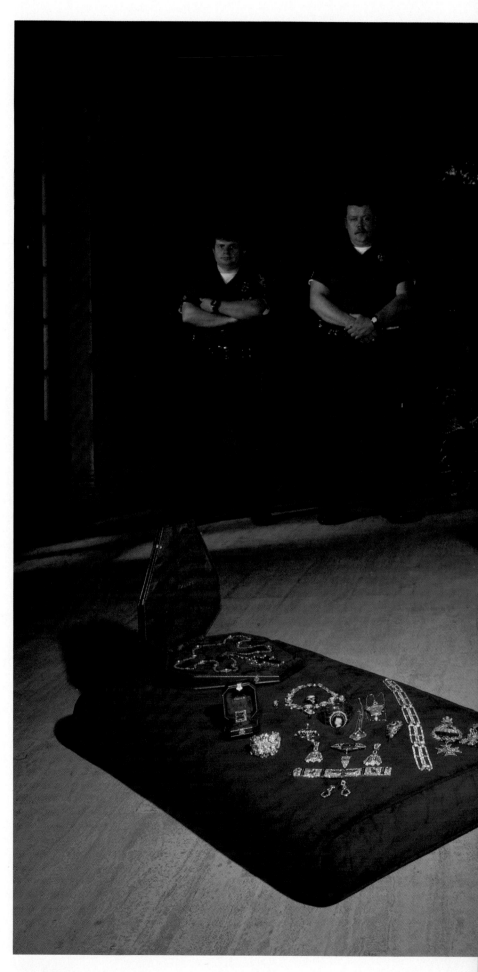

DONA POWELL
BEVERLY HILLS, CALIFORNIA

154

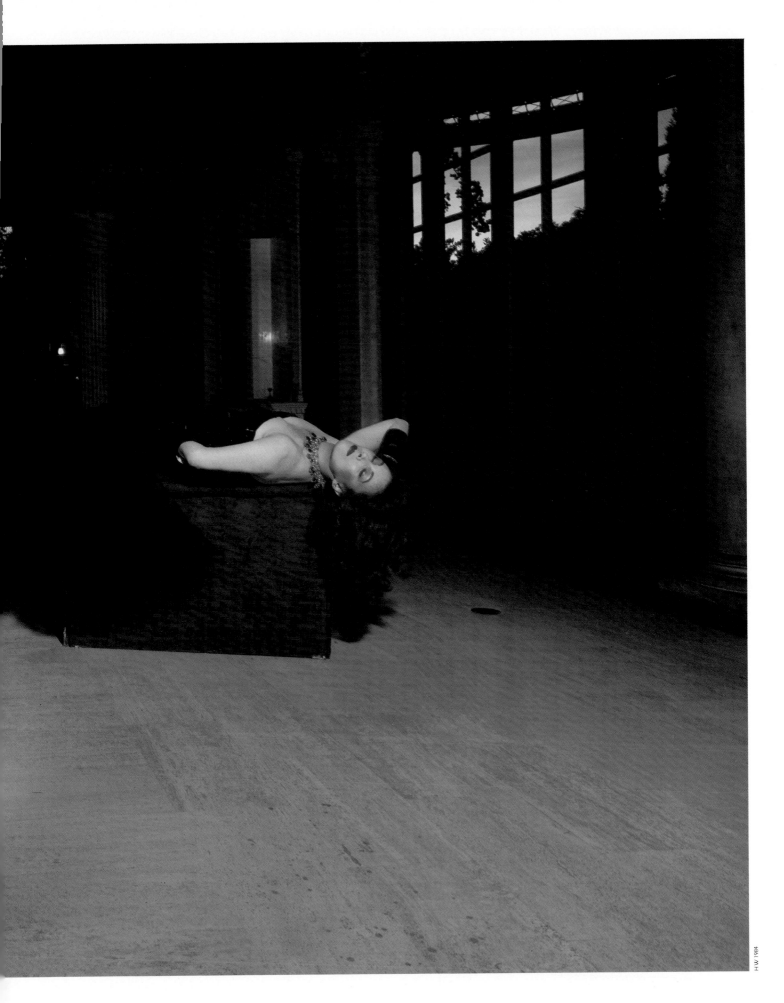

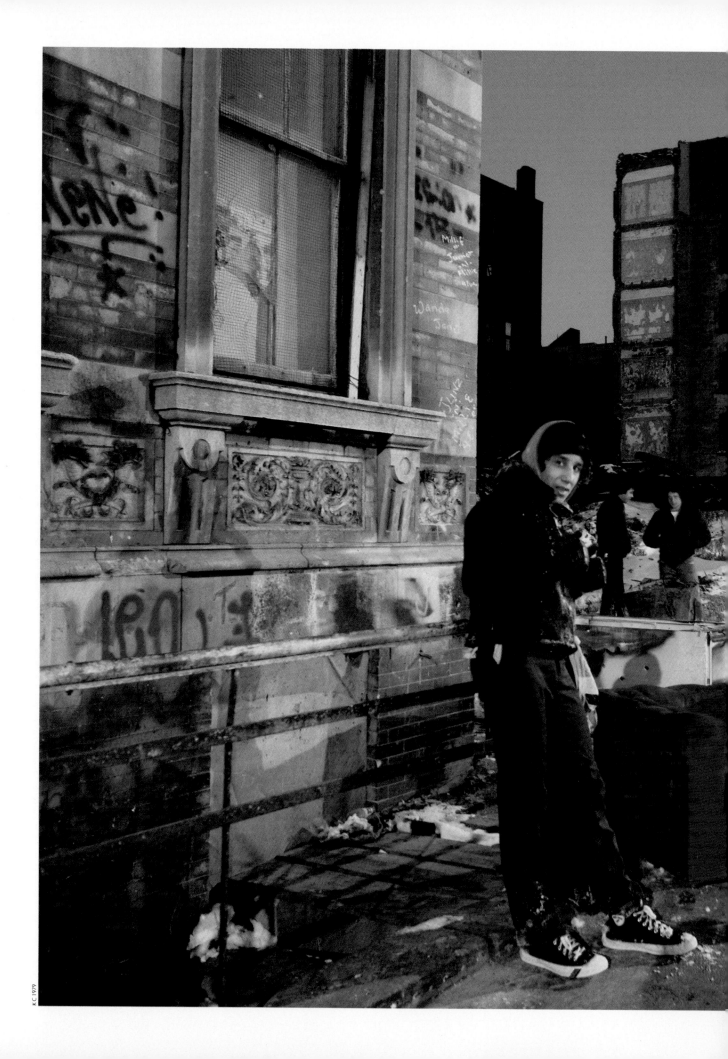

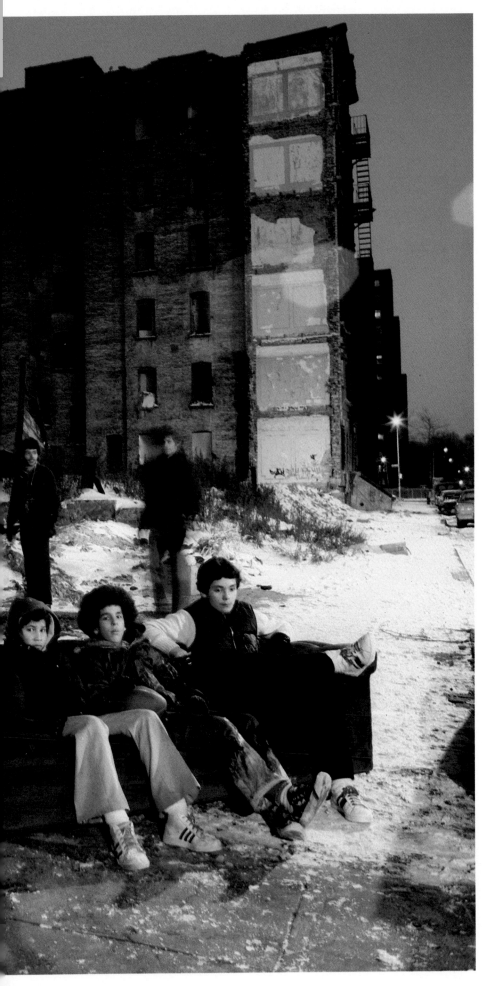

At dusk I drove up and interrupted the touch football game of these Puerto Rican Americans on the Lower East Side. The buildings are condemned, and the area has lots of drug dealing. Like most Manhattanites, these boys had a well-developed media sense—they wanted to sit on the couch so they could appear in a magazine.

TEENAGERS OF ALPHABET CITY
NEW YORK CITY

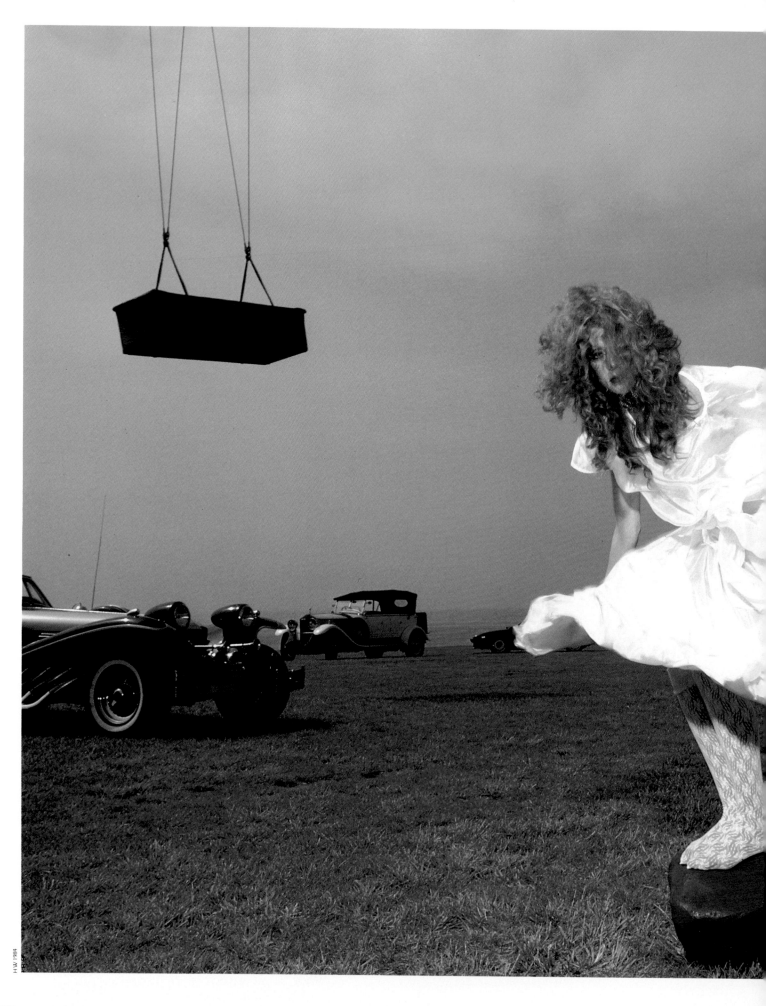

M iss Mirkin is the wealthy daughter of the founder of Budget car rental, and she has added two new divisions—Drive-a-Dream, which rents rare and classic cars, and Budget Helicopter Charters. We couldn't have afforded this picture without her backing.

She said in an interview that she has a lot of beautiful props in her life but that she doesn't take any of them seriously. After she saw my pictures, she wrote me an interesting letter about my ideas:

"Dear Horst, this story is a multidimensional, life-style piece that truly captures the Golden Era of Hollywood. I am confident we share the same visions. With your strong visual sense of aesthetics I am positive we can get the public to see the story in all of its color, glamor, and glory. Specifically I want to incorporate the most ultimate fashion accessory of all—cars—with totally high fashion clothes, denoting the feeling of Hollywood's most glamorous essence. It would be a grand marriage and when the aesthetics are achieved, we will have created an incredible life-style, personality, high fashion piece that could be sold to *Vogue, Harper's Bazaar, Official, Paris Match*, etc.

I believe in the salability of the story: it is my story, my heritage, my business world.

The stage is set in Hollywood, Beverly Hills, the tantamount glamor capital of the world.

It has a mystique that cannot be duplicated. It has a magical essence people never tire of. It is a natural.
It is Timeless.

Let us develop a story that has been waiting to happen."

MARGAUX MIRKIN
MALIBU, CALIFORNIA

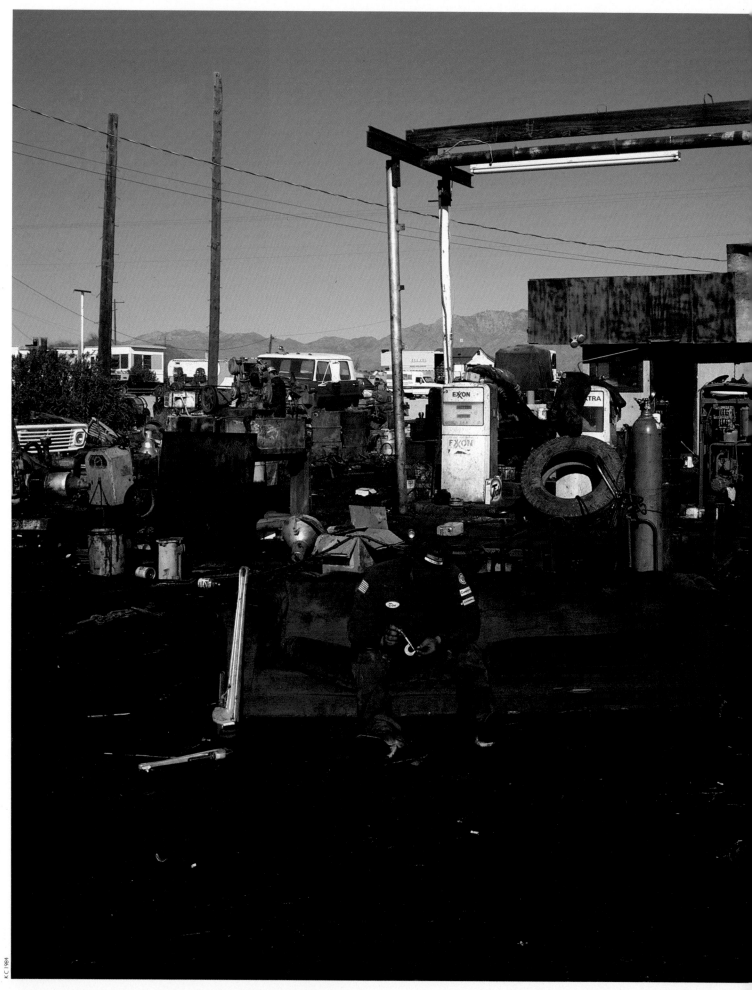

When I drove up with the couch to this diesel repair shop along Interstate 40, Mr. Farrell, the chief mechanic, said, "So you're the guy with the red couch!" He'd bought the red couch issue of *Life* magazine in the grocery store, the only issue he'd bought in years. Every so often arrangements to photograph were easy.

DON FARRELL AND MECHANICS
YUCCA, ARIZONA

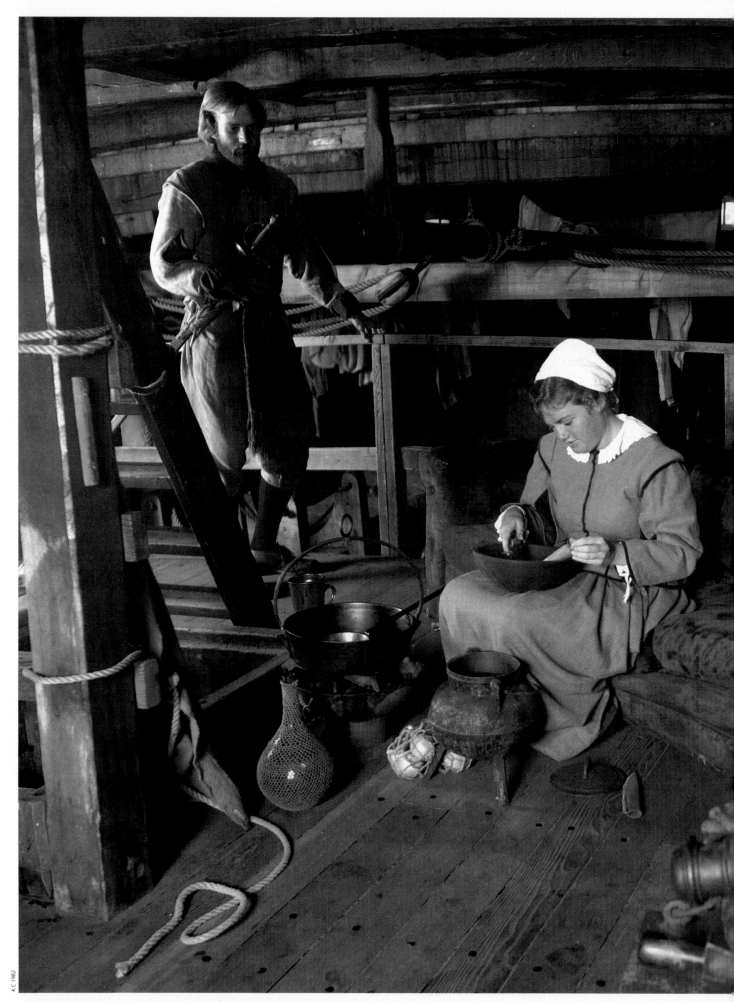

K C 1982

The two people are historical interpreters who work on board the *Mayflower II,* which is part of the living museum at Plimoth Plantation. This full-scale replica retraced the Pilgrim's 1620 route in 1957. I was looking for an incongruity or an irony.

STEVE KOCUR AND MARY JANE CALHOUN
PLYMOUTH HARBOR, MASSACHUSETTS

From start to finish, this photograph is a compromise. I began by asking for permission to shoot the couch on the flight deck during flight operations at sea. Request denied. So I ended up in port, asking the Navy to lend me a globe. As a symbol, it saves the picture.

CAPTAIN RAYMOND P. ILG AND THE USS NIMITZ
NORFOLK, VIRGINIA

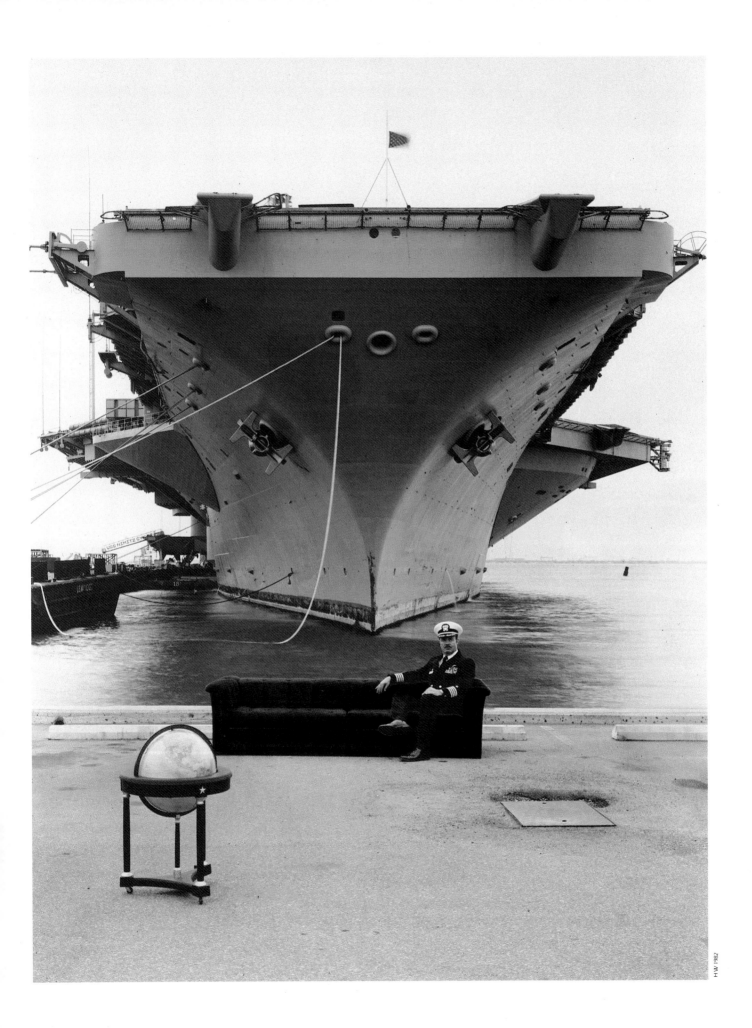

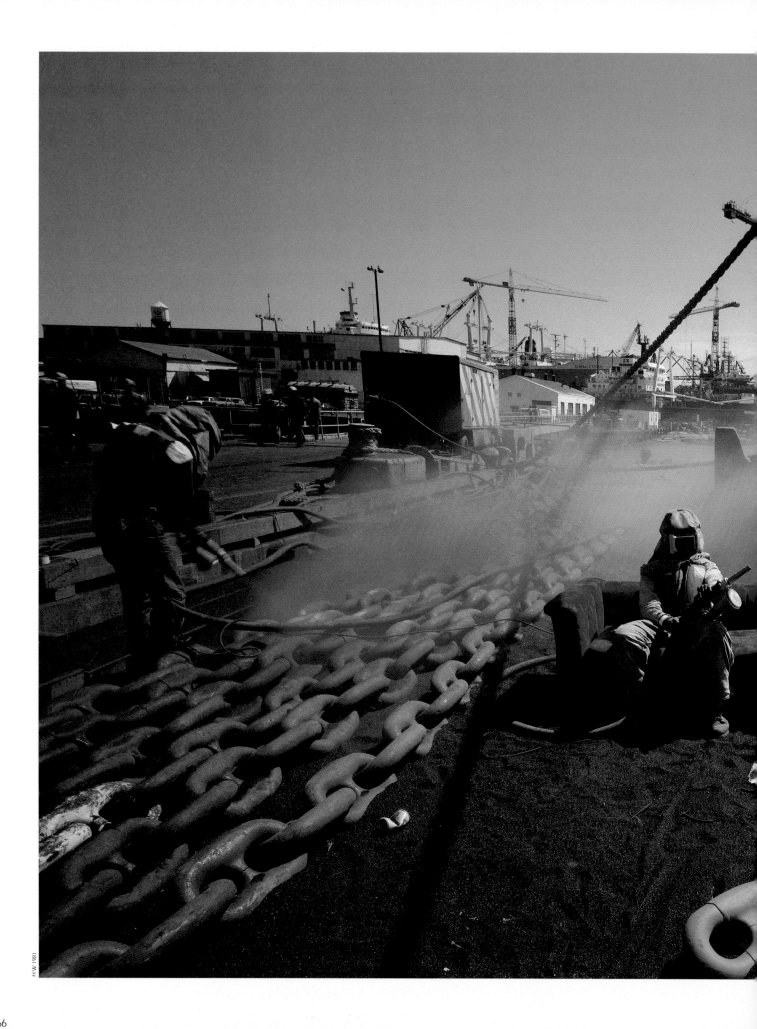

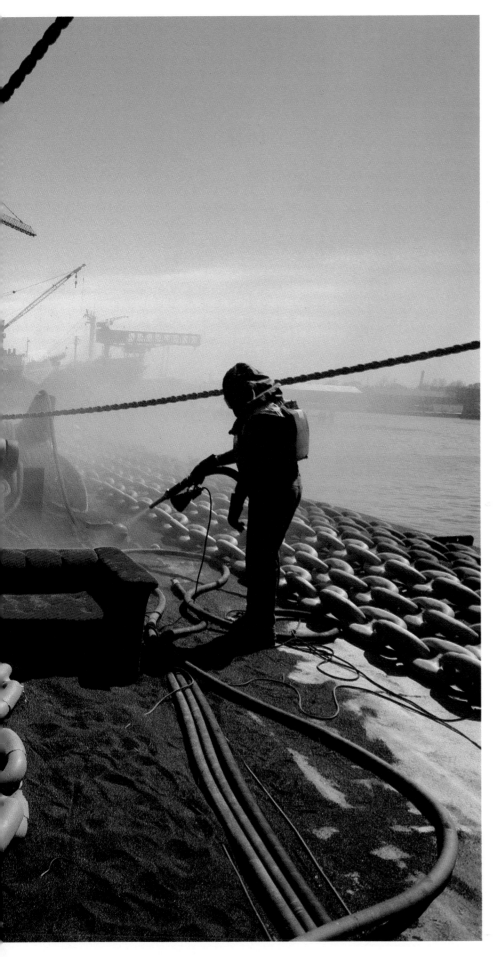

These men were cleaning anchors and anchor chains from the USS Detroit, a supply ship. The blasting hoses can cut a foot off. When we finished shooting, our equipment had almost as much sand in it as the poor couch. This was one of the few action pictures of the couch that I liked.

SANDBLASTERS
NORFOLK, VIRGINIA

General Tibbets—he's retired—was more than just the pilot of the B-29 that dropped the atomic bomb on Hiroshima in 1945. He helped develop the flight techniques that made the aerial bombardment successful. Until his flight, no atomic weapon had ever been dropped from an airplane.

I had the five-by-seven-foot photograph of the explosion specially made from the Associated Press original. It cost five hundred dollars, and I was afraid it might make him uneasy, but you can see from his expression that he's at ease. Later, in our video interview, he told me that General Fushiyada, the Japanese officer who led the attack on Pearl Harbor, told him that the people of Japan at that time were so fanatical they would have fought an invasion to the last child throwing stones. Fushiyada was a guest in Mr. Tibbets's home, and he told him, "You did what had to be done. You saved many lives an invasion would have taken. The Japanese understand this better than the Americans." General Tibbets takes satisfaction in his role in history. That's why he named his plane *Enola Gay,* after his mother.

PAUL TIBBETS
COLUMBUS, OHIO

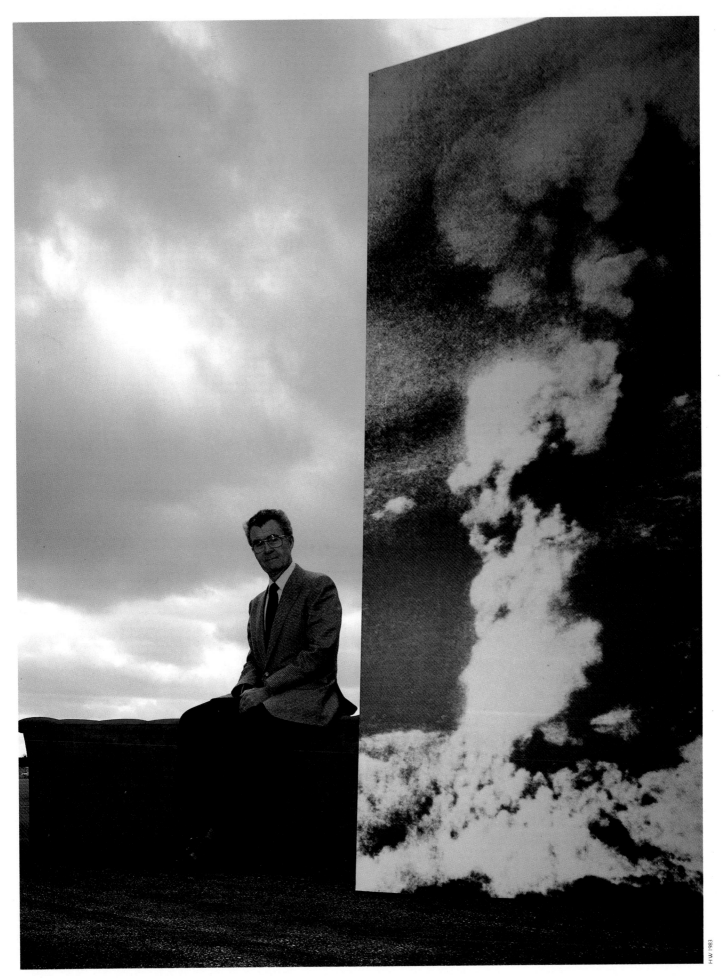

The Whittocks lived in the house closest to Three-Mile Island when the nuclear plant cracked in 1979. Mr. Whittock was the only one at home when it happened. He heard a loud noise in the night, immediately gathered up his deeds and documents, photographs, the dog and cat, and a shotgun and pistol, and then drove to his office.

I wanted the eerie light of a winter sunset and a tree glowing from a strobe flash. Behind, the four cooling towers also seem to glow. I wanted everything along the Susquehanna River to look threatening to these three generations of a nuclear family.

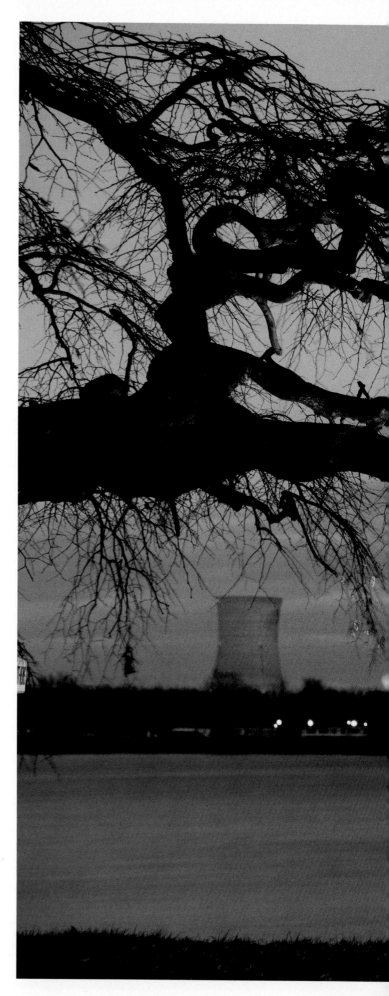

THE WILLIAM WHITTOCK FAMILY
GOLDSBOROUGH, PENNSYLVANIA

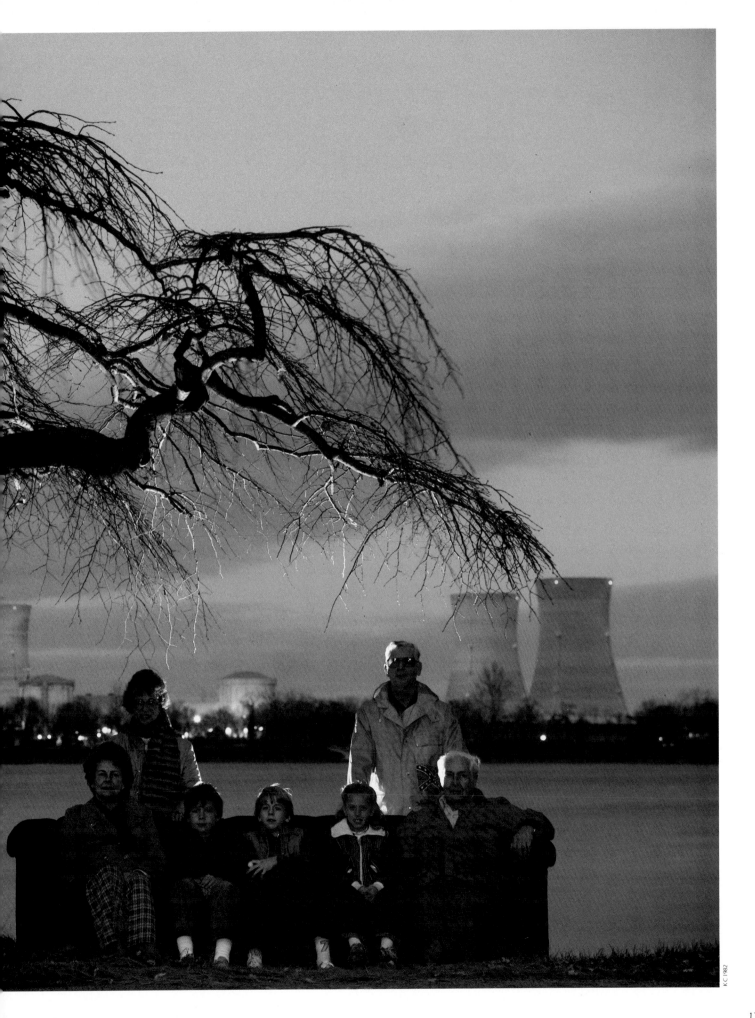

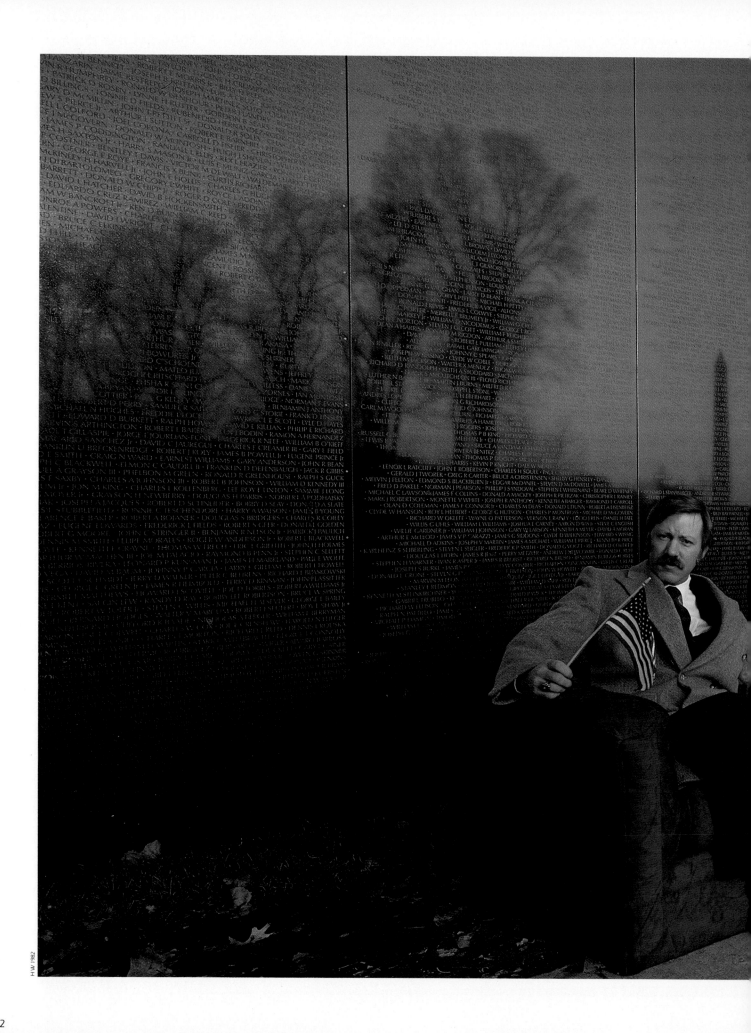

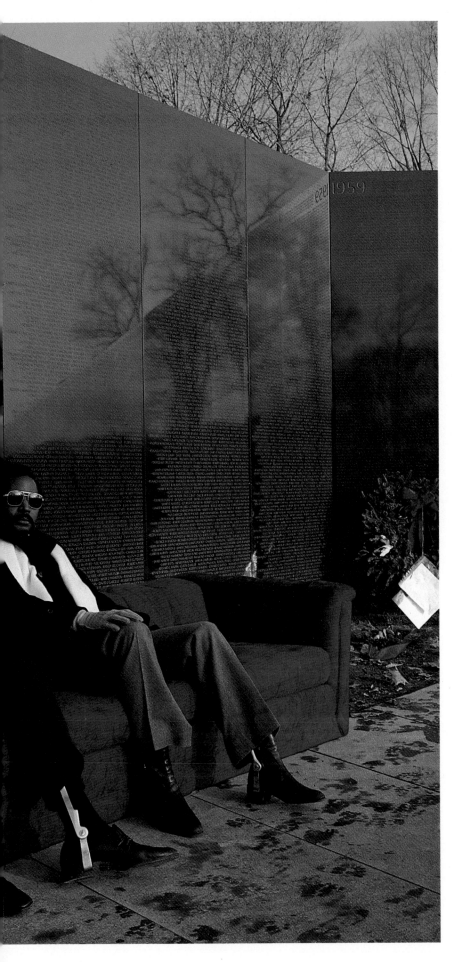

This is the one photograph I would not do again. It is on the edge of going too far, even though the headquarters of the Disabled American Veterans supported our idea at the time the National Park Service opposed it. The NPS allowed it only when they found nothing in their rules about couches on park property.

We photographed early in the morning so we wouldn't disturb visitors who come to find a special name. The two disabled veterans posed themselves, but the flag was my idea. They didn't like it, and maybe I shouldn't have used it. Maybe it's too literal. Other icons in the picture work better—the Christmas wreath, which was there, that unites with the red couch and makes the two men a kind of living memorial wreath. And there are the reflections of bare trees and a rising sun and the Washington Memorial. Americans consider George Washington the father of their country, but they see Vietnam veterans as stepsons.

When we were taking the last picture, an enraged vet came up with a pistol and screamed at us to take the couch away or he would kill us. I was very scared. He was waving the gun around. When we carried the couch away, we kept dropping it, and he was shouting he was going to blow us away and then go to court to stop publication of the picture.

ANTHONY BASKERVILLE AND JAMES COMBS
WASHINGTON, DC

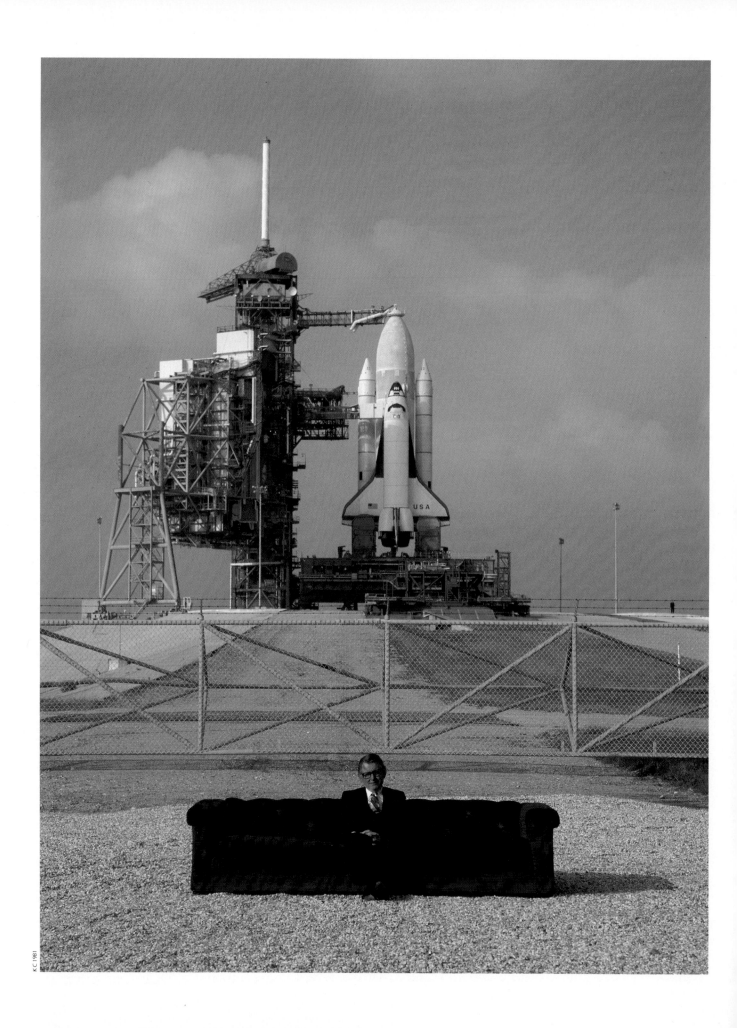

I first thought about taking a photograph of the *Columbia II* the day before the scheduled launch, but I knew I didn't have enough time. Then the launch was delayed for two weeks, so I decided to try for it. I spent three solid days on the phone arranging for the picture. I finally got permission for a brief photo session, but I had to be in Cape Canaveral in twenty-six hours. Despite the time pressure, when I got there, I waited another forty-five minutes, until I could catch the afternoon sunlight on the nose of the booster.

L. MICHAEL WEEKS
CAPE CANAVERAL, FLORIDA

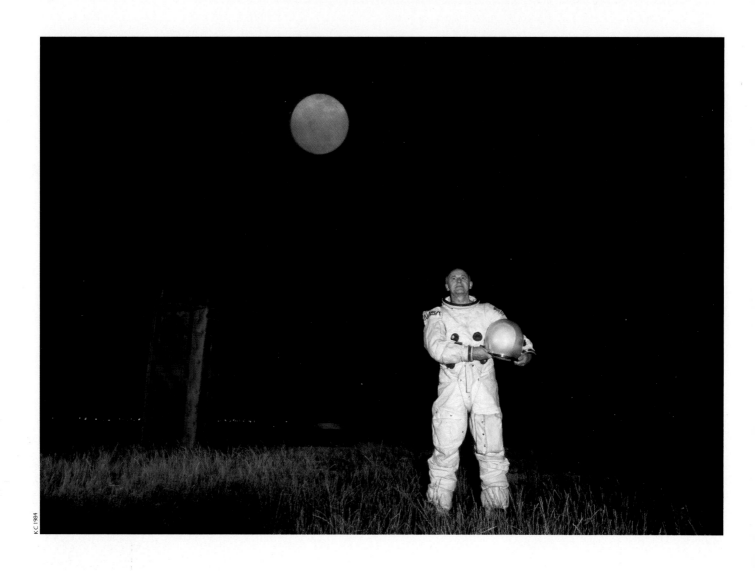

K.C. 1984

Astronaut Alan Bean was the module pilot of the Apollo Twelve mission, the second lunar landing. He was the fourth man to walk on the moon. He retired early to paint what he encountered, things only a half dozen other humans have ever seen. In the manner of *2001*, the couch is a monolith, a sign of a new beginning. Mr. Bean pointed out that the first three men on the moon were Armstrong, Aldrin, and Collins— names starting with A, A, and C: Adam, Abel, and Cain.

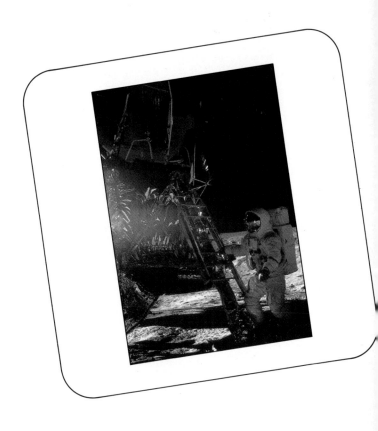

ALAN BEAN
HOUSTON, TEXAS

The Oglala Lakota medicine man used to hunt the Badlands with a bow and arrow. Now times are hard for him. We gave him fifty dollars, but I turned down his offer to trade my expensive Claude Montana leather jacket for his plastic coat. Between photographs Hedy, my girlfriend, hugged him to keep him warm. When she was off camera, he could only clasp his hands in the wind.

I wanted the mountain to parallel the chief's face. This picture is a study of erosion, and the big view camera is good for recording it because a person has to hold still for the long exposures that turn people into monuments.

The mountain looks barren, the land looks lifeless, and the old chief is so uncomfortable and alone. When I asked him in a video interview how he saw the future, he said through his interpreter, "All is lost."

FRANK FOOL'S CROW
SOUTH DAKOTA BADLANDS

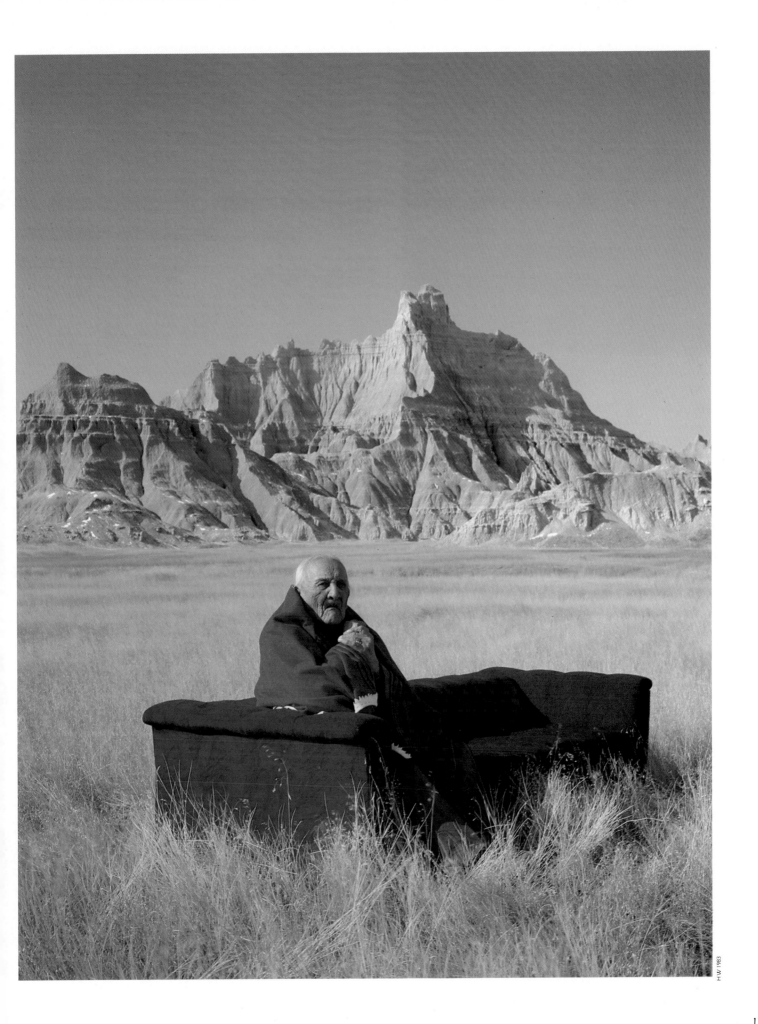

179

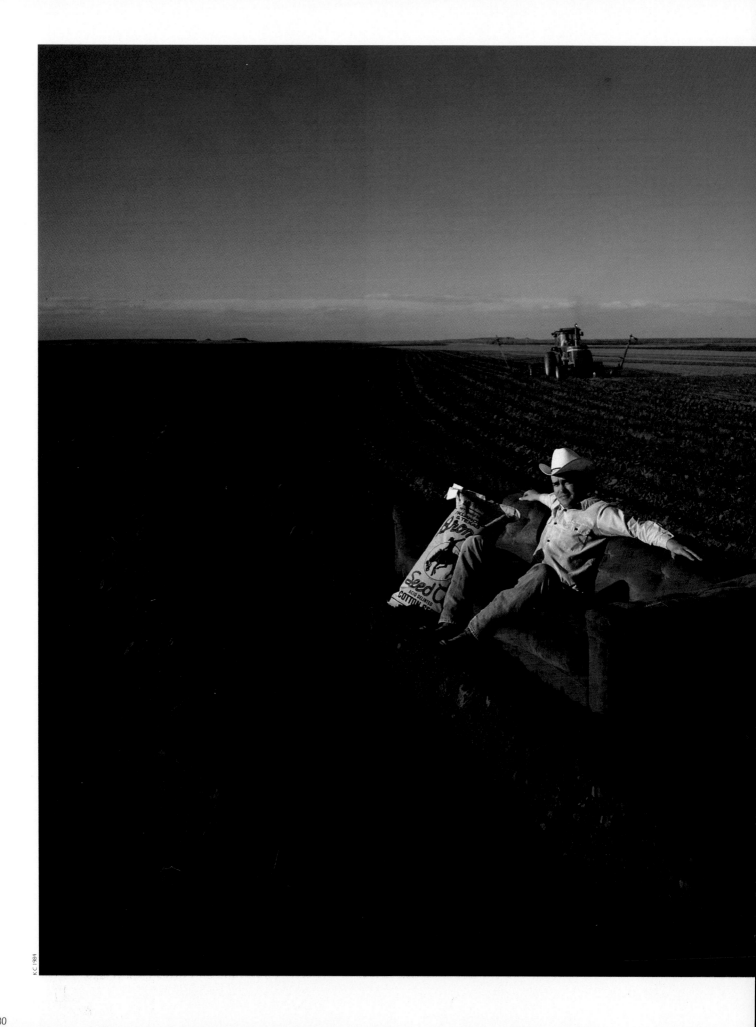

Driving through the cotton region in the Texas Panhandle, I saw these curving lines of orange soil. I wanted a composition as strong and direct as the furrowed land.

DAVID RICHARDS
MEMPHIS, TEXAS

These six Mexicans had just been apprehended that morning near this point on the Rio Grande, known as Crossing Thirty-one. Mexico is the shoreline to the left. The men wear backpacks and carry water jugs because they are prepared to walk two hundred miles into the interior of the United States. Although the three border patrol agents, with help from the helicopter, often arrest criminals at this point, these Mexicans were only unemployed men looking for jobs. Officer Jack Richardson, who's sitting on the couch, said, "Hunting bear ain't nothing compared to hunting man, where you get brains and emotions."

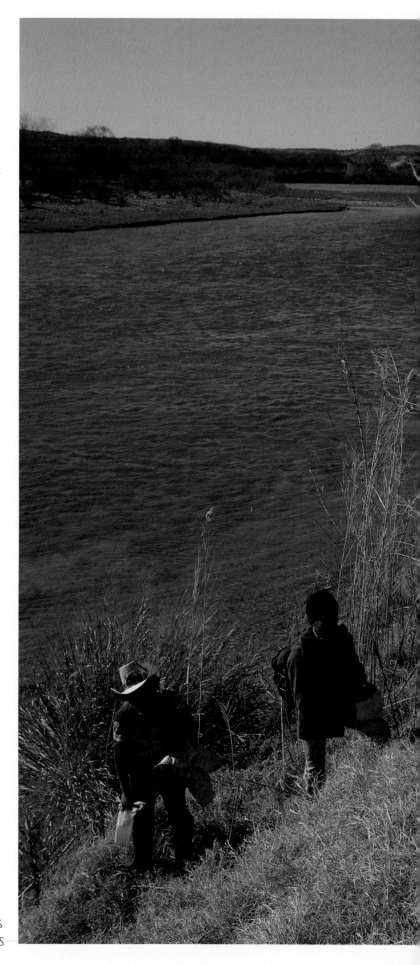

US IMMIGRATION SERVICE BORDER PATROL AND ILLEGAL ALIENS
DEL RIO, TEXAS

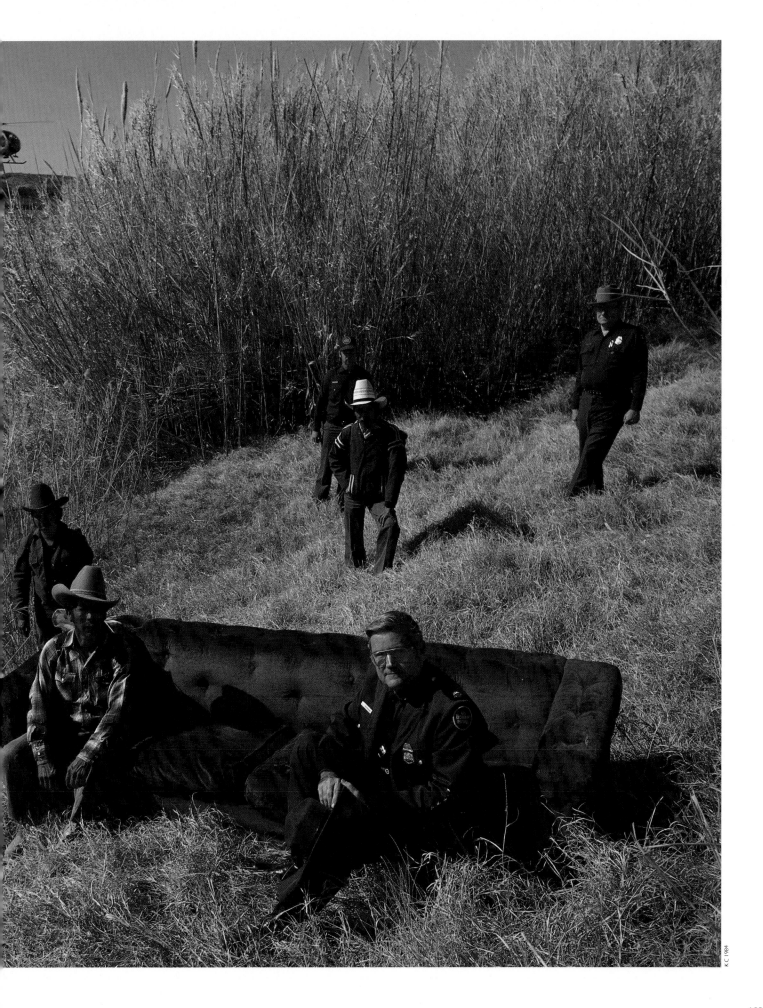

The worker on the couch has been coming from Mexico to the San Joaquin Valley to work the tomato fields for fourteen years. Always, he enters illegally, and he almost never gets caught. He owns a nice house in Mexico. When his foreman, a Mexican-American, came to the fields to see how we were doing, the worker jumped waist deep into the aqueduct to wash off the handle of the shovel for him. It was so feudalistic. Then I understood why so many farms can't survive without the braceros.

UNDOCUMENTED WORKERS
MENDOTA, CALIFORNIA

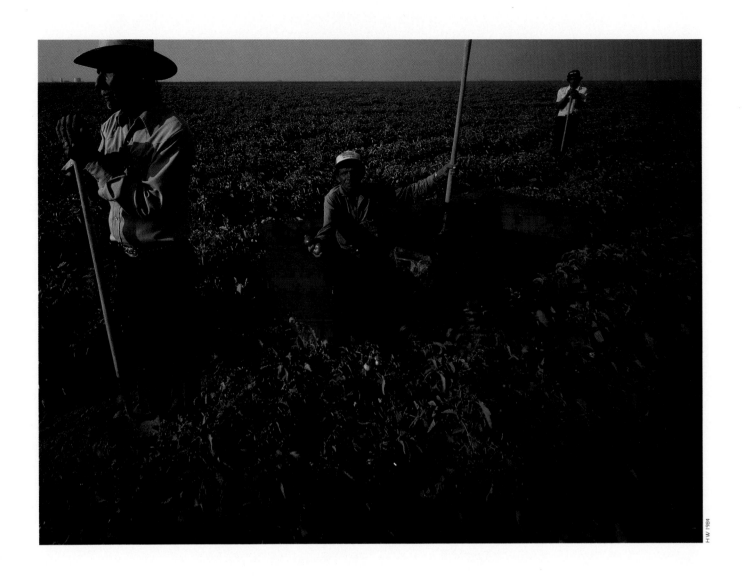

HW 1984

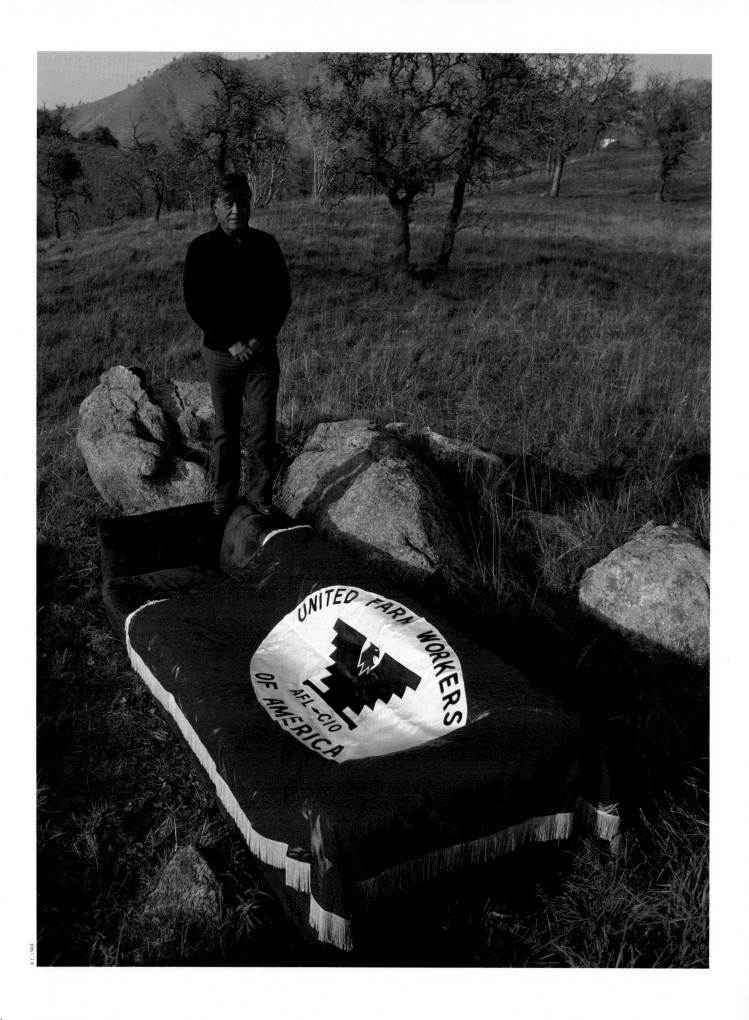

When I got to the headquarters of the United Farm Workers, I found out they were currently boycotting a brand of lettuce called Red Couch. I thought that might be the end of the picture.

I asked the founder of the UFW to stand on the couch because I believe he's transcended many of the cravings of ordinary people—pursuit of material gain, prominence for its own sake. He's not a man given to meaningless stunts. When I left, he gave me a copy of *Cesar Chavez: An Autobiography of La Causa.* On the flyleaf he wrote, "May the red couch be interpreted in the most beneficial way possible to humanity."

CESAR CHAVEZ
KEENE, CALIFORNIA

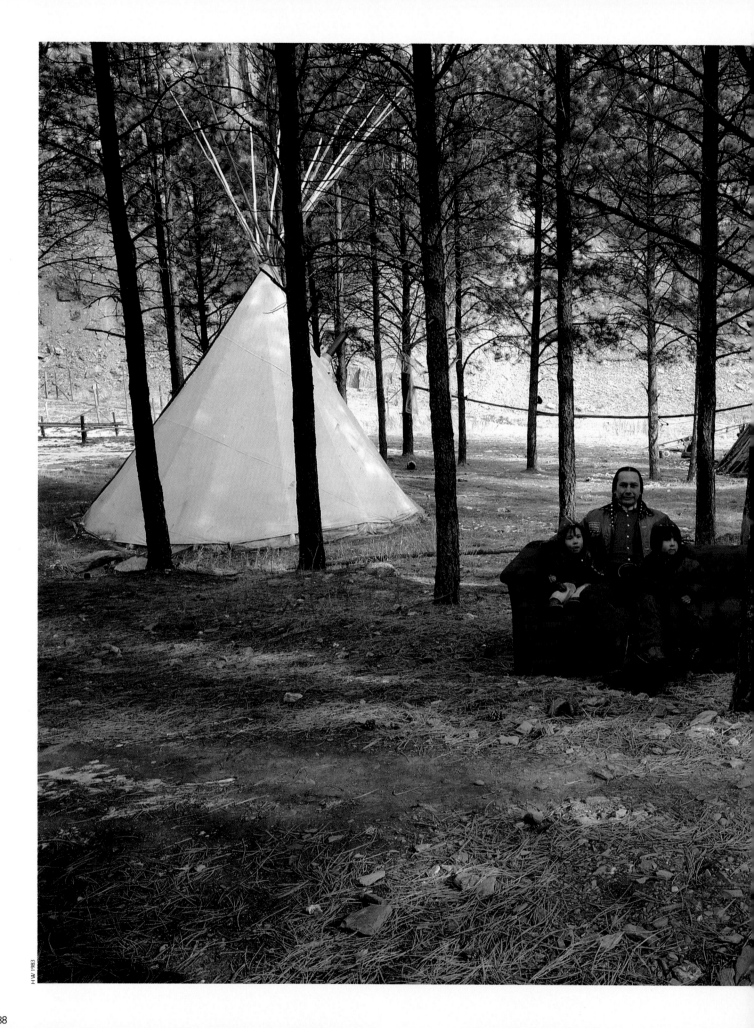

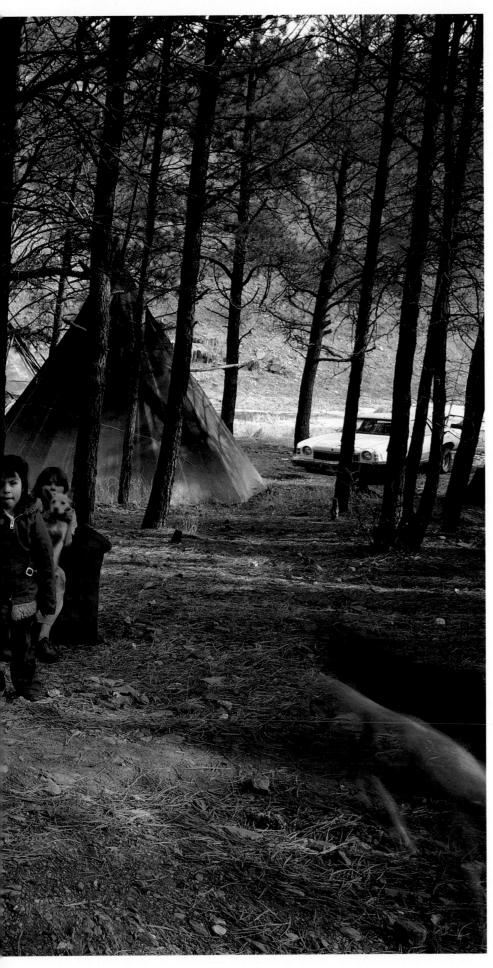

The leader of the American Indian Movement lives near Rapid City on eight hundred acres of government land, which he and other Lakotas (Sioux) hope will be turned over to them. It has been sacred ground to them for hundreds of years. Mr. Means told me that Yellow Thunder represents a revolution—a true *revolving*, where the turn of the circle comes back to a respect for every sacred thing in the land. In our video interview, I asked him how an industrial society could help the camp. He said, "We're on our way to self-sufficiency here. It's industrial society that needs help. In the belly of the monster, we're a small root of the tree of life. We're an alternative to a society that has lost its beginnings."

Once I used the phrase "white people." He said that to the Lakota, the four sacred colors have always been red, white, black, and yellow. He said, "Our allies are those who love the earth."

I wanted just him in the picture, but he insisted on the children. I asked why. He said, "They are the future."

RUSSELL MEANS
CAMP YELLOW THUNDER, SOUTH DAKOTA

*R*everend Jackson's aids had many times refused our project, but when I got a chance to show him in person, he said, "You don't have to sell me." It's usually that way with celebrities—their underlings say no and they say yes.

Secret Service men checked the couch for bombs. Just before he appeared, I got nervous and started fumbling with keys and coins in my pockets. The Secret Service immediately searched me again.

Reverend Jackson was on his way to a victory party just after the polls closed for the California primary. I asked him to stand on the couch to suggest an activist politician. The buttons and stickers place the photograph in time. Maybe they also suggest the promotional circus that American elections are.

JESSE JACKSON
LOS ANGELES, CALIFORNIA

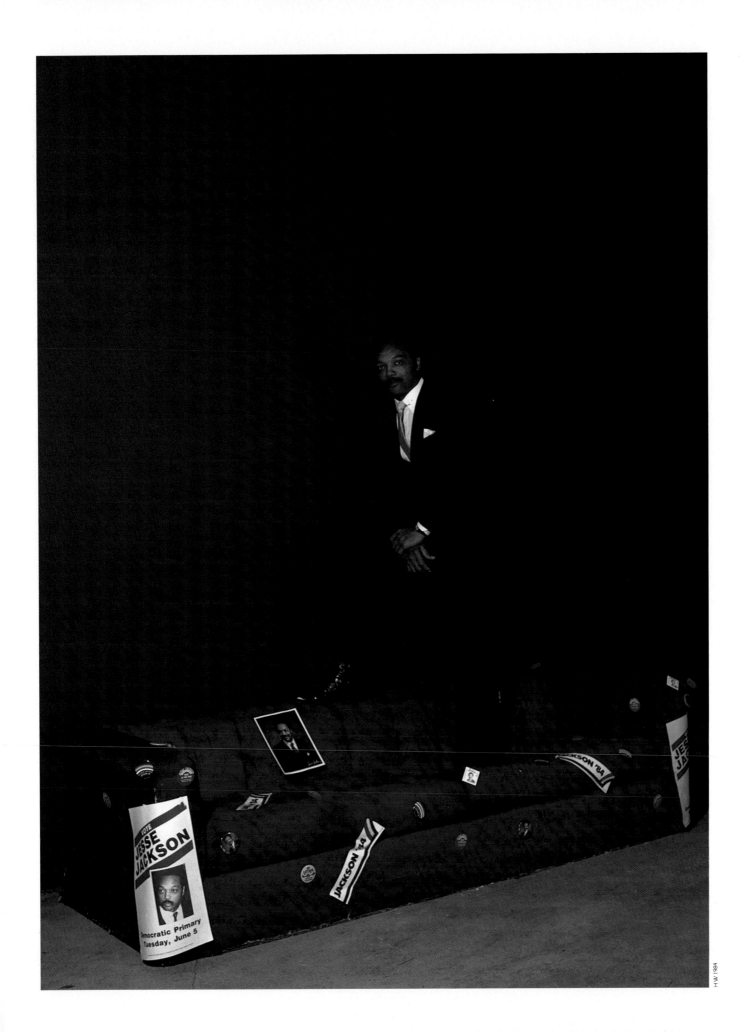

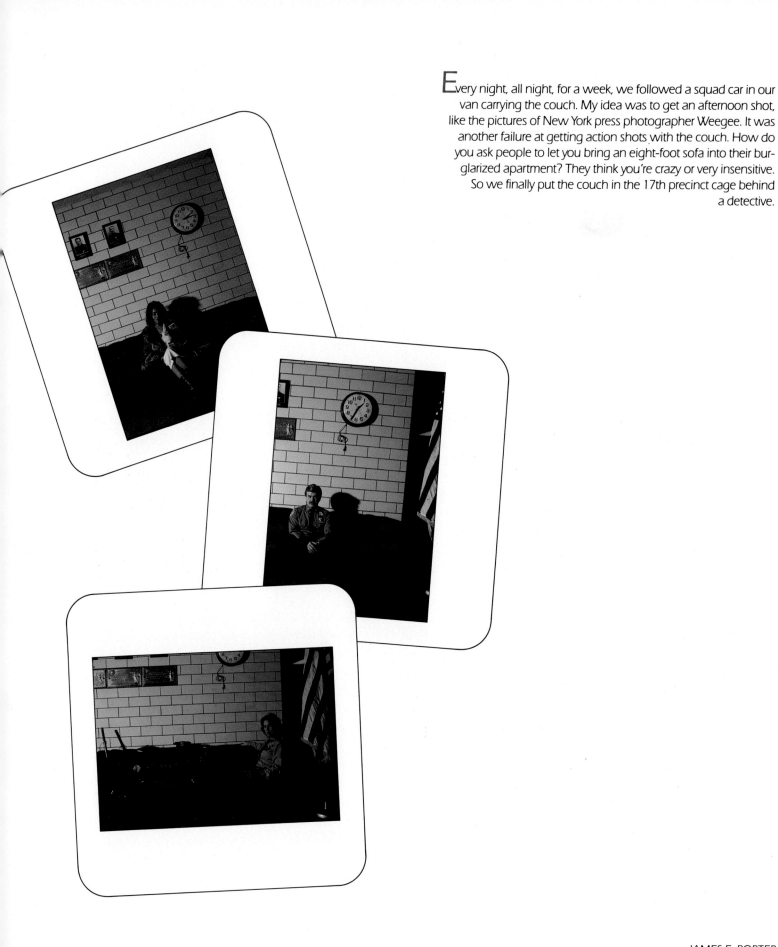

Every night, all night, for a week, we followed a squad car in our van carrying the couch. My idea was to get an afternoon shot, like the pictures of New York press photographer Weegee. It was another failure at getting action shots with the couch. How do you ask people to let you bring an eight-foot sofa into their burglarized apartment? They think you're crazy or very insensitive. So we finally put the couch in the 17th precinct cage behind a detective.

JAMES E. PORTER
NEW YORK CITY

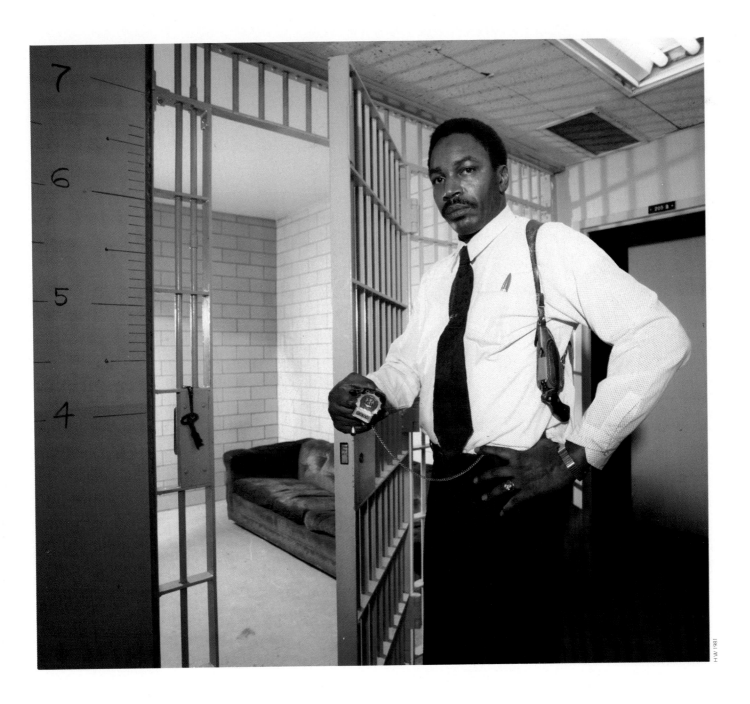

In 1976 Mr. Hughes was convicted of shooting a state trooper who had stopped him on an isolated stretch of highway. Hughes, now known as Execution Number 556, is from Fairhope, Alabama, and was just passing through. He still hasn't made it home. He's been on Death Row at Huntsville State Prison for seven years although he has steadfastly maintained he did not kill the trooper. He has had two stays of execution, one just in the nick of time. To keep his spirits up, he writes other condemned men around the world and draws illustrations for the Louisiana Society for the Prevention of Cruelty to Animals.

When I asked for permission to take his portrait, the warden said, "There's no way you can bring that couch in here—this ain't the free world." So I photographed the couch behind bars as a symbol of what has been denied him and had Mr. Hughes hold up the picture behind the glass and wire window in the visiting room. His only touch with his family in seven years has been from the slight warmth and pressure he can feel on that glass when they press hands against it. He told me, "Things could be worse. I read about people with nothing to eat, sick people, and dying ones."

BILLY GEORGE HUGHES
HUNTSVILLE, TEXAS

The photograph is a forty-second, six-exposure picture on a night of thunder and lightning. I wanted an anthropomorphic presence among the tombs of Lafayette Cemetery. The place was crawling with cockroaches. My assistant lived in the neighborhood and was uneasy about robbers. He said they wait in graveyards. After we left, I found out he had a gun in his pocket, and here I'd been trying to create ghosts.

SELF-PORTRAIT
NEW ORLEANS, LOUISIANA

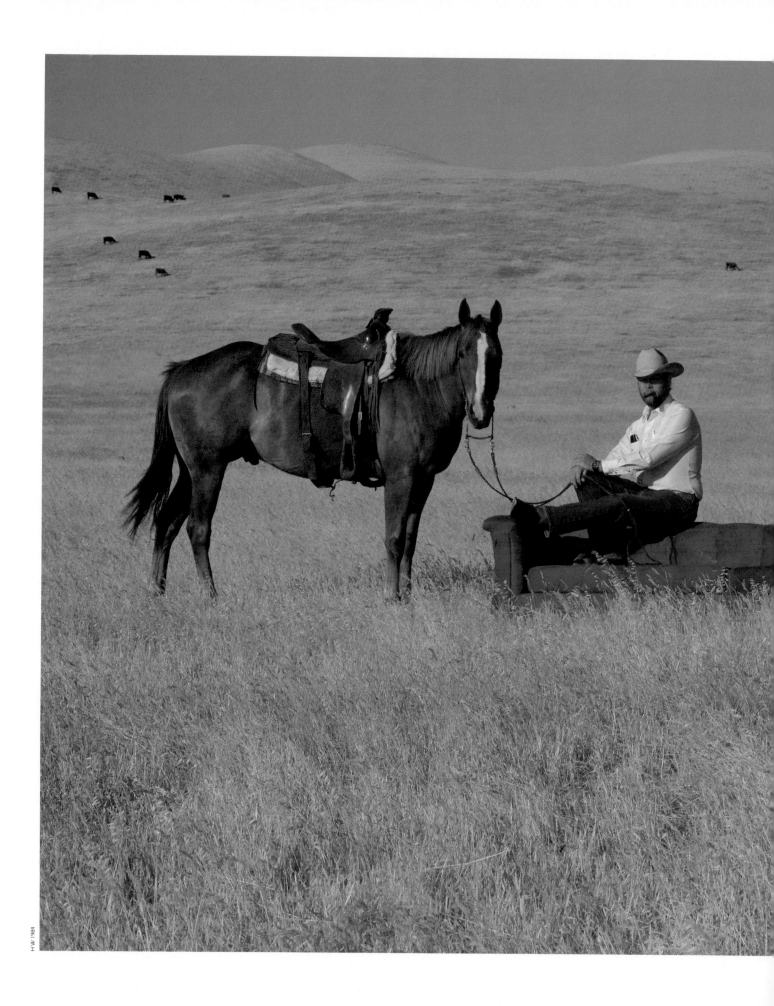

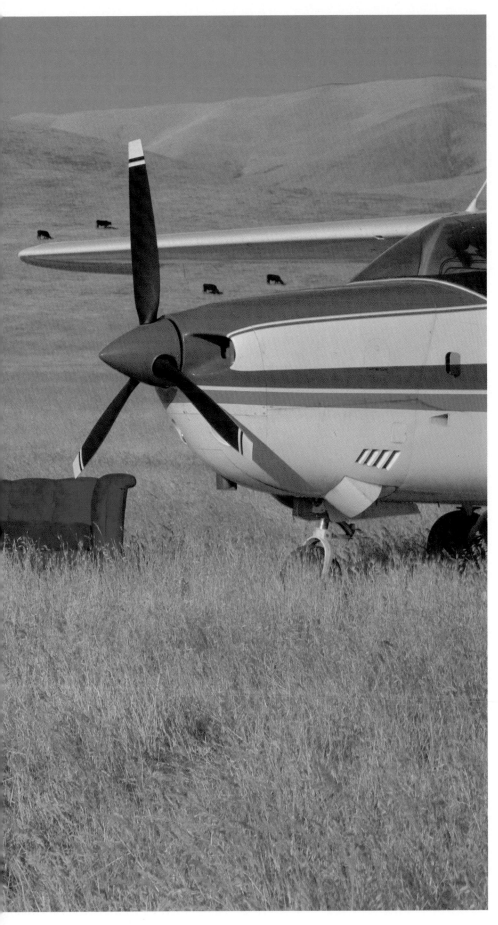

This rancher is the president of a large agri-business that owns thirty-five thousand head of cattle, eight hundred dairy cows, a tomato paste manufacturing plant, and a cotton gin. The company land produces corn, tomatoes, sugar beets, cotton, and almonds. People say he's the future of American agriculture.

WARREN WOLFSEN
NEAR LOS BANOS, CALIFORNIA ⎯⎯⎯⎯

A Park Service helicopter took me and Professor Blakey and the couch to the top of Merry-go-round Pinnacle. He's been studying the structure of the canyon for several years. He holds a quartz crystal, a form of silica, which is the basic element of the rock at Sedona. Fifty-mile-an-hour winds threatened to send the couch airborne. The next day Professor Blakey told me he had dreamed that night that he was falling off the world.

RONALD C. BLAKEY
SEDONA CANYON, ARIZONA

Kevin Lynch, my assistant, found the sled and dogs by making an announcement over a Juneau radio station. Mr. Denton is a general contractor who got into dogsled racing when a man moved out of town and left him the sled and huskies. Soon he found he needed five dogs, and then seven; then his wife needed dogs. Now he has thirty huskies and races them in the Thousand Mile Race, from Anchorage to Nome.

The dogs had to be transported up the Eagle Crest ski lift. They were so nervous they mussed all over the seats. A photographer spends a lot of time cleaning up.

BRUCE DENTON
EAGLE CREST, ALASKA

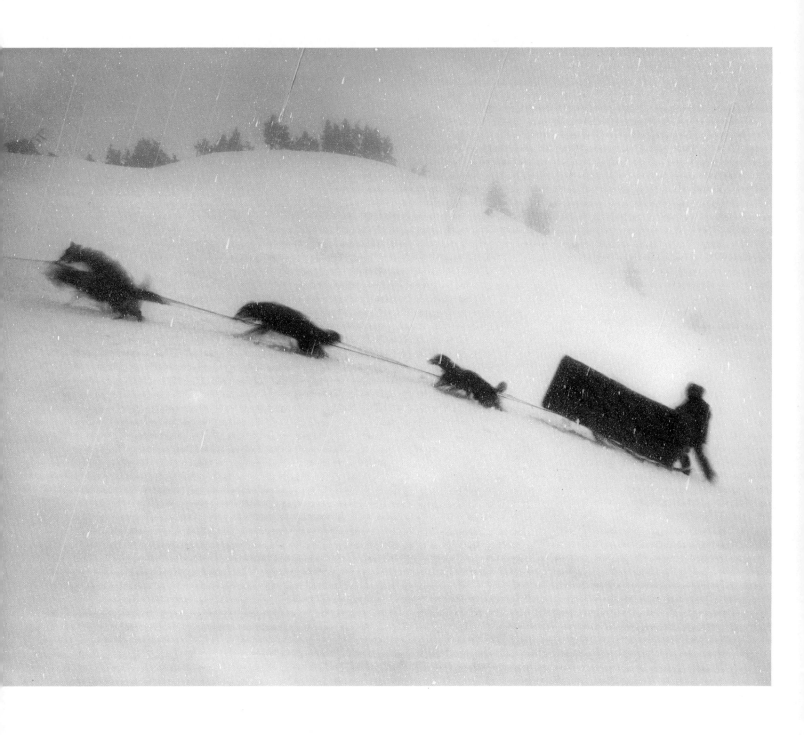

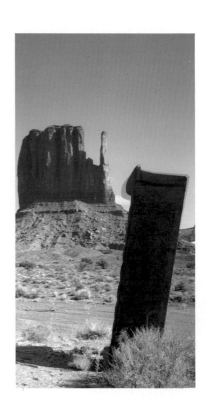

ACKNOWLEDGMENTS _____

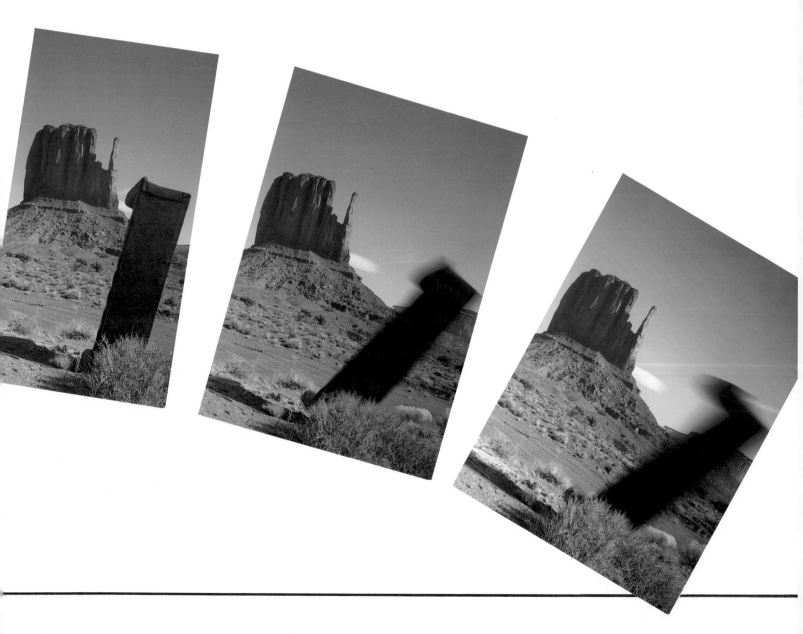

KEVIN CLARKE

I dedicate this book to my wife, Klara Berg, whose support, sacrifices, love, and belief in the project made it possible to endure the road.

Russell Maltz was there from start to finish; he loaned his couch for a day, with this book being the unanticipated result.

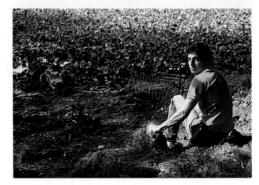

Special thanks to my assistants—Bill Voorhest, Nelson Bakerman, and Francesco Ruggeri—who traveled many long miles.

My friends Melitta del Villar, Herb Kliegerman, Klaus Fabricius, Kevin Anhalt, and Joe Taranto helped sustain the project at critical junctures.

My thanks to the many people who helped me while traveling, especially: Igor & Donna Alexander, Suzi Paul, Owen Murphy & Jude Solomon, the Andersons, Mr. & Mrs. H. A. Clarke, Hy Jacobs, Eric Sax, Ed & Gail Mell, and John Llewellyn, J. Harrison Itz, Julius Tobias, and Art Gallagher.

My thanks to Ingrid Schick, Ellen Jacobs, Rob Grudman Studio, Broderson Backdrops, Westin Hotels, N.A.S.A., Gulf Oil Corporation, Plimouth Plantation, and Air Services International.

Dr. Blakey was photographed on location in the Colorado National Forest, Forest Service, United States Department of Agriculture.

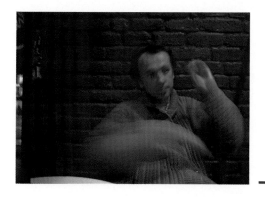

—————————————————————————— HORST WACKERBARTH

I dedicate this book to Hedy Valencise, without whose loving assistance it would not have been possible.

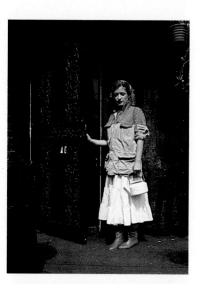

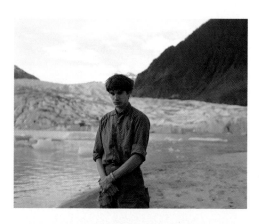

Special thanks to my good friend and fine assistant, Kevin Lynch, who was always there when I needed him.

My friends Cornelia Kiss, Kelvyn Hallifax, and Eddy Pollock were valuable allies throughout the project. Walter Lürzer was invaluable.

I gratefully acknowledge the special support I received from my agents: Klaus Fabricius (London), France Aline (Los Angeles), and Marsha Fox (Los Angeles).

My thanks to Uschi Henkes, Urs Frick, Klaus Thiem, Antje van Dieken, Fritz Meyer, Ronald & Nanni Schaefer, Wil & Inge Deichmann, and Icke Winzer, as well as Mr. Neuberger & Mr. Vogler of the Berliner Bank (Frankfurt).

My thanks to all those who helped me out along the way, particularly: (in Los Angeles) Dona Powell, Dominique Marsden, Matti Klatt, Margaux Mirkin, Mike Doud, Michael Barett, Christine Thomas, Marlene Jansen, Christine del Sangro, and Randee St. Nicholas; (in New York) Carla Domann, Tom Ferrara, Lori Hallifax, Tom Graves, Elly Shurany, Karli, Jerry & Elke, and Leslie van de Velde; (in Germany) Tom Glaeser, Lilo & Nick Lynch, Axel Hinnen, and Claudia Hammerschmitt; and Lou Gamell, Dolores & Nann Sullivan, Ida & Jerry Biros, and Jane Anderson.

For the preparation of this book, Ilford Cibachrome materials were used to preserve color fidelity and for archival permanence. Most of the portraits in this book were photographed in large format with the Sinar P 5" x 7" view camera. Our thanks to Sinar-Bron for technical assistance. D. O. Industries provided Fujinon lenses, and Balcar-Tekno gave us strobes. We often tested exposures and composition with Polaroid instant film (courtesy of Barbara Hitchcock). Video equipment was provided by Bell & Howell (Germany). Our thanks to James Ishihara and A & I Labs (Los Angeles) for their special services.

Critical assistance came from *Life* magazine (Bob Ciano and John Loengard) and from *Stern* magazine (Wolfgang Behnken, Christiane Breustedt, and Rolf Gillhausen). We also appreciate the aid we received from April Silver and Ellen Madiere of *Esquire* magazine.

We extend our special appreciation to Mr. Baldev Duggal, of Duggal Color Projects (New York City), who saw six early slides and offered his total support for the duration of the project.

BALDEV DUGGAL
NEW YORK CITY

At the American Booksellers Association 1984 convention a lottery was held to determine which bookstore would be the first visited by the Red Couch. The name drawn was Regina L. Little, owner of the Little Professor Book Center in Gainesville, Florida.

REGINA L. LITTLE AND FAMILY
GAINESVILLE, FLORIDA

Finally, and most importantly, we offer our heartfelt thanks to the many individuals who "sat" for portraits on the Red Couch. The realization of each photograph required considerable effort on the part of everyone involved, and we deeply regret that we were unable to include in this book each and every picture that we took. KC & HW